This Is the Story of a Happy Marriage

Ann Patchett

B L O O M S B U R Y

LONDON · NEW DELHI · NEW YORK · SYDNEY

First published in Great Britain 2013
This paperback edition published in 2014

Copyright © 2013 by Ann Patchett

The moral right of the author has been asserted

Bloomsbury Publishing plc
50 Bedford Square
London
WC1B 3DP

www.bloomsbury.com

Bloomsbury Publishing, London, New Delhi, New York and Sydney

Bloomsbury is a trademark of Bloomsbury Publishing Plc

A CIP catalogue record for this book is available from the British Library

ISBN 978 1 4088 4241 6

10 9 8 7 6 5 4 3 2 1

Designed by Jo Anne Metsch
Printed and bound in Great Britain by CPI Group (UK) Ltd, Croydon CR0 4YY

Portions of this work appeared, in both slightly and significantly different forms, in the following:

Atlantic Monthly: "My Life in Sales"; "'The Love Between the Two Women Is Not Normal'"; "The Bookstore Strikes Back"

Audible Originals: "This Is the Story of a Happy Marriage"

The Bark: "On Responsibility"

The Best American Short Stories 2006: "Introduction"

Byliner: "The Getaway Car"

Gourmet: "Do Not Disturb"

Granta: "The Mercies"

Harper's Magazine: "Love Sustained"

New York Times: "Our Deluge, Drop by Drop"

New York Times Magazine: "The Paris Match"

Outside: "My Road to Hell Was Paved"

South Carolina Review: "The Right to Read: The Clemson Freshman Convocation Address of 2006"

State by State: A Panoramic Portrait of America: "Tennessee"

Vogue: "The Sacrament of Divorce"; "This Dog's Life"; "Dog without End"

Wall Street Journal: "The Best Seat in the House"

Washington Post Magazine: "How to Read a Christmas Story"; "The Wall"

For Karl

Contents

—— • ——

This Is the Story of a Happy Marriage

Nonfiction, an Introduction

THE TRICKY THING about being a writer, or about being any kind of artist, is that in addition to making art you also have to make a living. My short stories and novels have always filled my life with meaning, but, at least in the first decade of my career, they were no more capable of supporting me than my dog was. But part of what I love about both novels and dogs is that they are so beautifully oblivious to economic concerns. We serve them, and in return they thrive. It isn't their responsibility to figure out where the rent is coming from.

What I was looking for in a job was simple enough: something that would allow me to pay the bills and still leave me time to write. At first I thought the key would be to put the burden on my back rather than my brain, and so I worked as a restaurant cook and, later, as a waitress. And I was right, there was plenty of room in my head for stories, but because I fell asleep the minute I stopped moving, very few of those stories were ever written down. Once I realized that physical labor wasn't the answer, I switched to teaching—the universally suggested career for all M.F.A. graduates—and while I wasn't so

tired, days spent attending to the creativity of others often left me uninterested in any sort of creativity of my own. Food service and teaching were the only two paying jobs I thought I was qualified for, and once I'd discovered that neither of them met my requirements, I was at a loss. Could I follow the example of Wallace Stevens and sell insurance? All I knew for certain was that I had to figure out how to both eat and write.

The answer, at least the first spark of it, came in the form of a 250-word book review of Amy Tan's novel *The Joy Luck Club*. I had published several short stories in *Seventeen* magazine, and had asked my editor, Adrian Nicole LeBlanc—both of us twenty-five at the time—if I could have a nonfiction assignment as well. The economics were easy enough to figure: *Seventeen* ran one short story a month, twelve stories a year, and if I was doing my absolute best I could never hope for more than one or two of those spots. A writer of nonfiction, on the other hand, could publish an article in every issue, sometimes multiple articles in a single issue. I had finally identified a job that I more or less knew how to do that would be neither mentally nor physically exhausting.

Which is not to say that it wasn't aggravating at times. I was asked to rewrite that book review half a dozen times, and each time I was told I had to consider yet another aspect of the novel. My word count was not increased to match these new points of interest, and more words in meant that, somewhere, other words had to come out. So I trimmed and tucked, found a single word to express five words' worth of feeling. I explored the realm of mother-daughter relationships on the head of a pin. Once my book review was accepted, I started pitching ideas for articles to Adrian, who took the better ones to her boss, Robbie Myers. Unlike in my fiction, where I prided myself on making things up, I found these articles wanted personal experience. For every ten story ideas I came up with—"Growing Up with Horses," or "When Your Best Friend's a Guy," or "How to Decorate Your Locker"—I would be given the green light to write one of them (without a con-

tract or kill fee), and for every ten I was allowed to write, maybe one would actually make its way into the magazine. The one that was accepted would then be rewritten ten times as I received round after round of notes, not only from Adrian and Robbie, but from various editors in other departments and all their interns, who were honing their own editorial skills. *I never felt that way when I was fifteen*, read the note most regularly penciled in the margins. And while I wanted to say, *Did you grow up in Tennessee? Did you go to a Catholic girls' school? Did you stay home with your parents on the weekends and never go on a single date?*, I refrained. If they wanted to see themselves reflected in my piece, I would put them there. I would find a way to wedge in every single one of them and stay within the confines of my word count.

Seventeen magazine, where I never had an office and rarely visited, was the site of my apprenticeship; I learned how to write an essay there, just as I had learned how to write fiction at Sarah Lawrence College and the Iowa Writers' Workshop. Whereas fiction was singularly mine—I would never have changed a short story to reflect an editor's experience—nonfiction was collectively ours. I readjusted the slant of an article to satisfy the vision of various editors, or spiced up the action to meet the attention span of the readers. I saw my best paragraphs cut after everything was finished and agreed upon because the art department wanted more space for their illustration. I sliced a piece in half because an ad was suddenly dropped, and fewer advertising dollars meant fewer editorial pages. I was learning how to work for a magazine by shaping my writing, yes, but I was also shaping myself: it was my aim to be flexible and fast, the go-to girl.

Years later, a magazine editor called to say that they were closing the issue the next day and their lead article, a long piece about procrastination, had fallen through at the last minute. Could I write something, anything, by tomorrow? Of course I could. This was the person I had trained myself to be.

Magazine work was an uncertain business—assignments were

killed on a whim, checks were late, and there was always someone who owed me expenses—but I never lost sight of how much easier it was than busing tables or grading papers. The years spent in the free-lance trenches eventually paid off; I would go on to have some re-markable assignments. I've toured the great opera houses of Italy, gone on a mock honeymoon in Hawaii, driven an RV across the American West, all on someone else's dime. Whenever people ask how they can get those same kinds of assignments, I recommend what worked for me: eight years writing freelance articles for *Seventeen*.

In my mind, fiction and nonfiction stayed so far away from each other that for years I would have maintained they had no more a rela-tionship than fiction and waitressing. Writing a novel, even when it's going smoothly, is hard for me, and writing an article, even a challeng-ing one, is easy. I believe nonfiction is easy for me precisely *because* fiction is hard; I would always rather knock off an essay than face down the next chapter of my novel. But I've come to realize that while all those years of writing fiction had improved my craft as a writer across the board, all those years of writing articles, and especially the early years at *Seventeen*, had made me a workhorse, and that, in turn, was a skill I brought back to my novels. *Seventeen* also went a long way to beat any ego out of me. Somewhere along the line I learned to experience only the smallest, most private stabbing sensation when I watched my best sentences cut from an article because they did not advance the story. Ultimately, this skill came to benefit my fiction as well. The conversations I had had so often with magazine editors were now internalized. I could read both parts of the script. *Did I think that was a beautiful scene I had written?* Yes, I did. *Did it further the cause of the novel?* No, not really. *Could I then delete it?* It was al-ready gone.

I wrote for *Seventeen* until I was thirty; by then I had exhausted everything I remembered about growing up. I then moved on to fash-

ion magazines, the way a girl who has cut her teeth reading *Seventeen* goes on to read *Harper's Bazaar*. I got new assignments not by sending out clippings and a résumé, but by doggedly following editors and friends as they advanced through their careers. Someone I knew at *Seventeen* went to *Elle*, which meant I could now write for *Elle*. My friend Lucy wrote a piece for *Vogue*, which meant I now had a contact at *Vogue*. When that editor got a job at *GQ*, I added *GQ* to my list of employers. In this way my career expanded exponentially. A friend of mine from college went to work for *Mercedes-Benz Magazine* (who knew such a thing existed?), and so I wrote articles that appealed to the owners of luxury cars. Later, my friend Erica Goldberg Schultz became the editor of *Bridal Guide* and made me a contributing editor, which meant I paid my bills by writing about the challenges of finding cake-toppers that resembled the actual bride and groom. As trivial as this work was, I had no intention of setting my sights any higher; I wanted to finish my article on ballroom dancing or boutique farming and get back to my novel. Writing fiction, after all, was what I did.

In truth, I wasn't the one who decided to better myself; one of my editors did it for me. When Ilena Silverman, my editor at *GQ*, got a job at the *New York Times Magazine*, she took me with her, along with another writer she favored, my friend Adrian LeBlanc, who had long ago left *Seventeen* for a reporting career. Though I felt intimidated and unqualified to write for the *Times*, I realized magazine writing had given me yet another skill (also essential to fiction): the ability to fake authority. The first assignment I was given was a small piece on "nutraceuticals." Did I know what they were? No, I did not. Did I mention that to Ilena Silverman? No again. I will never forget calling an executive at Monsanto to discuss the high-beta-carotene cooking oil they were developing. "This is Ann Patchett from the *New York Times*," I said to the assistant. I had never had a call put through so quickly in my life.

For the most part, I loved my editors and the brief, intense intima-

cies that could come from working together on a piece. I loved Ilena Silverman so much I would have written anything she asked me to, just for the chance to spend hours talking with her on the phone. Had we actually been friends who spent time together, I'm sure I wouldn't have written for her, as her editorial style drove me mad. She never seemed to know quite what she wanted where I was concerned, but she felt sure she'd know it when she saw it. That meant I was asked to rewrite pieces from every conceivable angle so that she could say, *No, that wasn't what I had in mind.* It was like having someone ask you to move the living room furniture over and over again: *Let's see that sofa under the window. No, no, I don't like it under the window; let's see what it looks like next to the door.* Still, thanks to her intelligence and good company, I remember the pieces we worked on together with great fondness. She was trying to drag me to the smarter, better places she could see inside her own mind.

While I was still writing for the *Times*, I started on the best freelance job of my career: writing for Bill Sertl and Ruth Reichl at *Gourmet*. If the *New York Times Magazine* challenged my thinking, *Gourmet* expanded my art. What Ruth and Bill wanted to see was how much warmth and exuberance could be packed into a single piece. Working for them was like having the world's most supportive parents. They were eager to get behind everything I wanted to do. When I was working on *Bel Canto* and wanted to learn more about opera, they packed me off to Italy. When I was writing *State of Wonder* and wanted to take a boat up the Amazon in Brazil, Bill found me a boat, though not one in Brazil. "It's in Peru," he said, "but let me tell you, the jungle's the jungle." I ate the food, made notes on hotel rooms, and participated in available tourist activities, all the while soaking up the atmosphere for my next novel. Once I called Bill after what had been months of overlapping houseguests and told him I wanted to check into a fancy hotel by myself for a week and never leave the property. "Brilliant!" he said. "I love it." And so I took up

residence at the Hotel Bel-Air. The resulting piece, "Do Not Disturb," was one that no other magazine would have assigned, and it's probably the best piece of travel writing I've ever done. Those were the salad days of freelance writing. I can only hope I gave back to *Gourmet* half of all it gave to me.

Considering the limitless freedoms of fiction (make up the people and all their problems; make their houses, their rivers and trees; decide when they're born and when they'll die; turn the book in whenever you're finished), I took some real comfort from my day job. Like a soprano's boned corset, the built-in restrictions provided both support and something to push against. I often took ideas to editors, but just as often they brought ideas to me. At times, I found myself writing on subjects I knew nothing about in a voice that was more the magazine's than my own. Whom I should talk to and where I would go and when the piece was due were decisions that weren't often mine to make, and that was fine. My only true obsession was with word count. I saw the length of essays as track-and-field events: the 900-word essay was the shot put, 1,200 the high jump, 2,000 the long jump. Each one had a particular pacing and shape that I understood deeply. "Just write it as long as you want," some editors liked to say. "We'll cut it down later." But a 2,000-word essay that's cut to 800 words winds up feeling irrevocably mangled to me, as if I can see the lines of stitching running between the paragraphs.

My fiction, which had for so many years failed to provide me with a living wage, was suddenly able to buy me a house after the publication of *Bel Canto* in 2001 (in the same way I suppose a well-cared-for dog will occasionally dig up a small chest of gold in the backyard—not that mine ever did). I was free to quit my day job, and that was, of course, the point at which I realized how much I liked my day job. Still, I knew there were things I needed to change. Throughout the years when I had been supporting myself by writing nonfiction, my

modus operandi had been to accept all comers, and while I found that habit very hard to break (it's difficult to convince the freelance brain that the well isn't going to run dry tomorrow), I tried to be a little more discerning in the assignments I accepted. No, I would not cover a country music star's soup party in Atlanta. I would not go on a group-therapy Outward Bound trip that would necessitate authorial nudity in a natural hot spring. (You may be wondering if I'm making that up. I'm not.) I started thinking more about the stories I wanted to tell, regardless of whether any magazine wanted to buy them, and while I was still obsessed with word counts, I let some of those stories get longer. When my friend Sister Nena had to find an apartment and live by herself for the first time at the age of seventy-eight, I called Patrick Ryan at *Granta* and asked how much space I could have, not how much they could pay. Then I wrote "The Mercies."

In the years I made my living writing nonfiction, I thought of the work I did as being temporary, with a life span that would, in most cases, not exceed a magazine's last tattered days in a dentist's waiting room, but the essays kept resurfacing. People would bring them to book signings and show them to me. *I read this when my grandmother died. Someone gave this to me when I got divorced.* They told me my story was their story, and they wondered if there was more, something they might have missed. I marveled that a back issue of the *Atlantic* could have stayed around for so long, or that the subjects of the articles were still resonant. The job of these essays had been to support art, not to be art, but maybe that was what spared them from self-consciousness.

Many, many years ago, in an effort to save space, I started tearing up the magazines I wrote for, keeping my articles in a big plastic bin and throwing away the other pages. I had thought in the past about putting together a collection of essays, but every time I tried to sift through what was a fairly enormous body of work, I got stuck: if writ-

ing a personal story in a magazine was like putting out a single piece
of a jigsaw puzzle, then collecting those essays in a book would be like
publishing the finished puzzle, which would look very much like a
map to my house. I always wound up snapping down the lid again.

What finally made the difference was my friend Niki Castle, who
has long taken a deep personal interest in my essays. When I contin-
ued to refuse, reconsider, and stall, she took the bin away, and later
came back with a list of the essays she thought could make a book.
While nothing from my earliest days of *Seventeen* and *Bridal Guide*
was included (those pieces were meant only for the young and the
recently engaged), she had chosen pieces from every other point in my
career to date. She told me that these essays deserved the chance to
sit together, and that by keeping company, they would inform one
another. I claimed not to agree, but I found myself writing new essays
to fill in the gaps. (After all, if there was going to be a book, there had
to be something about the bookstore.) I read through the collection
Niki had put together, took out some of her choices, added in nothing
from the bin that she had passed over, and then got back to writing.
Byliner and Audible both contacted me in the same month asking for
essays that would be in the neighborhood of 15,000 words, and I said
yes before I had any idea what I would write about. After a career
built largely on 1,200-word pieces, the possibilities suggested by so
much open space were dazzling. I had to ask myself what it was I
really wanted to think deeply about. The answer was fiction writing
for Byliner ("The Getaway Car: A Practical Memoir about Writing
and Life"), and, for Audible, marriage ("This Is the Story of a Happy
Marriage"). By the time those pieces were written it was obvious even
to me that I was working on a book.

Whatever I've become as an essayist, this collection bears the
stamp of a writer who got her start in women's magazines: it is full of
example and advice. I will never be a war correspondent or an inves-
tigative reporter, but the tradition I come from is an honorable one,

and, at times, daunting. Many of the essays I'm proudest of were made from the things that were at hand—writing and love, work and loss. I may have roamed in my fiction, but this work tends to reflect a life lived close to home.

Good as I was at keeping to my assigned word counts over the years, I have in some cases gone back and made these pieces longer. This is true most notably of "The Wall," because there was so much more to tell than the *Washington Post Magazine* had room for, and because I no longer have to worry about how much space the art department is going to requisition. For the most part, though, I've left things alone. I have no desire to rewrite the past; in fact, for me the beauty of this book is how it keeps the past alive: here Rose is, a puppy again, and there is my grandmother. Karl and I are meeting for the first time and we are young with no idea of what's ahead. If I'm lucky, someday in the future I'll see what I've written here and think how young I still was and how much more there was ahead. Until then I'll keep writing things down, both the things I make up and the things that have happened. It is the way I've learned to see my life.

How to Read a Christmas Story

I HAVE NEVER LIKED Christmas. In my family, there were happy Thanksgivings and tolerable Easters, but Christmas was a holiday we failed at with real vigor. I blame this on my parents' divorce. I was nearly six when my mother and sister and I left our home and my father in Los Angeles. The man my mother had been seeing in Los Angeles had moved to Nashville, and so we moved to Nashville as well. A year or so later they were married. My stepfather's four children still lived in Los Angeles with their mother. My stepfather's children spent their Christmases on a plane so that they could open presents in the morning with their mother in California and then open a second set of presents at night with their father in Tennessee. Thinking about this now, I realize how impossibly young they were to make a trip like that alone—a stepbrother and stepsister slightly older than I, a stepsister and stepbrother slightly younger. We were strangers but we had the world in common: they had betrayed their mother by leaving her alone on Christmas Day, just as my sister and I betrayed our father by staying in Tennessee.

Lonely and spent, my stepsiblings fell apart soon after they arrived, fighting and weeping among themselves. That was when my stepfather, overwhelmed by the presence of his children, would take his cue to recount his own unhappy childhood. He had had the great misfortune to be born on Christmas Day, and so Christmas never came without the sad reminiscence of all the years he never got a birthday cake or a birthday present because his own parents hadn't cared for him at all. He was a sentimental man, my stepfather, and easily moved himself to tears at this memory. Somewhere in all of this my mother, crushed by everything that had fallen to her, would begin to cry as she tried to settle the six small, miserable children who were now in her care.

I might have managed all of this had it not been for the Christmas phone call from my father. My father was largely stoic in the face of his circumstances—two young daughters relocated to Tennessee—but he wasn't stoic where the holidays were concerned. His misery at our being so far away came through the phone and sat with us like a living thing while my sister and I, virtually incapable of stoicism, went down like a house of cards.

It wasn't that everything about the holiday was bad. The school part of Christmas that the nuns were in charge of—the door-decorating contest, the advent calendar, and the Christmas pageant—packed in all the joy and anticipation the occasion was billed to have. When we went to the chapel and sang *Rejoice! Rejoice!* I felt it. I landed the role of the Archangel Gabriel two years running because my mother had made me such a transcendent pair of wings out of cardboard and gold foil wrapping paper. But by December 20, school had ended. There was no other option but to go home and wait it out.

No matter how the members of my reconfigured family suffered through Christmas year after year, all we ever thought to change were the details. There was the year we made our own ornaments, strung endless garlands of popcorn and cranberries and baked sugar cookies

in the shape of stars to hang on the tree. We were living in the country then, and though it had taken us a week to make the decorations, the mice shut us down in a single night. There was the year we decided to exchange only homemade gifts. My stepfather gathered up his first wedding ring, his various class rings, and all the gold fillings he'd had taken from his teeth and had them melted down. Then he made wax casts of rings and pendants and earrings and had them cast. I still have a big, lumpy A that hangs off a chain. The other girls all had their ears pierced and so received post earrings—H for Heather, P for Patchett. There was the year my mother thought to move Christmas to early January so that we could celebrate the Feast of the Magi and my stepfather could finally have the 25th to himself, but even with the birthday cake and birthday hats none of us was fooled. That year when our father called, we said it was our stepfather's birthday and that he should call again on the Feast of the Magi. He told us to put down the phone and go open our presents.

Because Christmas and presents are inseparable, I have never liked the presents either. Christmas was a bad day for expectations and heart's desires. My father's presents were always the saddest because they were so consistently wrong. He sent me clothes I never liked and dolls that were big and artistic and creepy. The year I very much wanted a pair of boot roller skates, he got me a pair in black. At recess, all the girls skated around the convent parking lot wearing white boot skates. I was disappointed to know that I would spend another year not skating, but more than that I was shaken by how little my father understood the circumstances of my life. On the phone I thanked him and said they were perfect. I never put the laces in.

Then one year my father called me late on Christmas Eve. This was unusual, because my father's time to call was after he went to Mass on Christmas morning. In my memory I was already in bed, although it seems more likely that I went to my mother's room and lay

down on her bed to talk since that was where the phone was. I will say that I was twelve but in truth I have no idea how old I was. I was a child. My father called because he wanted to read me a short story that was in the newspaper. My father's newspaper has always been the *Los Angeles Times*.

If I was twelve that Christmas Eve, I already knew I wanted to be a writer. That knowledge goes back as early as six, as early as the start of school and maybe even before that. I may at times forget the details of my life but I remember the stories I read. Plots, characters, entire passages of dialogue are stenciled on my brain. They are softened now but for the most part legible. Authors—poor authors!—are gone completely. It was much, much later that I took any notice of who was doing the writing.

I am certain this is the only time my father, or anyone else for that matter, ever read me a story over the phone. I closed my eyes in order to give myself over completely to the pleasures of listening, the phone against my ear like a conch shell. The narrator of the story was a grown woman who was remembering a Christmas Eve in her childhood. She had grown up in a Catholic orphanage and every year each of the girls received a single, disappointing gift that had come to them by way of charity. The gifts were given out in a random sort of lottery and for years the heroine had received a pair of gloves or a package of underwear, some article of necessity that might have been appreciated had it not been masquerading as a Christmas present. But on this particular night her luck changed dramatically. She received a tin box of colored drawing pencils that she had desperately wanted. The narrator planned to be an artist and so not only was the gift delightful, it was actually her only shot at having a future. She both loved the pencils and needed them, and she took them to bed with her in a cold room with a good blanket where she slept with the other girls, and she was happy.

Christmas morning in this story came early. The nuns woke the

girls up before it was light and told them that during the night a large group of gypsies had come to sleep in the field on the other side of the woods from the orphanage. The gypsy children had no presents at all, and no breakfast, and so the nuns told the girls that they should think about giving up their gifts to the poor children.

This is the only detail of the story that I puzzle over: Did the nuns tell the girls they had to give up their presents or did they suggest the idea and leave it up to them? Morally, of course, it's more interesting to give the girls the choice, but I'm certain the nuns where I went to school would have made us give the presents up.

Bundled in their coats and scarves, the girls went through the woods towards the gypsy camp in the darkness, carrying not only their presents but their breakfasts. The gypsy children were poor and thin and shivering in the cold, and the narrator was beautifully brave as she gave her colored pencil set to one of the little gypsy girls. She was glad to do it, because at that moment she recognized all that she had—a place to sleep, food, an education, nuns to look after her. She knew how lucky she was to be the girl who had something as extraordinary as colored pencils to give away. They walked back to the orphanage as the sun was coming up and it seems to me that there was singing, by the nuns or the orphans or the gypsies, though the singing may be my own embellishment, so great was my happiness by the time my father drew the story to a close.

Though there was no talk of it during this particular phone conversation, my father wanted me to be a dental hygienist. Unlike my sister, I wasn't shooting the lights out in school, and he thought it was essential that I have a practical skill to fall back on. A career in writing seemed about as likely to him as the chances of my inheriting Disneyland. My father thought I should be realistic.

But my father was a great reader who had a real appreciation for stories. He wouldn't have read me a bad short story no matter how moral it was, and I'm certain that he read me this one as much for its

simple and lovely construction as for its messages—there's always someone who's worse off than you; it is better to give than to receive; and, most of all, listen to the nuns, who are bound to steer you towards your best self.

And I got all of that, but in the kind of explosion of understanding that sometimes happens in childhood, I got more and more. My father loved to cut the newspaper apart and mail his favorite articles to my sister and me, and even now it strikes me as tender that he called to read this one to me over the phone. There was no gift that could have made me feel my father really knew me the way that story did. I loved the bright portrait of Catholicism at its best: as much as I wanted to be a writer when I was a child, I also wanted to be a shining example of my faith, which meant that I wanted the nuns and the other children in my school to be dazzled by my selflessness and piety while I, in my transcendent goodness, never noticed them noticing me. Oh, what I wouldn't have given to be that orphaned narrator! Wouldn't it be so much better to be an orphan, not to feel that you were letting one parent down by being with the other parent on Christmas? But children don't get to pick their hardships. I would have to make do with having too many parents and too many siblings instead of not having enough. I wanted the chance to receive something as wonderful as those colored pencils and then have the opportunity to give them away, but I had no idea where to find gypsies on Christmas Eve in Nashville. It never occurred to me to look in the living room, where my four dark-eyed stepsiblings sat amid the piles of spent wrapping paper, no doubt disheartened by the practical gifts that proved to them how little they were known.

If it was true that I didn't know much about the people who spent Christmas in my house, I had a remarkable grasp of the inner workings of that short story. The narrator presented that Christmas as a memory, looking back from the safe perch of adulthood, so that I would know from the very start she had survived. Even as I wanted to

be the heroine of that story, I understood how much better it was to have her be a Catholic orphan instead of a Catholic girl like me. In terms of plot, there is nothing interesting about a middle-class child giving colored pencils to the poor, but it moved me to tears to see an orphan give her present away. The poverty of the narrator was striking until one considered the poverty of the gypsies; it seemed sad to get only one Christmas present until you found someone who had no present at all; these were the wheels that moved the story along. All the while I understood it was fiction. I knew the narrator was a made-up person. The author very likely had never been to an orphanage before. I understood this not because there was anything shoddy about the work, but because I was concentrating very hard on what it meant to write at that time in my life. Writers need not be confined by their own dull lives and petty Christmas sadness. They could cut new stories out of whole cloth, stories that did not reflect their own experiences but spoke instead to the depth of their emotions. In short, this was something I could do.

The first completely happy Christmas I remember came when I was twenty-two. I was in graduate school in Iowa City and Jack Leggett, who was then the director of the program, asked me to house-sit for him over the holidays. His house was big and old and beautiful and freezing cold. There were cross-country skis propped up beside the back door and an endless number of hardback books I'd never read and an enormous fireplace in the kitchen that required my constant attention. My father in California was happily remarried by then, and my mother and stepfather were nearly divorced. My sister and my stepsiblings had begun to scatter, looking around for a better version of the holiday for themselves. In Iowa I was alone, knitting and reading. Every hour I spent without a gift or decorated tree restored me, and in the peace of falling snow and isolation I let go of Christmas past. I let go of everything except the story of the orphan and her colored pencils, which, sitting in Jack's kitchen, I told myself

again, as I had done on all the Christmases before, as I would continue to do on all the Christmases in the future. It was the shining star, the one thing I wanted to keep. The story is the best gift I have no record of.

(*Washington Post Magazine*, December 2009)

The Getaway Car

•

A Practical Memoir about Writing and Life

I WAS ALWAYS GOING to be a writer. I've known this for as long as I've known anything. It was an accepted fact in my family by the time I had entered the first grade, which makes no sense, as I was late to both read and write. In fact, I was a terrible student when I was young. I've always believed the reason I was passed from grade to grade was that I could put together some raw version of a story or poem, even if all of the words were misspelled and half of them were written backwards. Like a cave child scratching pictures on the wall of bison and fire and dancing, I showed an early knack for content. Only writing kept me from being swept into the dust heap of third grade, and for this reason I not only loved writing, I felt a strong sense of loyalty to it. I may have been shaky about tying my shoes or telling time, but I was sure about my career, and I consider this certainty the greatest gift of my life. I can't explain where the knowledge came from, only that I hung on to it and never let go. Knowing that I wanted to write made my existence feel purposeful and gave me a sense of priorities as I was growing up. Did I want to get a big job and make a lot of

money? No, I wanted to be a writer, and writers were poor. Did I want to get married, have children, live in a nice house? No again; by the time I was in middle school I'd figured out that a low overhead and few dependents would increase my time to work. While I thought I might publish something someday, I was sure that very few people, and maybe no one at all, would read what I wrote. By ninth grade I was drawing from the Kafka model: obscurity during life with the chance of being discovered after death. Young as I was when I made this commitment, it wasn't quite as morbid as it sounds—so many of the writers we studied in school were unknown in their lifetimes (or, better still, scorned and dismissed) that I naturally assumed this to be the preferable scenario. It was also in keeping with my Catholic education, which stressed the importance of modesty and humility. I did not daydream of royalty checks, movie deals, or foreign rights. Success never figured into my picture. The life I would have would be straight out of *La Bohème* (having never heard of *La Bohème*): I would be poor, obscure, alone, possibly in Paris. The one thing I allowed myself was the certainty of future happiness. Even though the history of literature was filled with alcoholics, insane asylums, and shotguns, I could not imagine that I would be miserable if I received the only thing I wanted.

It turns out that I was right about some of the details of my future and wrong about others, which is fitting, given the fact I was making it all up. No writers came to St. Bernard's Academy for Catholic girls on Career Day, and so I marched towards the vision in my head without guidance or practical advice. This is where it got me.

I am now a veritable clearinghouse of practical advice, and since I have neither children nor students, I mostly dispense it in talks or short articles. There is a great appeal in the thought of consolidating the bulk of what I know about the work I do in one place, so that when someone asks me for advice I can say, *Look, it's here, I wrote it all down*. Every writer approaches writing in a different way, and

while some of those ways may be more straightforward than others, very few can be dismissed as categorically wrong. There are people who write in order to find out where the story goes. They never talk about what they're working on. They say if they knew the ending of the book there would be no point in writing it, that the story would then be dead to them. And they're right. There are also people, and I am one of them, who map out everything in advance. (John Irving, for example, can't start writing his books until he thinks up the last sentence.) And we are also right. There are a couple of habits I have acquired through years of trial and error that I would recommend emulating, but either you will or you won't. This isn't an instruction booklet. This is an account of what I did and what has worked for me, and now that that's been said, I will resist the temptation to open every paragraph with the phrase "It's been my experience . . ." That's what this is: my experience.

Logic dictates that writing should be a natural act, a function of a well-operating human body, along the lines of speaking and walking and breathing. We should be able to tap into the constant narrative flow our minds provide, the roaring river of words filling up our heads, and direct it out into a neat stream of organized thought so that other people can read it. Look at what we already have going for us: some level of education, which has given us control of written and spoken language; the ability to use a computer or a pencil; and an imagination that naturally turns the events of our lives into stories that are both true and false. We all have ideas, sometimes good ones, not to mention the gift of emotional turmoil that every childhood provides. In short, the story is in us, and all we have to do is sit there and write it down.

But it's right about there, right about when we sit down to write that story, that things fall apart. I've had people come up to me at book signings, in grocery stores, at every cocktail party I've ever at-

tended, and tell me they have a brilliant idea for a book. I get letters that try to pass themselves off as here's-an-offer-you-can't-refuse business proposals: *My story will be a true blockbuster, a best-selling American original. Unfortunately, my busy schedule does not afford me the time to write it myself. This is where you come in.* . . . The person then offers me some sort of deal, usually a fifty-fifty split, though sometimes it's less. All I have to do is agree, and he or she will tell me the (*Compelling! Unforgettable!*) story, and I will type it up in his or her own voice, a task that is presumed to be barely above the level of transcription. Like those random Internet letters that begin *Dear Sir or Madam* and tell of the countless millions that will be left to me, *This is my lucky day.*

I feel for these people, even as they're assuming I'm not bright enough to realize where they've gotten stuck. I would also like to take this opportunity to apologize on the record to Amy Bloom, because once when we were madly signing books at the end of a *New York Times* book and author lunch (with Alan Alda, Chris Matthews, and Stephen L. Carter in between us, a very busy event), an older woman appeared at the front of my line to tell me that the story of her family's arrival from the old country was a tale of inestimable fascination, beauty, and intrigue, and that it must be made into a book, a book that I must write for her. I politely but firmly demurred, saying that I was sure it was a fantastic story but I scarcely had the time to write about my own family's journey from the old country, much less all the things I made up. She kept on talking, outlining in broad strokes her parents and their sacrifices and adventures. *No,* I said, trying to hold on to good manners, *that is not what I do.* But she didn't budge. She leaned forward and wrapped her fingers beneath the table's edge in case someone thought to try to pull her away. Short of *yes,* nothing I said was going to dislodge her from her spot. The crowd was backing up behind her, people who wanted to get my signature quickly so they could be free to adore Alan Alda (who was fully worthy of adoration).

When I was completely out of tricks, I told the woman from the old country to ask Amy Bloom. *Amy Bloom might be interested*, I said, and I pointed my pen three authors away. The woman, seized by the prospect of a new captive audience, scurried into Amy's line. It was a deplorable act on my part, and I am sorry.

If a person has never given writing a try, they assume that a brilliant idea is hard to come by. But really, even if it takes some digging, ideas are out there. Just open your eyes and look at the world. Writing the ideas down, it turns out, is the real trick, a point that was best illustrated to me on one of the more boring afternoons of my life. (Boring anecdote, thoughtfully condensed, now follows.) I once attended a VanDevender reunion in Preston, Mississippi, a dot on the map about forty-five minutes from Shuqualak (inevitably pronounced "Sugarlock"). I went because I am married to a VanDevender. It was not a family reunion, but rather a reunion of people in Mississippi named VanDevender, many of whom had never met before. The event was held in a low, square Masonic Lodge built of cinder blocks on a concrete slab that was so flush with the ground there was not even a hint of a step to go inside. All we could see was a field and, beyond that, a forest of loblolly pines. Because we had come so far with our friends, distant VanDevender cousins, we were planning to stay for a while. It was in the third or fourth hour of this event that one of the few VanDevenders I had not already engaged said that my husband had told her I was a novelist. Regrettably, I admitted this was the case. That was when she told me that everyone had at least one great novel in them.

I have learned the hard way not to tell strangers what I do for a living. Frequently, no matter how often I ask him not to, my husband does it for me. Ordinarily, in a circumstance like this one, in the Masonic Lodge in Preston, Mississippi, I would have just agreed with this woman and sidled off (*One great novel, yes, of course, absolutely everyone*), but I was tired and bored and there was nowhere to sidle

to except the field. We happened to be standing next to the name-tag table, where all the tags had been filled out with *VanDevender* in advance so that you could just print your first name on the top and get your lemonade. On that table was a towering assortment of wildflowers stuck into a clear glass vase. "Does everyone have one great floral arrangement in them?" I asked her.

"No," she said.

I remember that her gray hair was thick and cropped short and that she looked at me directly, not glancing over at the flowers.

"One algebraic proof?"

She shook her head.

"One Hail Mary pass? One five-minute mile?"

"One great novel," she said.

"But why a novel?" I asked, having lost for the moment the good sense to let it go. "Why a great one?"

"Because we each have the story of our life to tell," she said. It was her trump card, her indisputable piece of evidence. She took my silence as a confirmation of victory and so I was able to excuse myself. I found my husband and begged him to get me out of there.

But I couldn't stop thinking about this woman, not later that same day, not five years later. Was it possible that, in everybody's lymph system, a nascent novel is knocking around? A few errant cells that, if given the proper encouragement, cigarettes and gin, the requisite number of bad affairs, could turn into something serious? Living a life is not the same as writing a book, and it got me thinking about the relationship between what we know and what we can put on paper. For me it's like this: I make up a novel in my head (there will be more about this later). This is the happiest time in the arc of my writing process. The book is my invisible friend, omnipresent, evolving, thrilling. During the months (or years) it takes me to put my ideas together, I don't take notes or make outlines; I'm figuring things out, and all the while the book makes a breeze around my head like an oversized butterfly whose wings were cut from the rose window in Notre Dame.

This book I have not yet written one word of is a thing of indescribable beauty, unpredictable in its patterns, piercing in its color, so wild and loyal in its nature that my love for this book, and my faith in it as I track its lazy flight, is the single perfect joy in my life. It is the greatest novel in the history of literature, and I have thought it up, and all I have to do is put it down on paper and then everyone can see this beauty that I see.

And so I do. When I can't think of another stall, when putting it off has actually become more painful than doing it, I reach up and pluck the butterfly from the air. I take it from the region of my head and I press it down against my desk, and there, with my own hand, I kill it. It's not that I want to kill it, but it's the only way I can get something that is so three-dimensional onto the flat page. Just to make sure the job is done I stick it into place with a pin. Imagine running over a butterfly with an SUV. Everything that was beautiful about this living thing—all the color, the light and movement—is gone. What I'm left with is the dry husk of my friend, the broken body chipped, dismantled, and poorly reassembled. Dead. That's my book.

When I tell this story in front of an audience it tends to get a laugh. People think I'm being charmingly self-deprecating, when really it is the closest thing to the truth about my writing process that I know. The journey from the head to hand is perilous and lined with bodies. It is the road on which nearly everyone who wants to write— and many of the people who do write—get lost. So maybe Mrs. X. VanDevender in the Preston, Mississippi, Masonic Lodge was right; maybe everyone does have a novel in them, perhaps even a great one. I don't believe it, but for the purposes of this argument let's say it's so. Only a few of us are going to be willing to break our own hearts by trading in the living beauty of imagination for the stark disappointment of words. This is why we type a line or two and then hit the delete button or crumple up the page. Certainly *that* was not what I meant to say! *That* does not represent what I see. Maybe I should try again another time. Maybe the muse has stepped out back for a

smoke. Maybe I have writer's block. Maybe I'm an idiot and was never meant to write at all.

I had my first real spin with this particular inadequacy when I was a freshman in college. As a child and as a teenager I had wanted to be a poet. I wrote sonnets and sestinas and villanelles, read Eliot and Bishop and Yeats. I entered high school poetry competitions and won them. I would say that a deep, early love of poetry should be mandatory for all writers. A close examination of language did me nothing but good. When I arrived at Sarah Lawrence College as a freshman I submitted my poems and was admitted into Jane Cooper's poetry class. I was seventeen.

Jane Cooper was a kind and gentle soul whose poor health was exceedingly bad the year I studied with her. She faded in her own class, which was primarily run by a group of seniors and several graduate students, the best of whom was a woman named Robyn. Robyn drove a Volvo and wore a raccoon coat. She was not only an astute writer, she was the kind of critic who, in a matter of a few thoughtful sentences, could show that the poem up for discussion was a pile of sentimental, disconnected words. I admired Robyn and was terrified of her, and soon I had so assimilated her critical voice that I was able to bring the full weight of her intelligence to bear on my work without her actually needing to be in the room. I could hear her explaining how what I was writing would fail, and so I scratched it out and started over. But I knew she wouldn't deem my second effort to be any better. Before long I was able to think the sentence, anticipate her critique of it, and decide against it, all without ever uncapping my pen. I called this "editing myself off the page." My great gush of youthful confidence was constricted to a smaller and smaller passage until finally my writing was down to a trickle, and then a drip. I'm not even sure how I passed the class.

At the end of that year, I moved my poetry books to the bottom shelf and signed up to study fiction with Allan Gurganus. I thank

Robyn for that. I would have arrived at fiction eventually, but without her unwitting encouragement it could have taken me considerably longer.

Most of what I know about writing I learned from Allan, and it is a testament to my great good luck (heart-stopping, in retrospect, such dumb luck) that it was his classroom I turned up in when I first started to write stories. Bad habits are easy to acquire and excruciating to break. I came to him a blank slate, drained of all the confidence I had brought with me to that first poetry class. I knew I still wanted to be a writer, but now I wasn't sure what that even meant. I needed someone to tell me how to go forward. The course that Allan set me on was one that has guided my life ever since. It was the course of hard work. But he also managed, and may God bless him forever for this, to make the work appear to be a thing of beauty.

Allan had what must have been the best office on campus, with a fireplace and French doors leading out onto a garden, which in the spring was full of heavy French tulips and dogwood trees. There were hardback volumes of Chekhov and a framed black-and-white photo of John Cheever. There were drawings Allan had done, postcards from exotic friends in exotic places, a large crazy quilt on the wall made out of satins and velvets. When he walked into a room, we stirred, we leaned towards him. Everybody did. Allan, young, with a handful of well-published stories, was as dazzling to us as Chekhov or Cheever themselves would have been.

There was an enormous generosity in him. The class, a weekly fiction workshop that lasted two semesters, had fourteen people in it. I remember each of them. I remember their stories in a way I cannot remember stories from any other class I have taken or taught since. The deal was as follows: we were to write a story a week, every week, until it was over. For a while there were assignments, the most skeletal nudges towards plot: *write a story about an animal; write a fairy tale; write a story from the point of view of* . . . and so forth. Then

even those little starters fell away and we were out there alone, typing. I am respectful of people whose college careers consisted of classes I was (am) unfit to audit—inorganic chemistry, advanced statistics, upper-level Greek—but I would say the best of them would have struggled under this particular load. Ninety percent of what I know about fiction writing I learned that year. Write it out. Tell the truth. Stack up the pages. Learn to write by writing. Slowing down was for later, years later. We were to keep going at all costs. To miss a week was to have two stories due, which was a little like taking in a mouthful of water when you were doing your best not to drown.

It turns out that the distance from head to hand, from wafting butterfly to entomological specimen, is achieved through regular practice. What begins as something like a dream will in fact stay a dream forever unless you have the tools and the discipline to bring it out. Think of the diamonds, or, for that matter, the ever-practical coal that must be chipped out of the mine. Had I wound up with a different sort of teacher, one who suggested we keep an ear cocked for the muse instead of hoisting a pick, I don't think I would have gotten very far.

Why is it that we understand playing the cello will require work, but we attribute writing to the magic of inspiration? Chances are, any child who stays with an instrument for more than two weeks has some adult making her practice, and any child who sticks with it longer than that does so because she understands that practice makes her play better and that there is a deep, soul-satisfying pleasure in improvement. If a person of any age picked up the cello for the first time and said, "I'll be playing in Carnegie Hall next month!" you would pity their delusion, yet beginning fiction writers all across the country polish up their best efforts and send them off to *The New Yorker*. Perhaps you're thinking here that playing an instrument is not an art itself but an interpretation of the composer's art, but I stand by

my metaphor. The *art* of writing comes way down the line, as does the *art* of interpreting Bach. Art stands on the shoulders of craft, which means that to get to the art you must master the craft. If you want to write, practice writing. Practice it for hours a day, not to come up with a story you can publish, but because you long to learn how to write well, because there is something that you alone can say. Write the story, learn from it, put it away, write another story. Think of a sink pipe filled with sticky sediment. The only way to get clean water is to force a small ocean through the tap. Most of us are full up with bad stories, boring stories, self-indulgent stories, searing works of un-endurable melodrama. We must get all of them out of our system in order to find the good stories that may or may not exist in the fresh-water underneath. Does this sound like a lot of work without any guarantee of success? Well, yes, but it also calls into question our definition of success. Playing the cello, we're more likely to realize that the pleasure *is* the practice, the ability to create this beautiful sound; not to do it as well as Yo-Yo Ma, but still, to touch the hem of the gown that is art itself. Allan Gurganus taught me how to love the practice, and how to write in a quantity that would allow me to figure out for myself what I was actually good at. I got better at closing the gap between my hand and my head by clocking in the hours, stacking up the pages. Somewhere in all my years of practice, I don't know where exactly, I arrived at the art. I never learned how to take the beautiful thing in my imagination and put it on paper without feeling I killed it along the way. I did, however, learn how to weather the death, and I learned how to forgive myself for it.

Forgiveness. The ability to forgive oneself. Stop here for a few breaths and think about this because it is the key to making art, and very possibly the key to finding any semblance of happiness in life. Every time I have set out to translate the book (or story, or hopelessly long essay) that exists in such brilliant detail on the big screen of my limbic system onto a piece of paper (which, let's face it, was once a

towering tree crowned with leaves and a home to birds), I grieve for my own lack of talent and intelligence. Every. Single. Time. Were I smarter, more gifted, I could pin down a closer facsimile of the wonders I see. I believe, more than anything, that this grief of constantly having to face down our own inadequacies is what keeps people from being writers. Forgiveness, therefore, is key. I can't write the book I want to write, but I can and will write the book I am capable of writing. Again and again throughout the course of my life I will forgive myself.

In my junior year, I studied with Grace Paley. The fact that I even met Grace Paley, much less sat in her classroom for an entire year, is a wonder to me even now. There was no better short story writer, and very possibly no better person, though she would smack me on the head with a newspaper were she around to hear me say such a thing. (Interested in being a better writer? Go buy yourself a copy of *The Collected Stories* by Grace Paley.) The lesson that Grace taught was a complicated one, and I will admit I had been out of her class for a couple of years before I fully understood all she had given me. I was used to Allan, who was as diligent a teacher as he was a writer. He was where he said he would be at the appointed minute, our manuscripts meticulously commented on in his trademark brown ink. He gave assignments and picked readings that spoke directly to our needs. But when we went to Grace's classroom there was often a cancellation notice taped to the door—*Grace has gone to Chile to protest human rights violations*, or something of that nature. Or I would be sitting outside her office, waiting for our scheduled conference, but the door stayed closed. I could hear someone in there, and frequently that someone was crying. After half an hour or so, Grace would pop her head out, telling me very kindly that I should go. "She's having troubles," she would say of that unseen person who had arrived before me. If I held up my poor little short story, a reminder of why I was there, she would smile and nod. "You'll be fine."

Oh, Grace, with her raveling sweaters and thick socks, her gray hair flying in every direction, the dulcet tones of Brooklyn in her voice, she was a masterpiece of human life. There was the time she came to class and said she couldn't return our stories because she had been robbed the night before. A burglar had broken into her apartment and tied her to the kitchen chair. She then proceeded to talk to him about his hard life for more than an hour. In the end he took her camera and her bag full of our homework. I'm sure I was not alone in thinking how lucky that guy was to have gotten so much of Grace's undivided attention. Another time, she came to class and herded us all into a school van, then she drove us to Times Square. We were to march with the assembling throngs to the Marine recruitment office chanting USA, CIA, out of Grenada! It was crowded and cold and after we were sent off down Forty-second Street with our signs we never did find Grace or the van again. I once heard her read her story "The Loudest Voice" in a small room at Sarah Lawrence where we all sat on pillows. Somewhere in the middle of the reading she stopped, said her tooth was bothering her, reached into her mouth, pulled out a back molar, and kept on going.

Like most of my classmates, I was young and filled with a degree of self-interest that could rightly be called selfishness. Nothing was more important than the stories we wrote, the Sturm und Drang of our college lives. Grace wanted us to be better people than we were, and she knew that the chances of our becoming real writers depended on it. Instead of telling us what to do, she showed us. Human rights violations were more important than fiction. Giving your full attention to a person who is suffering was bigger than marking up a story, bigger than writing a story. Grace turned out a slender but vital body of work during her life. She kept her editors waiting longer than her students. She taught me that writing must not be compartmentalized. You don't step out of the stream of your life to do your work. Work was the life, and who you were as a mother, teacher, friend, citizen, activist, and

artist was all the same person. People like to ask me if writing can be taught, and I say yes. I can teach you how to write a better sentence, how to write dialogue, maybe even how to construct a plot. But I can't teach you how to have something to say. I would not begin to know how to teach another person how to have character, which was what Grace Paley did.

The last time I saw Grace was at a luncheon at the American Academy of Arts and Letters. She was being treated for breast cancer. Her hearing was bad and she didn't answer my questions about how she was doing. She gave me a hug instead. "You wouldn't believe all the nice people I've met at chemotherapy," she told me.

My last fiction teacher in college was Russell Banks, and the lesson I got from him came in a single conversation that changed everything I did from that day on. He told me I was a good writer, that I would never get any substantial criticism from the other students in the class because my stories were polished and well put together. But then he told me I was shallow, that I skated along on the surface, being clever. He said if I wanted to be a better writer, I was the only person who could push myself to do it. It was up to me to challenge myself, to be vigilant about finding the places in my own work where I was just getting by. "You have to ask yourself," he said to me, "if you want to write great literature or great television."

I remember leaving his office and stepping out into the full blooming springtime. I was dizzy. I felt as if he had just taken my head off and reattached it at a slightly different angle, and as disquieting as the sensation was, I knew that my head would be better now. The world I was walking in was a different place than the one I had been in an hour before. I was going to do a better job. There are in life a few miraculous moments when the right person is there to tell you what you need to hear and you are still open enough, impressionable enough, to take it in. When I thought about the writer I had wanted to be when I was a child, the one who was noble and hungry and lived for art, that person was not shallow. I would go back to my better, deeper self.

I've run into Russell many times over the years and I've told him how he changed my life. He says he has no memory of the conversation, a fact which does not trouble me in the least. I too have given a lot of advice I've forgotten about over the years. I can only hope it was half as good as Russell's.

While I give due credit to Sarah Lawrence for having hired the right people and for fostering a philosophy of education in which a young writer could thrive, I also realize that there was a large component of luck involved. It's a wonderful thing to find a great teacher, but we also have to find him or her at a time in life when we're able to listen to and trust and implement the lessons we are given. The same is true of the books we read. I think that what influences us in literature comes less from what we love and more from what we happen to pick up in moments when we are especially open. For this reason I've always been grateful (and somewhat amazed) that I read *The Magic Mountain* in my high school English class. That novel's basic plot—a group of strangers are thrown together by circumstance and form a society in confinement—became the story line for just about everything I've ever written. (Then again, that was also the plot of *The Poseidon Adventure*, a cheesy 1970s disaster flick I had seen several years earlier that also had an impact on me.) I was greatly affected by Saul Bellow's novel *Humboldt's Gift*, which I read when I was fourteen or fifteen, not long after it was awarded the Pulitzer Prize. I read it because a copy was lying around the house after both my mother and stepfather had finished it. I'm certain it was much too adult for me then, but I can still bring up more of the imagery and emotion from that novel than anything I've read in a long time. It was because of *Humboldt* that I went on to read the stories of Delmore Schwartz, and fell in love with *In Dreams Begin Responsibilities*. Even as a teenager I knew a brilliant title when I saw it.

Based on my own experience, I believe the brain is as soft and malleable as bread dough when we're young. I am grateful for every class trip to the symphony I went on and curse any night I was al-

lowed to watch *The Brady Bunch*, because all of it stuck. Conversely, I am now capable of forgetting entire novels that I've read, and I've been influenced not at all by books I passionately love and would kill to be influenced by. Think about this before you let your child have an iPad.

If the gifts I received as an undergraduate were of fairy-tale dimensions, that was not the case for me at the esteemed Iowa Writers' Workshop, where I arrived at the age of twenty-one. I never had a class in graduate school that approached what I had had in college, but I chalk it up to the luck of the draw. (Luck, come to find out, works in both directions.) Had I been in Iowa two years later, or two years earlier, or had I merely signed up for a different roster of classes, I would have had an entirely different experience. (The same, of course, would have been true at Sarah Lawrence.) The ability to write and the ability to teach are not the same, and while I've known plenty of people who could do both, there are also plenty of people who can do only one or the other, and plenty who do both who should be doing neither. That's why picking an M.F.A. program is tricky. It may give you the opportunity to study with your hero, but your hero may prove a disappointment in the classroom. The best way to judge a program is to look at the person directing it. I once taught briefly at the University of California at Irvine, a small program that was run at the time by the wonderful writer Geoffrey Wolff. He controlled everything magnificently. He did a meticulous job choosing both the faculty and the students, oversaw a financial aid program that didn't pit students against one another, and in general set a tone that was congenial and supportive. All M.F.A. programs rely on visiting faculty and most of them change from year to year (if not semester to semester), so don't go by the prestige of a name or by someone else's experience five years ago. It's always a work in progress.

The answer to how important a Master of Fine Arts degree is to

becoming a fiction writer is, of course, not at all. The history of world literature is weighted heavily on the side of writers who put their masterpieces together without the benefit of two years of graduate school. Still, M.F.A. programs have been part of the mix, at least in this country, for a long time now, and many writers attend them. Even though it was an imperfect experience for me, it was not without benefit: spending two years devoting myself to writing was indisputably a good thing, as was meeting the other students who had come for the same reasons I had. We all had such good intentions, and most of us were eventually distracted from them. I remember complaining one night on the phone to my mother that we spent too much of our time worrying about love and money. "Think of it as research," she said. "That's what everybody writes about."

Iowa was where I learned how to tune my ear to the usefulness and uselessness of other people's opinions. An essential element of being a writer is learning whom to listen to and whom to ignore where your work is concerned. Every workshop was an explosion of judgment. A third of the class would love a story, a third would rip it to shreds, and a third would sit there staring off into space, no doubt wondering what they were going to have for dinner. Sometimes an entire class would say that something wasn't working, and they'd be wrong. I had to trust myself and keep doing whatever I was doing. Other times one lone dissenter would point out a problem and the rest of the class would disagree, but that person was right. Had I given equal weight to everyone who had something to say, every story would have turned into a terrible game of Twister (left hand, yellow; right foot, blue; nose on red; so forth and so on). On the other hand, had I listened to no one, or only to the people who liked me, the workshop would have been a waste of time.

One misconception about workshops is that you learn the most about how to be a better writer on the day your story is discussed—not true. People are nervous, sometimes deathly so, when their story

is being dissected, and there's always a great deal of ego involved. But it's when someone else has their turn at bat that you actually get to see what's going on; the view is always clearer without all those emotional defenses in the way. This is where M.F.A. programs are most valuable: you can learn more, and more quickly, from other people's missteps than you can their successes. If we could learn everything we needed to know about writing fiction by seeing it masterfully executed, we could just stay in bed and read Chekhov. But when you see someone putting in five pages of unnecessary descriptive detail in a twenty-page story, or not bothering to engage the reader's interest until the seventh page, or writing dialogue that reads like a government wiretap transcription from a particularly boring conversation between a couple of fourteen-year-old girls, then you learn and learn fast. You may not always grasp what you need to do in order to make your own work better, but if you pay attention you'll figure out what you need to avoid. It doesn't take long to identify who the best critics in the class are, and those people become the ones you seek out. Making friends with other writers you respect is reason enough to go to graduate school. You're not always going to have teachers, but if you're lucky, you'll always have a couple of tough, loving, forthright peers who have something to teach you.

The best thing I got out of my time at Iowa was that I learned how to teach. In my first year, my financial aid package entailed teaching an undergraduate Introduction to Literature class. Then, in my second year, I taught undergraduate fiction writing. The degree to which I was unqualified for this work is appalling. I was twenty-one years old and had never given teaching a thought. For the literature class, the teaching assistants were told to cover two novels (any two novels, any of them), two plays (one Shakespeare and one contemporary), some short stories, and a section on poetry. We were given two days of group instruction, a class schedule, a room number, and that was it. We were on our own. It was terrifying, and I learned more from that

experience than all the writing and reading I had done in my life to date. Being the one to stand in front of the class and talk about a book for fifty minutes made me read at a whole new level. I was forced to think through every idea I had about a story, to support all of those ideas with examples from the text, and articulate my thoughts in a cogent manner. In short, I started to study how writers did what they did with a great deal more diligence because I had to explain it to someone else. I've often wished there had been a way for me to teach before being a student—I was so much better at studying now.

Education aside, my most emphatic piece of advice regarding whether or not to attend an M.F.A. program has to do with money: no one should go into debt to study creative writing. It's simply not worth it. Do not think of it as an investment in yourself that you'll be able to recoup later on. This is not medical school. There are many more M.F.A. programs turning out many more writers than the market can possibly bear; the law of averages dictates that a great percentage of graduates are never going to make anywhere close to a living practicing their craft. Every M.F.A. program has some level of financial aid that is based on how talented you are deemed to be, which is another way of saying how badly that program wants you. If you get into an M.F.A. program without an offer of financial aid, sit out a year and then reapply. Who accepts you, and how much money they give you, is a capricious business, subject to who happens to be serving on the admissions panel (which is often composed of students in the early rounds). I applied to four M.F.A. programs and I got into one—the one that was supposedly the most competitive—and I received financial aid in the form of a teaching assistance, a small income I supplemented with a great deal of babysitting. Would I have gone to Iowa without financial aid? Probably, but only because I wouldn't have known any better. At the time I had no idea what I was buying. I will admit to being a profoundly practical person, especially where money is concerned; but unless you are independently wealthy, I urge you to

listen to this. If you plan to roll the dice, thinking, *Well, surely I'll get a big book contract at the end of two years that will cover the loan I've taken out*, the chances are excellent it's not going to happen.

And while we're on the subject of writing programs, let me touch on summer programs as well. They can be a lot of fun, as long as you're honest with yourself about what your goals are: if you want to make friends with other people who want to be writers, have a vacation with an opportunity to learn something, and have the chance to listen for a week or two to the wisdom of a writer you respect—and you can do it all within your budget—then summer programs are great. But if you think you'll find an agent who will take on your novel, or that the writer you love will love you in return and will mentor you beyond the parameters of the summer schedule, forget it. I stopped teaching in summer programs a long time ago because I felt uncomfortable with the promises that were being sold. Those programs can be a life-saving connection for people who are toiling away by themselves month after month with no one to share work with. Like an M.F.A. program writ in miniature, it's the chance to find friends and reliable critics among classmates. I imagine that every now and then a book is picked up by a prestigious New York agent and sold to a prestigious New York publisher, but it is statistically akin to finding a four-leaf clover. On the banks of the Dead Sea. In July.

After finishing the Iowa Writers' Workshop, I got a job as the writer-in-residence at a small college in Pennsylvania. Two days before my second school year was set to begin, I left my husband, left the job, and very quickly left the state. I moved back to Tennessee and in with my mother. Having burned my last employers so badly, there was pretty much no chance of my finding another teaching job, so I wound up getting a job as a waitress. I was twenty-five years old. It wasn't the best time in my life, but at least I wasn't mailing in a percentage of my tip money to pay down student loans for my M.F.A.

Up until that point there had never been any reason to doubt that

my life was going to work out exactly according to script. I had thought I was a writer when I was a student, but would I still be a writer now that I was also a waitress? It was a test of love: How long would I stick around once things were no longer going my way? (Illustrative anecdote: Many years later, I was in London interviewing Ralph Fiennes for *GQ*. While we were at lunch the waiter approached to tell Fiennes how much he admired his work. "I'm an actor, too," the waiter said as he held out a piece of paper for an autograph. Later I asked Fiennes how long he would have been willing to be a waiter who struggled to be an actor. Things had gone well for him pretty much right off the bat, but let's say for the sake of argument that they hadn't and he had to pick up dirty plates and sweep up the crushed saltines of children. How much resilience had there been in his dream, and how far would he have slogged on without any signs of success? The actor shook his head. "I couldn't have done it," he said.)

There were things I learned about writing while working as a waitress that I hadn't come to during my student years, and the first was my own level of commitment. As the months went by, I knew that I wrote because it was my joy, and if I kept on being a waitress forever, writing would still be my joy. But that didn't mean I didn't have plans to use writing as a means of escape. I had been unwaveringly loyal to my talent, and now that the chips were down I expected it to be loyal to me. With so much time for thinking and so little time for writing, I learned how to work in my head. Between pilfering croutons off salad plates and microwaving fudge sauce for the sundaes, I decided I was going to make up a novel, and that the novel was going to get me out of the restaurant. The novel was going to be my getaway car.

From the moment I walked into Allan Gurganus's class, I had been utterly devoted to the short story. When people asked me when I planned to write a novel, I would say, *If I were a violinist, would you ask me when I was going to play the viola just because it's bigger?* (Shake your head in pity here for the self-righteous undergraduate.) But I had gotten myself into a novel-sized hole, and I knew it was

going to take a lot more than a story to save me. The problem was that I had received a massive and expensive education in how to write short stories, and not so much as a correspondence course in how to write a novel. (I realize now this is largely a matter of time, logistics, and to some degree patience. A teacher may be willing to read fifteen short stories a week, but no one can read rambling, lengthy, decontextualized segments of fifteen novels. There is also the fact that excerpts rarely benefit from group critique. It's one thing to get all those opinions when you've finished, but when you're still in the middle of a project it's like having fifteen people give you conflicting directions as to how best to get to the interstate.) And so, with a couple of cheeseburger platters balanced up my arm, I began to teach myself how to write a novel while being a waitress.

No matter what you're writing—story, novel, poem, essay—the first thing you're going to need is an idea. As I said earlier, don't make this the intimidating part. Ideas are everywhere. Lift up a big rock and look under it, stare into a window of a house you drive past and dream about what's going on inside. Read the newspaper, ask your father about his sister, think of something that happened to you or someone you know and then think about it turning out in an entirely different way. Make up two characters and put them in a room together and see what happens. Sometimes it starts with a person, a place, a voice, an event. For some writers it's always the same point of entry; for me it's never the same. If I'm really stuck, nothing helps like looking through a book of photography. Open it up, look at a picture, make up a story.

If you decide to work completely from your imagination, you will find yourself shocked by all the autobiographical elements that make their way into the text. If, on the other hand, you go the path of the roman à clef, you'll wind up changing the details of your life that are dull. You will take bits from books you've read and movies you've seen and conversations you've had and stories friends have told you, and half the time you won't even realize you're doing it. I am a compost

heap, and everything I interact with, every experience I've had, gets shoveled onto the heap where it eventually mulches down, is digested and excreted by worms, and rots. It's from that rich, dark humus, the combination of what you encountered, what you know and what you've forgotten, that ideas start to grow. (I could make a case for the benefits of wide-ranging experience, both personal and literary, as enriching the compost, but the life of Emily Dickinson neatly dismantles that theory.)

When I was putting my first novel together in my head I didn't take notes, nor did I write down my customers' orders. I figured if I came up with something that was worth remembering I would remember it, and I would forget about the rest. (This approach did not extend to what people wanted for dinner.) I don't think my theory on memory is necessarily true—I'm sure I've forgotten plenty of things that would seem good to me now—but not writing things down, especially in the early stages of thinking them through, does cause me to concentrate more deeply and not become overly committed to anything that isn't firmly in place. Also, in the early stages of thinking up a novel I'm not exactly sure what I would write down anyway. It's like walking through a field in a snowstorm and for a long time I see nothing but the snow, but then in the distance there's something, a tree or a figure or smoke, I just don't know. I always have the sensation that I'm straining to see what's in front of me. The snow lessens for a minute and I catch a glimpse of an idea, but when I get closer the light starts to fade. I squint constantly. It goes on like this for a long time. If I were taking notes they would read: *I see something. A shape? I have no idea.* It's not exactly the stuff that literary archives are made of.

The Patron Saint of Liars, the novel largely assembled at a now-defunct Nashville branch of T.G.I. Friday's, started like this: there was a girl in a Catholic home for unwed mothers and she goes into labor. The home is far out in the country, maybe forty-five minutes from the hospital, and the girl decides she's not going to tell anyone

what's going on. She's not going to cry out because she wants to ride in the ambulance with her baby, although I think that should be plural, I vaguely remember she had twins. (Were I in analysis, I would say in retrospect this idea probably had something to do with the fact that I had left my husband and was very, very glad I wasn't pregnant and didn't have a child. But who knows? I certainly wasn't thinking about that at the time. I rolled some silverware into napkins, took daiquiris to the businessmen at table eight. It was 1989, and we sold frozen strawberry daiquiris by the tankerful.) So here's this girl giving birth in the middle of the night and there are other girls in the room, girls who live on her hall, her co-conspirators come to help her. I looked at each one of them. I spent days thinking of their stories while I bused tables and ran the dishwasher and restocked the expediter's table in the kitchen. (Parsley, parsley, parsley! We were all about parsley at Friday's. "To have no green would be obscene," another waitress told me.) I think the novel is going to be about the girl giving birth, but there's another girl in the room named Rose and she's come all the way to Kentucky from California in her own car and she has a secret. This girl has a husband. From there I start to stretch the story in every direction. What happened to Rose in California? Who were her parents and who was this husband and why did she marry him in the first place? Who does she meet and who will she marry later and where did he come from? I puzzled it out, went down dead ends and circled back, made connections and plot twists I never saw coming. All in my head.

While this noisy novel dominated my thoughts during shifts, my actual writing time was devoted to applications. I was applying to every fellowship program I could find, desperately hoping to land someplace that would feed me and put a roof over my head and give me time to put my fully imagined novel on paper. The stuff of dreams for people in my position is all contained in a single book called *Grants and Awards for American Writers*, which is issued yearly by the PEN American Center. If you want to know when a contest dead-

line is, or find out what prizes and fellowships are available, this is the place to look. I was down to being one of three finalists for a spot at the Bunting Institute at Radcliffe College (now called The Radcliffe Institute) and spent a few extremely hopeful weeks before finding out I didn't get it. That was a dark day of waitressing (though, happily, I got the fellowship four years later). Just about the time I had enough seniority at Friday's to land the best section in the high-cash Friday night/Saturday night/Sunday brunch trifecta, I heard from the Fine Arts Work Center in Provincetown, Massachusetts, a residency program that offered small apartments and a stipend of $350 a month to ten writers and ten visual artists, from the beginning of October until the beginning of May. I was in. It was the spiritual equivalent of Charlie Bucket finding the golden ticket in his Wonka bar. I quit my job, packed up my car, and drove to Cape Cod.

I made a decision on the trip up: I was going to put writing first. I should have done this earlier, but there were always too many other things going on. Mostly I was falling in love, and then falling out of love, and then falling in love with someone else. Love, with all its urgency, wound up getting more of my attention than writing. Work got a good deal of attention as well, and by work I mean waitressing. On top of that I was a good friend and a good daughter. I budgeted in a certain amount of time to feel guilty about what I had done in the past and anxious about what I would do in the future. I didn't know exactly where writing fell in this inventory. I was sure it wasn't at the bottom of the list but I also knew it had never been safely at the top. Well, now it was being transferred to the top. I could see the genius in not having given one hundred percent of myself over to writing before. It kept me from ever having to come to terms with how good I was, or wasn't. As long as something got in the way of writing, I could always look at a finished story and think it could have been a little better if only I hadn't spent so much time on life's pressing minutiae. How much better I never knew, because I never

knew how much of myself I was holding back. Now, though, I would have seven months to write the novel that was in my head, seven months to live up to the incalculable gift that had been bestowed on me by the Work Center. It was my intention for at least this seven-month chunk of my life to do my best work and see how good it was. I had an impetus now: desperation. The only thing waiting for me back at home was my job at Friday's. If I wanted a better life for myself I was going to have to write it.

When I arrived at the Work Center, I lugged my computer—a mid-eighties behemoth whose parts were packed into many boxes—up the narrow staircase to my tiny apartment. I made my single bed, hung up my towels, and went to the grocery store. The last of the summer tourists were decamping, and I caught a glimpse of what a ghost town Provincetown would be in the winter. The next day I got up, made a cup of tea, and sat down at my desk. Even though I had spent the last year living with the novel in my head, I had not committed one word to paper. That was the moment I remembered that I had never written a novel and had no idea what I was doing.

Now that I was sitting still in front of a blank screen, I was appalled by all the things I hadn't considered. Sure, I had some characters, a setting, a sketchy plot, but until that minute I had never considered the actual narrative structure. Who was telling this story? I wanted to write the story in an omniscient third, a big Russian-style narrative in which the point of view moved seamlessly between characters because these were people who were not forthcoming with each other and a single first-person narrative couldn't possibly tell the whole story. But I didn't know how to construct an omniscient voice. (I would take a running jump at it in the next two novels I wrote as well, and I always retreated. It wasn't until my fourth novel, *Bel Canto*, that I finally figured out how to do it.)

If I hadn't put together a narrative structure, what in the hell had I been doing all that time? I panicked. From the moment I arrived in

Provincetown I felt the sand slipping through the hourglass. Seven months left no time to dither. I decided to give each of my three main characters a first-person point of view. The narratives would not move back and forth, everyone would have one shot to tell his or her story, and that was it. Like many decisions, this one was both arbitrary and born of necessity. Would it work? I doubted it, but I couldn't identify any other options. From my window I saw the occasional writer or painter in the parking lot. They would stop and talk to one another, head off into town. I was upstairs having the revelation that the gorgeous, all-encompassing novel that had been with me for the last year was junk. I had to come up with another idea, fast. I had to hit the delete key and get rid of every trace of the awful work I'd done so far.

I did wind up writing the book I came to write, and a great deal of the credit for that goes to my friend Diane Goodman, who was living in Pennsylvania at the time. Long-distance phone calls were expensive in those days and I was hopelessly broke; still, talking to Diane proved a wise investment. She told me that I was not allowed to throw out anything I'd written. "Calm down," she said again and again. "Stick it out." It was life-saving counsel. Without it, I could have spent the next seven months writing the first chapters of eighteen different novels, all of which I would have ultimately hated as much as I hated this one. I was used to writing short stories. I was programmed for bright, impassioned binges of work that lasted a day or two or three, and knew nothing about the long haul. Novel writing, I soon discovered, is like channel swimming: a slow and steady stroke over a long distance in a cold, dark sea. If I thought too much about how far I'd come or the distance I still had to cover, I'd sink. As it turns out, I have had this same crisis with every novel I have written since. I am sure my idea is horrible, and that a new idea is my only hope. But what I've realized over the years is that every new idea eventually becomes the old idea. I made a pledge that I wouldn't start the sexy new novel I imagined until I had finished the tired old warhorse I was

dragging myself through at present. Keeping that pledge has always served me well. The part of my brain that makes art and the part that judges that art had to be separated. While I was writing I was not allowed to judge. That was the law. It was the lesson I had been unable to learn back in Jane Cooper's poetry class at Sarah Lawrence, but I was older now and it was high time.

Not only did I learn how to write a novel in Provincetown, I found the perfect person to read it. Elizabeth McCracken was another of the writing fellows at the Work Center that season, and she lived three houses away from me. If I looked out my kitchen window I could see if her light was on. Sometimes you don't realize what's lacking in life until you find it. That was the way I felt about Elizabeth. I had plenty of friends, and a few extremely close friends, but I'd never had a true reader, someone who didn't automatically love everything I did, someone whose criticism and praise were always thoughtful and consistent. She knew when to be tough and when just to be encouraging. She read everything I wrote and could say, "You know, you've already done this too many times" (as when she told me to cut about ninety-five percent of the dream sequences in State of Wonder, pointing out that enough of the characters in my books had received wise counsel from dead people already). Whatever I gave her, she read immediately, which is what every writer desperately wants, and she brought the full weight of her talent and intelligence to bear on all of it. I tried my best to do the same for her. Of course we didn't know it was going to be like this when we first met. We went for ice cream. We talked about books and movies, swapped magazines, got along. But two writers becoming friends pretty quickly get to a point when they're going to have to read each other's work. It's nervous-making, because if you like the person but you don't like her work, you know the friendship is going to go only so far. For Elizabeth and me, the moment of truth came about two weeks after we met; she gave me a story and I gave her the first chapter of my novel, and after we had

read the pages we went down to the Governor Bradford, one of the few bars in Provincetown that stayed open all winter, and talked the night away. We had so much to say, so much praise and advice, so many good ideas. We had found each other.

Over the years I've come to realize that I write the book I want to read, the one I can't find anywhere. I don't sell my books before I finish them, and no one reads them while I'm writing them, except Elizabeth. I write my books for myself, and for her. You might infer from this that our books and our writing processes are very much alike, but it isn't the case at all. Not only is our work different, but *how* we work is incredibly different: I get everything set in my head and then I go, whereas Elizabeth will write her way into her characters' world, trying out scenes, writing backstories she'll never use. We marvel at each other's process, and for me it's a constant reminder that there isn't one way to do this work. I love Elizabeth's books, but the road she takes to get to them would kill me.

Paradoxically, a single winter day in Provincetown is somewhere between seventy and eighty hours long. I had never encountered such an overwhelming amount of silent, unstructured time. After years of saying I needed more freedom, I suddenly found that I needed more structure. My novel needed structure as well. Knowing I should write a long, beautiful description has never gotten me out of bed in the morning, which is probably why I never made it as a poet. The thing I relied on most heavily to get me up and typing was the power of plot. It was my indispensable road map. I also realized—and learned this more with every novel I've written—that the plot had to be complicated enough and interesting enough to keep me sitting in a straight-backed kitchen chair seven days a week. (Brace yourself: a lengthy diatribe about plot now follows.)

If you wind up boring yourself, you can pretty much bank on the fact you're going to bore your reader. I believe in keeping several plots going at once. The plot of a novel should be like walking down a busy

city street: first there are all the other people around you, the dog walkers and the skateboarders, the couples fighting, the construction guys swearing and shouting, the pretty girl on teetering heels that causes those construction guys to turn around for a split second of silence. There are drivers hitting the brakes, diving birds slicing between buildings, and the suddenly ominous clouds banking to the west. All manner of action and movement is rushing towards you and away. But that isn't enough. You should also have the storefronts at street level, and the twenty stories of apartments full of people and their babies and their dreams. Below the street there should be infrastructure: water, sewer, electric. Maybe there's a subway down there as well, and it's full of people. For me, it took all of that to stay emotionally present for seven months of endless days. Many writers feel that plot is passé—they're so over plot, who needs plot?—to which I say: Learn how to construct one first, and then feel free to reject it.

The length and shape of the chapter go a long way towards determining how your plot will move forward. Maybe an understanding of chapters was one skill that was transferable from my short-story-writing days (which, by the way, were over. As much as I had loved the story, I now loved the novel, loved the huge expanse of space in which to work. I never went back). A chapter isn't a short story and needn't be able to stand alone, nor is it just a random break that signifies the novelist is tired of this particular story line and would like to go on to something else. Chapters are like the foot pedals on a piano; they give you another level of control. Short chapters can speed the book along, while long chapters can deepen intensity. Tiny chapters, a lone paragraph or a single sentence, can be irritatingly cute. I like a chapter that has both a certain degree of autonomy and at the same time pushes the reader forward, so that someone who is reading in bed and has vowed to turn off the light at the chapter's end will instead sit up straighter and keep turning the pages. (If you want to study the master of the well-constructed

chapter—and plot and flat-out gorgeous writing—read Raymond Chandler. *The Long Goodbye* is my favorite.)

Although my novel was written in three separate first-person sections, I wrote it linearly—that is to say, page two was started after page one was finished. This is one of the very few pieces of advice that I'm passing out, along with not going into debt for your M.F.A., that I implore you to heed. Even if you're writing a book that jumps around in time, has ten points of view, and is chest deep in flashbacks, do your best to write it in the order in which it will be read, because it will make the writing, and the later editing, incalculably easier. Say you know the girlfriend is going to drown. It's going to be a power-house scene. You've thought it through a thousand times and it's all written out in your head, so you decide to go ahead and drown her in advance, get that out of the way. You have yet to work out why it happens, or what she's doing in the water in the first place, but at least you know she's going under, so why not go ahead? Here's why: because then you have to go back and write the boring parts, the lead-up, but you aren't letting the scene build logically. Instead, you're steering the action towards this gem you've already written. When you write your story in chronological order, you may in fact decide that this girl shouldn't drown after all. Maybe the boyfriend jumps in to save her and he drowns instead. You learn things about characters as you write them, so even if you think you know where things are heading, don't set it in stone; you might change your mind. You have to let the action progress the way it must, not the way you want it to. You create an order for the universe and then you set that universe in motion. No doubt Shakespeare loved King Lear, but it was clear that Cordelia would not survive, and how could Lear go on without Cordelia? The writer cannot go against the tide of logic he himself has established, or, to put it another way, he can—but then the book ceases to be any good.

So if you originally plan to drown the girl and then it turns out the

girl doesn't drown, does that mean the characters are capable of taking over the book? No. And if you're building a house with a downstairs master bedroom, and then decide to move the bedroom upstairs, the bedroom has not taken over the house. You have simply changed your mind, and your architectural plans, something that is considerably easier to do before the house is completely built/novel is entirely written. No matter what you may have heard, the characters don't write their story. Oh, people love to believe that, and certain writers love to tell it—*I was typing away and then all of a sudden it was as if I had been possessed. The story was unfolding before me. I had been hijacked by my own characters. I was no longer in control.* Yeah, yeah, yeah. What I like about the job of being a novelist, and at the same time what I find so exhausting about it, is that it's the closest thing to being God you're ever going to get. All of the decisions are yours. You decide when the sun comes up. You decide who gets to fall in love and who gets hit by a car. You have to make all the trees and all the leaves and then sew the leaves onto the trees. You make the entire world. As much as I might wish for it to happen, my characters no more write the book than the puppets take over the puppet show. (Many books later, I was giving a talk in Texas and a woman raised her hand and said that her minister had told the congregation that they should never read novels with omniscient narrators because the writer was trying to imitate God. "Really?" I said. "No Tolstoy? No Dickens?" The woman shook her head. I have to say it thrilled me to think that narrative structure was dangerous enough to rate its own Sunday sermon.)

One more thing to think about when putting a novel together: make it hard. Set your sights on something that you aren't quite capable of doing, whether artistically, emotionally, or intellectually. You can also go for broke and take on all three. I raise the bar with every book I write, making sure I'm doing something that is uncomfortably beyond what I can manage. It's the only way I know to improve over

time, and going back to Russell Banks's advice, I'm the only person who can make myself do better work.

Meanwhile, back in Provincetown, winter had set in. The ice cream shop closed. The few bars that hadn't closed for the season stayed open later. I holed up in my apartment and wrote, and plenty of times I got stuck. Despite all the good plans I had made while waiting tables, I could see now that my strokes had been broad and there were plenty of details that had yet to be devised. Occasionally I panicked. I did not, however, get writer's block, because as far as I'm concerned, writer's block is a myth.

Writer's block is a topic of great discussion, especially among young writers and people who think I should write their book for them. I understand being stuck. It can take a very long time to figure something out, and sometimes, no matter how much time you put in, the problem cannot be solved. To put it another way, if it were a complicated math proof you were wrestling with, instead of, say, the unknowable ending of chapter seven, would you consider yourself "blocked" if you couldn't figure it out right away, or would you think that the proof was difficult and required more consideration? The many months (and sometimes years) I put into thinking about a novel before I start to write it saves me considerable time while I'm writing, but as Elizabeth McCracken likes to point out, it's all a trick of accounting. There may be no tangible evidence of the work I do in my head, but I've done it nevertheless.

Even if I don't believe in writer's block, I certainly believe in procrastination. Writing can be frustrating and demoralizing, and so it's only natural that we try to put it off. But don't give "putting it off" a magic label. Writer's block is out of our control, like a blocked kidney. We are not responsible. We are, however, entirely responsible for procrastination and, in the best of all possible worlds, should also be responsible for being honest with ourselves about what's really going on.

I have a habit of ranking everything in my life that needs doing. The thing I least want to do is number one on the list, and that is almost always writing fiction. The second thing on the list may be calling Verizon to dispute a charge on my bill, or cleaning the oven. Below that, there is mail to answer, an article to write for a newspaper in Australia about the five most influential books in my life and why. What this means is that I will zoom through a whole host of unpleasant tasks in an attempt to avoid item number one—writing fiction. (I admit this is complicated, that I can simultaneously profess to love writing and to hate it, but if you've read this far you must be pretty interested in writing yourself, and if you are, well, you know what I'm talking about.)

The beautiful thing about living in Provincetown in the winter, and having no money and no place to spend it even if I did, was that there was rarely anything in the number-two spot on my to-do list. There was really nothing to distract me from the work I was there to do, and so the work got done. The lesson is this: the more we are willing to separate from distraction and step into the open arms of boredom, the more writing will get on the page. If you want to write and can't figure out how to do it, try picking an amount of time to sit at your desk every day. Start with twenty minutes, say, and work up as quickly as possible to as much time as you can spare. Do you really want to write? Sit for two hours a day. During that time, you don't have to write, but you must stay at your desk without distraction: no phone, no Internet, no books. Sit still quietly. Do this for a week, for two weeks. Do not nap or check your e-mail. Keep on sitting for as long as you remain interested in writing. Sooner or later you will write because you will no longer be able to stand not writing, or you'll get up and turn the television on because you will no longer be able to stand all the sitting. Either way, you'll have your answer.

I once gave this entire explanation to an earnest group of college freshmen who had all suffered cruelly from writer's block. When I

finished, one girl raised her hand. "Clearly, you've just never had it," she said, and the other students nodded in relieved agreement. Maybe not.

I finished my novel at the beginning of April 1991. I printed it out and then I stood on the pages. There were about four hundred of them, and I felt considerably taller. I went out and found Elizabeth in the yard hanging her laundry on the clothesline, and I told her I was done and we hugged and made a lot of noise and went off for a drink in the middle of the day. Because Elizabeth had read every chapter as I wrote it, and because I took all of her suggestions and did my revisions along the way, I was able to straighten up the manuscript fairly quickly. Writers handle the process of revision in as many different ways as they handle the writing itself. I do a great deal of tinkering, but I never make any structural changes—putting in a different narrator, say, or giving the main character a sister. Elizabeth will do such major rewrites from draft to draft that every version could exist as a separate book. We both get to the same place in the end. One method of revision that I find both loathsome and indispensable is reading my work aloud when I'm finished. There are things I can hear—the repetition of words, a particularly flat sentence—that I don't otherwise catch. My friend Jane Hamilton, who is a paragon of patience, has me read my novels to her once I finish. She'll lie across the sofa, eyes closed, listening, and from time to time she'll raise her hand. "Bad metaphor," she'll say, or, "You've already used the word *inculcate*." She's never wrong.

Back in Provincetown, that April, I finally had my book but was missing a title to go with it. I had had a title while I was writing it, and it was so bad that lo these many years later I still cringe to admit to it: *The Luck You Make*. Not long before I finished the book I was talking to my mother on the phone one night and she asked me to tell her again what my title was. And so I did. "What?" she said, long distance. "*The Lucky Mink?*" Once your own mother has called your book *The Lucky Mink*, you pretty much have to throw the title out.

After that I was at a complete loss, and then a friend told me to come up with ten titles. "Do it fast," she said. "Don't think about it too much." She said to type each title on a separate sheet of paper, and underneath type, *a novel by Ann Patchett*. I was then to tape them all to the wall. Every evening, in those last weeks at the Work Center, I invited the other fellows over to pull a single title from the wall and throw it away. It was my one attempt at participatory installation art. At the end of the ten days the only title left was *The Patron Saint of Liars, a novel by Ann Patchett*, so I went with that.

When the fellowship was over on the first of May, I packed up my manuscript and drove away. I cried all the way to the Sagamore Bridge. I knew I was leaving behind one of the greatest experiences of my life. I will forever miss what I had there: the endless quiet days, the joy of living a hundred feet from my new best friend, the privilege of getting to stay inside the fog of my own imagination for as long as I could stand it without anyone asking me to come out. It might not have been a realistic life, but dear God, it was a beautiful one.

When I was twenty, I published my first short story in the *Paris Review*. An agent had called me soon after and asked to take me on as a client and I said yes, though I didn't have another story that was any good at all. Now, seven years later, I arrived from Provincetown at her office in New York with my novel in a box. I had borrowed money to make the drive home to Nashville, but I wasn't in any hurry to get there. My agent told me that the market for first fiction wasn't what it used to be. (Note: this is what agents say. It's probably what Scott Fitzgerald's agent told him when he brought in *This Side of Paradise*.) "But I'm young!" I said cheerfully. (Note: young is always in fashion for debuting novelists. I was twenty-seven.) "You weren't exactly packing up your college textbooks yesterday," my agent said. (Fitzgerald was twenty-three.)

When I arrived home four days later, my mother came out to the driveway to meet me. An editor at Houghton Mifflin had bought *The Patron Saint of Liars* for $45,000.

For the first time in my life, I was going to have money (paid out over three years in four installments), and the only thing I could think of to spend it on was having the air conditioner in my car fixed. It had been out for two years. Now that I had a book contract and an advance on the way, I went to a mechanic. He said the air conditioner was low on coolant, a problem that was resolved for fifteen bucks. Somehow, that's the detail of selling my first book I always remember.

The question that aspiring writers are likely to ask me (after I've politely declined to write their book for them) is how to get an agent. Obviously, I'm not the best person to address this question, since my agent found me just moments after the end of my childhood and we have been together happily ever since. Still, there are a few things I've learned along the way. My best piece of advice is to finish the book you're writing, especially if it's your first book, before looking for an agent. Most agents will tell you the same thing, unless you've already published half of said unfinished book in *The New Yorker*. Writers need agents these days. Not only are rights getting more and more complicated in this electronic age, but for the most part publishing houses no longer have slush-pile readers. Agents now do the work of sifting and sorting the unsolicited manuscripts themselves. I was recently doing a book signing when someone came up in the line and asked me how to get an agent. You'd think I'd have a pat answer down for this one but it always stumps me. Fortunately, my friend Niki Castle was standing close by and I turned the question over to her. Niki had worked at International Creative Management in New York for four years and I thought her advice was excellent: she told the woman to go to one of the online sites that list agents who are looking for new clients, and then follow their submission guidelines *to the letter*. If they ask for a twenty-page writing sample, do not send in

twenty-two pages. "The smallest infractions of the guidelines can mean your work may never get read," Niki said.

Do not assume that finding an agent or getting published is something that automatically happens to well-connected insiders. I have sent my agent countless potential clients over the years, ones I believed were worthy, and I think she's signed three of them. Publishing is still a market-driven enterprise, so an agent wants to find a great writer as much as the writer wants to find a great agent. But no agent takes on a client as a favor to someone if they really don't like the book and don't think they can sell it. Therefore, I suggest focusing your energy on the part of the equation you control—the quality of your work. You can also try to publish your work in general interest or literary magazines in the hope that an agent will find you; it worked for me. If you try that route I have two pieces of advice: first, read the magazine you're submitting to. If you aren't willing to read several back issues of *Granta* or *Tin House*, then you have no business sending them a story. Magazines really do have personalities, and you should be able to figure out if your story might fit in. Second, if you have one really good, perfectly polished story—wait until you've written some more. If you're lucky, you'll get a letter from the editor saying they liked this one but it wasn't quite right and now they'd like to see something else. That's a very depressing letter to receive if you don't have anything else to send.

At every stage of writing a book there is a sense of *If only . . .* If only I could find the time to write and if only I could figure out the third chapter and if only I could get my book finished. If only I could find an agent. If only some editor would buy my book. If only I had a good publicist. If only the book would get reviewed. If only they would do more promotion. If only it would sell. It goes on like this forever.

After Houghton Mifflin bought my novel, I went to Boston and got dressed up to meet the people at my new publishers. My editor took me to lunch at the Ritz and we ate crab cakes and drank martinis.

This was twenty years ago, and at the time it felt like something that must have happened twenty years before. I've always thought that book publishing was an old-fashioned business, and Houghton Mifflin, back in their long-gone warren of interconnected houses, seemed one step removed from Leonard Woolf's Bloomsbury.

I've been at this writing job for a long time now, and yet for the most part I still solve my problems in the same ways I first learned to solve them as a college student, a graduate student, a waitress. There are certain indispensable things I came to early, like discipline. But other things, like serious research, I came to later on in my career. I have never subscribed to the notion of "writing what you know," at least not for myself. I don't know enough interesting things. I began to see research as both a means of writing more interesting novels and a way to improve my own education. Case in point: I didn't know a thing about opera, so I figured that writing about an opera singer would force me to learn. Conducting research, which had never even occurred to me when I was young might be part of writing, has turned out to be the greatest perk of the job. I've read Darwin and Mayr and Gosse to get a toehold on evolutionary biology. I've floated down the Amazon in an open boat just to see the leaves and listen to the birds. I've called up the head of malaria research at the Bethesda Naval Hospital in Maryland and asked if I could spend the day following him around. He said yes.

As much as I love doing research, I also know that it provides a spectacular means of procrastination. It's easy to convince myself that I can't start to write my book until I've read ten other books, or gone ten other places, and the next thing I know a year has gone by. To combat this, I try to conduct my research after I've started writing, or sometimes even after I've finished, using it to go back and correct my mistakes. I try to shovel everything I learn onto the compost heap instead of straight into the book, so that the facts just become a part of my general knowledge. I hate to read a novel in which the author

had clearly researched every last detail to death and, to prove it, will force the reader to slog through two pages describing the candlesticks that were made in Salem in 1792.

No matter how far I venture outside my own experience, I also know that I am who I am, and that my work will always reflect my character regardless of whether I want it to. Dorothy Allison once told me that she was worried she had only one story to tell, and at that moment I realized that I had only one story as well (see: *The Magic Mountain*—a group of strangers are thrown together . . .), and that really the work of just about any writer you can think of can be boiled down to one story. The trick then is to learn not to fight it, and to thrive within that thing you feel deeply and care about most of all. I still think that's why Grace Paley was pushing us to be better people when we were still young and capable of change.

As much as I love what I do, I forever feel like a dog on the wrong side of the door. If I'm writing a book, I'm racing to be finished; if I'm finished, I feel aimless and wish that I were writing a book. I am vigilant in my avoidance of all talismans, rituals, and superstitions. I don't burn a certain candle or drink a certain cup of tea (neither a certain cup nor a certain kind of tea). I do not allow myself to believe that I can write only at home, or that I write better when I'm away from home. I was once at a writers' colony in Wyoming and the girl in the studio next to mine dragged her desk away from the window the minute we arrived. "My teacher says a real writer never has her desk in front of a window," she told me, and so I dragged my desk in front of the window. Desk positioning does not a real writer make. I had a terrible computer solitaire problem once. I decided that my writing day could not begin until I won a game, and soon after that I had to win another game every time I left my desk and came back again. By the time I had the game removed from my computer I was a crazy person, staking my creativity on my ability to lay a black ten on a red jack. I missed computer solitaire every day

for two years after it was gone. Habits stick, both the good ones and the bad.

I've spent long periods when I've written every day, though it's nothing that I'm slavish about. In keeping with the theory that there are times to write and times to think and times to just live your life, I've gone for months without writing and never missed it. One December my husband and I were having dinner with our friends Connie Heard and Edgar Meyer. I was complaining that I'd been traveling too much, giving too many talks, and that I wasn't getting any writing done. Edgar, who is a double bass player, was singing a similar tune. He'd been on the road constantly and he was nowhere near finishing all the compositions he had due. But then he told me a trick: he had put a sign-in sheet at the door of his studio, and when he went in to compose he wrote down the time, and when he stopped composing he wrote down that time, too. He told me he had found that the more hours he spent composing, the more compositions he finished.

Time applied equaled work completed. I was gobsmacked, and if you think I'm kidding, I'm not. It's possible to let the thinking about process become so overly analyzed that the obvious answer gets lost. I made a vow on the spot that for the month of January, I would dedicate a minimum of one hour a day to my chosen profession. One hour a day for thirty-one days wasn't asking so much, and I usually did more. The result was a stretch of some of the best writing I'd done in a long time, and so I stuck with the plan past the month of January and into the rest of the year. I'm sure it worked in part because I already had the story in my head and I was ready to start writing, but it also worked because my life had gotten so complicated and I was in need of a simple set of rules. Now when people tell me they're desperate to write a book, I tell them about Edgar's sign-in sheet. I tell them to give this great dream that is burning them down like a house fire one lousy hour a day for one measly month, and when they've done that—one month, every single day—to call me back and we'll talk.

They almost never call back. Do you want to do this thing? Sit down and do it. Are you not writing? Keep sitting there. Does it not feel right? Keep sitting there. Think of yourself as a monk walking the path to enlightenment. Think of yourself as a high school senior wanting to be a neurosurgeon. Is it possible? Yes. Is there some shortcut? Not one I've found. Writing is a miserable, awful business. Stay with it. It is better than anything in the world.

(Byliner, September 2011)

The Sacrament of Divorce

———————— • ————————

I CALL HIM MY ex-husband half the time and my husband the other half, but when I think of him, it is as my husband. This isn't because in my secret heart I want to be married to him (there is nothing I can think of wanting less) but because, like it or not, he has an important spot in my personal history. He has a title. I suppose I must be his ex-wife, since somebody told me he married again. It's been six years now. Enough time has passed that I wish him well, in a way that is so distant and abstract it doesn't even matter.

My divorce began less than a week before we were married. We had to drive out to Donelson, Tennessee, to the rectory at Holy Rosary, where we had an appointment with the priest who would perform the service. It was a good forty-five minutes from Nashville, my home-town, but marriage was a booming business that year, and the more convenient priests were already booked solid. We got lost once we got off the interstate and twisted through the dark and identical streets of tract houses with cinder-block foundations. We didn't talk about anything more important than directions. My husband thought I should know where we were, Tennessee being my state, but I hadn't been to

Donelson or Holy Rosary since I was ten years old. I have a notoriously bad sense of direction.

It was June, because that was the month to get married in, and it was buggy and hot. We had been through the weekend of mandatory Catholic marriage seminars, classes full of the nitty-gritty of natural family planning (what we had called rhythm when I was growing up) and personality questionnaires ("Which tasks will you do? Which will your husband do? Which will you do together? A. Iron; B. Take out the trash; C. Make decisions about major purchases"). Now we had to see Father Kibby one-on-one and go over a few things. My husband and I were both Catholic. He wanted nothing to do with the Church but was willing to be married by a priest to make his mother happy. For me it was worth more. I was a Catholic shaped by twelve years of Catholic school. Marriage was one of the seven sacraments I had memorized along with my multiplication tables in third grade. Catholicism wasn't at the heart of marriage for me, but it was part of it. Marriage was one of the sacraments I was entitled to.

My hands were sweating from more than the heat when we got to the rectory office. We were late and shouldn't have been. Seeing a priest meant trouble, sin, confession, nothing good, but Father Kibby was young and put us at ease. He explained that he would read the questions from the sheet attached to a clipboard and check off the appropriate boxes as we answered. June bugs were thumping against the screen. At the end, he explained, we would sign the form.

Did we believe in God and the Catholic Church? *Yes.*

Would we raise our children to be Catholic? *Yes.*

Were we entering into marriage lightly? *No.*

Was this a marriage that could be dissolved only by death? *Death?*

Death. That meant that if the marriage didn't work, my only way out was to die. He was asking me to swear to my preference for death over divorce. At that moment, before it had even started, I understood how my marriage would end.

I should have understood it anyway because even going in, I was

not happy with my husband. We had lived together for two and a half years before we got married, so I had a fairly good idea of how we got along. Not well. It's difficult to talk about divorce without getting into your marriage, and yet I'd just as soon leave my marriage alone. Our general patterns were much like those of any unhappy couple, periods of our screaming and my crying broken up by intolerable stretches of silence. We were not helpful to each other. We were not kind. These are the facts: I married him when I should not have, and later on I left. I ran out the door, got a ride to the airport, and bought a one-way ticket back to Tennessee.

People ask me, *If you knew it wasn't working, why did you marry him?* And all I can say is, I didn't know how not to. I believed I was in too deep before the invitations were ever mailed, before the engagement. Maybe it was inexperience or maybe I was stupid. The relationship had a momentum that was taking us to this place, and I couldn't figure out how to stop it until a night four nights before my wedding, when the choice was presented in very simple terms: death—my death—or divorce. I was twenty-four years old. My husband was thirty-one. The only way off a runaway train is to jump, but at that moment the ground looked to be going by so fast that I was paralyzed. And so I lied. I said yes.

Yes, this is a marriage that can be dissolved only by death.

I divorced my husband not much more than a year after I married him, a fact that I still find myself fluffing up by saying we were together for four years. But that's a lie, too; it was less than that. Oh, I longed for five years of marriage. I craved ten. I wanted to say, See how I tried? I did everything I could, God knows; there was nothing left for me to do. Sticking out that one year took every ounce of courage I had. But a year sounds like nothing, not a marriage but a breath, a long date. In my mind, after I had left my husband, women stopped me on the street and said to me, *Put your one year against my fifteen, twenty, thirty-eight. Put your slim, never-had-a-single-baby hips*

beside mine—four children. Look at the entrenchment of a lifetime spent together. Who owns this house, that photograph? What you had was nothing.

Of course, no one said this, at least no one who had been divorced. In fact, it was quite the opposite. Without knowing it, I had stumbled into the underground and was given the secret handshake to the world's largest club. The Divorced. We were everywhere. The insurance man called me the week after I left to say that my husband had removed me from all the policies and I had to sign in approval because I was, at that point, still married. But then our insurance man confided in me, "You don't have to do this. You're going to need to take some time." The receptionist at my divorce lawyer's office called back the day after the papers were filed to see how I was doing. It turned out that the receptionist's marriage had ended, too, and this was her first job after having spent half her life as a stay-at-home wife. And when I applied for my own credit card and the woman on the phone said to me, "Are you married or single?" and I didn't know the answer, the woman on the phone dropped the questions and called me honey. "Honey," she said, "I know."

They had empathy, a word I understood for the first time, because suddenly I had it, too. It was, perhaps, my only emotion outside of depression and guilt. Days after I left my husband, I propped myself up on my mother's sofa and watched the guests of Oprah Winfrey. I watched women with no education and six children, women without a single safety net beneath them, who day after day were abused by their husbands for cold food or misfolded towels or the sheer fun of it. I watched men and women from the studio audience stand up and say, "I have no sympathy for you! Why don't you get out? If someone raised a hand to me even once I'd be out of there. Don't you have any self-respect?"

I leaned forward. I knew that voice. I had been that audience. I had thought I would never stand for anything short of decency and kindness. I thought that anyone who accepted less must be a willing

participant, must like it on some level. But at that moment I wanted to be up there on that stage. I would rise out of my soft bucket chair, unclip my microphone. I would put my arm around the shoulders of the guest and whisper in her ear, "Honey, I know. Things happen that you never thought were possible." I didn't have any children, and I had a wonderful family who met me at the airport when I came home and kissed me a hundred times. I had a good education and a lot of friends. My husband didn't hit me, a fact he pointed out often. I was married for only a year, and with all I had going for me I barely scraped together the strength to leave. You get so worn down, it's hard to think of how you might find a suitcase, much less where you'd go or how you'd get there once it's packed. It wasn't just strangers I was starting to understand. My mother had divorced my father when I was four. Two years later she remarried. My mother and stepfather spent the next twenty years trying to decide whether or not they should stay together. While growing up I had never faulted her for the divorce, but I hated what I thought was her weakness. My mother didn't want to be wrong a second time. She wanted to believe in a person's ability to change, and so she went back and back, every resolution broken by some long talk they had that made things suddenly clear for a while. I wanted her to make her decision and stick to it. In or out, I ultimately didn't care, just make up your mind. But the mind isn't so easily made up. My mother used to say the more lost you are, the later it got, the more you had invested in not being lost. That's why people who are lost so often keep heading in the same direction.

It took my own divorce to really understand, not just to forgive her, but to think that she was doing the very best that could be done with the circumstances at hand. I understood how we long to believe in goodness, especially in the person we promised to love and honor. It isn't just about them, it is how we want to see ourselves. It says that we are good people, patient and kind.

If I couldn't see my way clear to leave my husband before we were married, I hadn't even begun to take into account the complications

that lay ahead. We had a job together, a split position in a college English department, adjoining offices. We had an Oldsmobile, a stacked washer-dryer. We had his family and mine. We had been married. I had promised, sworn, and I believed I was only as good as my word. But as I slowly began to realize that all the problems between us that I had counted on to change would never change, I started running over the list I kept in my head, a secret tally of things that stood between me and my freedom. The dining room suite? Don't need it. The job? I'll give it up. His parents, whom I cared for, who would certainly never speak to me again? Gone. It was a row of obstacles, each one a little more perilous than the one before. At every turn I thought, *Not this. I can't give this up, too*—but then I would.

The moment I decided to leave changed everything for me. I did the impossible thing, the thing I was sure would kill us both, and we lived. And I kept on doing the impossible. I moved home and became a waitress at a T.G.I. Friday's, where I received a special pin for being the first person at that particular branch of the restaurant to receive a perfect score on her written waitress exam. I was told I would be shift leader in no time. I was required to wear a funny hat. I served fajitas to people I had gone to high school with, and I smiled.

I did not die.

Sometimes I would spend half the morning in the shower because I couldn't remember if I'd already shampooed my hair and so I would wash it again and again. I would get so lost on the way to work some days that I had to pull the car over to the side of the road and take the map out of the glove compartment. I worked four miles from my house. When I woke up at three a.m., as I did every morning, I never once knew where I was. For several minutes I would lie in bed and wonder while my eyes adjusted to the dark. After a while it didn't frighten me anymore.

In time, a lot of time, after I left Friday's and Nashville on a fellowship that allowed me to write my first novel, I came to see that there

was something liberating about failure and humiliation. Life as I had known it had been destroyed so completely, so publicly, that in a way I was free, as I imagine anyone who walks away from a crash is free. I didn't have expectations anymore, and no one seemed to expect anything from me. I believed that nothing short of a speeding car could kill me. I knew there was nothing I couldn't give up.

One night, years later, on the other side of the country, I was giving a boring, obligatory dinner party. Among my guests were a man and a woman, both married but living apart from their spouses because of jobs. They must have been paired together at every social outing, though their missing spouses were all they had in common. Late in the evening, the conversation turned to where we had lived in the past. It came out, after a long series of questions, that the woman had been married before, that the husband she had now was her second husband.

I asked her when she was first married.

"A long time ago." She waved her hand, indicating somewhere back there. It was a gesture I knew. "Another life."

"I was married," I said in solidarity.

"Well, there you go," the man said. "Two out of three marriages end in divorce. I'm married, both of you are divorced."

But the woman had remarried. Where did that leave us? "I thought it was one out of two," I said.

And maybe because he was feeling secure with his wife who was a thousand miles away, he shook his head. There can be something cruel about people who have had good fortune. They equate it with personal goodness. "Two out of three," he said.

When you think of that statistic, think of me. I'm the one who did it; I divorced. I pulled the moral fabric of this country apart.

Time magazine ran an editorial not long after that by a man who cried out for "supervows" in this age of disposable marriages. Supervows

would demonstrate a higher level of commitment. They would be part of a more serious ceremony. There would be promises, legal and binding, that the couple would submit to lengthy marriage counseling before divorce, that they would seek divorce only after being married a certain length of time. Divorce, the writer said, had become too easy. Waltz in, waltz out.

Waltz in, maybe. Make marriage harder if you want to. Outlaw those Vegas chapels with the neon wedding bells, require marriage applications modeled after tax forms, but leave divorce alone. It's grueling. I have never known anyone who went into a marriage thinking they would have to get out, and I have never known anyone who got out simply. To leave, you have to involve the courts. You have to sue the person you live with for your freedom. You have to disconnect your life from another life and face the sea alone. Never easy, blithe. Never.

Nor do I think anyone should have to wait three months or six or nine, depending on the state, for a divorce to take effect. Termination is a serious business, but we do not need the state to mandate a waiting period so we can see if we really know our own minds. Three weeks after I left my husband, he called to say I had a week to come home or file for divorce. Oddly enough, I hadn't even been thinking about divorce; I wasn't planning any further than five minutes ahead. But since I knew at the end of the week I couldn't go back, I called a lawyer.

It turned out my husband was bluffing, thinking that a tough ultimatum would bring me back. When I told him I had filed for divorce, he told me he wouldn't give me one. He refused to sign the papers. In the Commonwealth of Pennsylvania, where we had been living, contested divorces had a three-year waiting period. We would be legally married for three more years. What choice did I have? I settled myself in for the wait, but it wasn't so long after all. One day about six months later the signed papers just showed up. My life in the mailbox, stacked

between catalogues and the electric bill. I never knew what brought on the change of heart. I never saw him or spoke to him again. We were divorced.

I have just reread *The Age of Innocence*. Poor Countess Olenska, so much more alive than everyone in New York. She was better than Newland Archer, to whom she couldn't give herself because she was married. It didn't matter to society that she had been wronged by her husband. They felt her life was over. Thanks to the modern age of divorce, my life is not. I am coming to see that as a blessing and not something to be ashamed of. I am starting to think that my life is a good thing to have. I do not believe that there were more happy marriages before divorce became socially acceptable, that people tried harder, got through their rough times, and were better off. I believe that more people suffered.

Divorce is in the machine now, like love and birth and death. Its possibility informs us, even when it goes untouched. And if we fail at marriage, we are lucky we don't have to fail with the force of our whole life. I would like there to be an eighth sacrament: the sacrament of divorce. Like Communion, it is a slim white wafer on the tongue. Like confession, it is forgiveness. Forgiveness is important not so much because we've done wrong as because we feel we need to be forgiven. Family, friends, God, whoever loves us forgives us, takes us in again. They are thrilled by our life, our possibilities, our second chances. They weep with gladness that we did not have to die.

(*Vogue*, April 1996)

The Paris Match

THERE ARE THINGS people do when they are first in love: they surprise one another with trips to Paris; they make reservations in impossibly expensive Paris restaurants; they have conversations about former lovers while they eat in those impossibly expensive Paris restaurants. All of these things can happen after years of marriage as well, but the chances are infinitely smaller.

Karl and I had been together a little more than a year. He arranged the trip and I made the reservations for a very late lunch. I can't remember how it all got started, but sitting in Taillevent, at such a beautiful table right in the center of the room, the conversation somehow turned to Mark. My relationship with Mark had been an amicable one that had come to a mostly amicable end. Karl's question was if we had fought very often. Or maybe I asked Karl if he had fought with his ex-wife, and so in return he asked me about Mark.

The waiter came and handed me a wine list the size of a tombstone. I turned the pages for a moment, the way I might have turned the pages of a calculus exam, with some interest and not a single

spark of comprehension. "White," I said, and Karl, who doesn't drink, just shook his head.

"The worst fight we ever had wasn't exactly a fight," I said. "We were playing a word game. When he told me about it I said I wanted to play, but then I couldn't figure out the answer and he wouldn't stop. He just kept playing it and playing it, and, I don't know—"

The waiter came to take our orders. We ordered something. Some food.

"What?" Karl asked after the waiter had gone.

I remembered the fight very clearly. We were in the car, and Mark was driving, and when we got to a red light I opened the door, got out, and walked through the traffic to the curb, something I have never done before or since. "I thought I was going to kill him."

"So what's the game?" he asked.

"It isn't hard. That's what's so awful about it. Once I actually got it, it was simple."

Karl sat back. He was beautiful in the rich light, beautiful between the damask draperies and the thick white tablecloth. He rested his fingers against the heavy fork beside his plate. "Tell me how to play. I'm good at these sorts of things."

We hadn't been together long enough to know that we shouldn't talk about old lovers. We probably hadn't been together long enough to go to Paris. No two people are ever together long enough to enjoy word games.

The waiter returned and instead of bringing me a glass of wine, he poured the wine into my glass right from the bottle. This struck me as very sophisticated. Our appetizers came. They were something I wanted. Something I had chosen carefully. I remember that when I bit into whatever it was, I closed my eyes, stunned that anything could be so delicate, so delicious. "I say a word, and then I tell you if the word is or isn't it. For example," I picked up my wineglass. "It is glass, but it isn't wine."

Karl nodded.

"Now you can ask me one word, and I'll tell you if it is or it isn't, and we keep going until you figure out what the difference is."

"Is it a plate?" he asked.

"It isn't a plate, but it is a bottle."

He waited a minute. He thought it over. "I don't get it."

"It takes some time," I said. "It's a rabbit, but it's not a box."

He finished his appetizer, whatever it was. He didn't offer me a bite. "I don't know."

"It's a tree but it isn't a leaf."

"I give up," he said.

"It's Woody, but it isn't Mia."

"I don't know," he said. "Tell me."

I went on for a while, not telling him, throwing out words in patterns that irritated him profoundly. The main course arrived. I can very nearly smell it now. It was so succulent, complex, divine, but I cannot for the life of me say what it was. "It's pretty," I said. "But it isn't shoes."

"Stop it."

"It isn't stop or go or wait." Even as I said it, I could see myself stepping out of the car into traffic. It is traffic. I had told Mark I was through if he didn't tell me the answer. I said it much more colorfully than that. But when the answer came to me later, an easy lightning bolt slicing open my head, I wasn't angry anymore. I got it. It had taken me more than an hour but I got it, and that joy, so sudden and unexpected, was the reward.

The waiter kept refilling my glass, though I don't remember asking him to. The desserts were sublime, and we pushed them aside. The bill—I do remember that much—was $350. We may as well have piled the money on the table and put a match to it. This had been the best meal either one of us had ever had in our lives, and we missed it.

"I'm glad I found out now what kind of person you are," Karl said.

He had never been so angry at me, not before or since. I knew how he felt. As we were walking away from the restaurant, I broke down and told him. I did it because he was walking so quickly and my heels were too high and I didn't know how to get back to the hotel alone. I told him, and I ruined everything. Mark had been smart to weather my fury so that I could find the answer for myself, because once I found it, I forgave him. Karl, on the other hand, just stayed mad. He told me I was cruel and cold, and the next night at L'Arpège, he told me it was over.

"You're not breaking up with me in a fish restaurant in Paris," I said. "Not over this."

And so he didn't. We stayed together for ten years after that, and then we married. It has been a very happy union. Our fight in Taille-vent is a tattoo on our relationship, though. Neither of us will ever forget it, but it all strikes me as funny now. The sad part is that the meal is gone forever. It's a fault of our brains to remember the fight while forgetting the sole. Was it sole? I know what I said, but I can only dream about what I must have eaten.

(New York Times Magazine, November 26, 2006)

This Dog's Life

———————— • ————————

IT HAPPENED LIKE this: after a walk in the park, Karl and I saw a young woman sitting in a car talking to a dog. Even from a distance, through the hard glass of the windshield, we could tell this was an exceptional animal. Karl, never shy, tapped on the window to ask her what kind of dog it was. We live in Nashville, where people do things like this and no one is frightened or surprised. The young woman told us the sad story: the dog—who was on closer viewing nothing but a mere slip of a puppy—had been dumped in a parking lot, rescued, and then passed among several well-intentioned friends, none of whom were allowed to have dogs in their apartments. The dog finally landed with the young woman in the car, who had been explaining to said dog that the day had come to look cute and find a permanent home.

The puppy was doing a knockout job at being cute. She was small and sleek and white. The sun came through her disproportionally large ears and showed them to be as pink and translucent as a Limoges teacup held up to the light. We petted. She licked. We went off to think it all over. In the end we came back for the dog.

I didn't think it would be this way. I thought when the time was right I would make a decision, consider breeds, look around. The truth is, I too was a woman who lived in an apartment that didn't allow dogs. But when fate knocks on the door, you'd better answer. "Let's call her Rose," Karl said.

I was breathless, besotted. My puppy tucked her nose under my arm and the hundred clever dog names I had dreamed up over a life-time vanished. "Sure," I said. "Rose."

All I had ever wanted was a dog. Other girls grew up dreaming of homes and children, true love and financial security; I envisioned shepherds and terriers, fields of happy, bounding mutts. Part of my childhood was spent on a farm where I lived in a sea of pets: horses and chickens; half a dozen sturdy, mouse-killing cats; rabbits; one pig; and many, many dogs—Rumble and Tumble and Sam and Lucy and especially Cuddles, who did justice to his name. Ever since that time I have believed that happiness and true adulthood would be mine at the moment of dog ownership. I would stop traveling so much. I would live someplace with a nice lawn. There would be plenty of money for vet bills.

At home, the puppy Rose played with balls, struggled with the stairs, and slept behind my knees while we watched in adoration. It's not that I was unhappy in what I now think of as "the dogless years," but I suspected things could be better. What I never could have imag-ined was how much better they would be. Whatever holes I had in my life, in my character, were suddenly filled. I had entered into my first adult relationship of mutual, unconditional love. I immediately found a much nicer apartment, one that allowed dogs for a ridiculously large, nonrefundable deposit. Since I work at home, Rose was able to spend her days in my lap, where she was most comfortable. We bonded in a way that some people looked upon as suspicious. I took Rose into stores like the rich ladies at Bergdorf's do. I took her to dinner parties. I took her to the Cape for vacation. As I have almost no ability to leave

her alone, when I had to go someplace that foolishly did not allow dogs, I'd drive her across town and leave her with my grandmother.

"Look at that," people said, looking at me and not Rose. "Look how badly she wants a baby."

A baby? I held up my dog for them to see, my bright, beautiful dog. "A dog," I said. "I've always wanted a dog." The truth is, I have no memory of ever wanting a baby. I have never peered longingly into someone else's stroller. I have, on occasions too numerous to list, bent down on the sidewalk to rub the ears of strange dogs, to whisper to them about their limpid eyes.

"Maybe you don't even realize it," strangers said, friends said, my family said. "Clearly, you want a baby."

"Look at the way you're holding that dog," my grandmother said. "Just like it's a baby."

People began to raise the issue with Karl, insisting that he open his eyes to the pathetic state of maternal want I was so clearly in. Being a very accommodating fellow, he took my hand. With his other hand he rubbed Rose's ears. Part of my love for Karl is his love for Rose. Her favorite game is to be draped over the back of his neck like a fox-fur stole, two legs dangling on either shoulder. "Ann," he said. "If you want to have a baby . . ."

When did the mammals get confusing? Who can't look at a baby and a puppy and see the differences? You can't leave babies at home alone with a chew toy when you go to the movies. Babies will not shimmy under the covers to sleep on your feet when you're cold. Babies, for all their many unarguable charms, will not run with you in the park, or wait by the door for your return, and, as far as I can tell, they know absolutely nothing of unconditional love.

Being a childless woman of childbearing age, I am a walking target for people's concerned analysis. No one looks at a single man with a Labrador retriever and says, "Will you look at the way he throws the tennis ball to that dog? Now there's a guy who wants to have a son." A

dog, after all, is man's best friend, a comrade, a pal. But give a dog to a woman and people will say she is sublimating. If she says that she, in fact, doesn't want children, they will nod understandingly and say, "You just wait." For the record, I do not speak to my dog in baby talk, nor when calling her do I say, "Come to Mama."

"You were always my most normal friend," my friend Elizabeth told me, "until you got this dog."

While I'm sure I would have enjoyed the company of many different dogs, I believe that the depth of my feeling for Rose comes from the fact that she is, in matters of intelligence, loyalty, and affection, an extraordinary animal. In the evenings, Karl and I drive Rose across town to a large open field where people come together to let their dogs off their leashes and play. As she bounds through the grass with the Great Danes and the Bernese mountain dogs, I believe that there was never a dog so popular and well adjusted as mine (and yet realize at the same time that this is the height of my own particular brand of insanity). The other dog owners want to talk about identifying her lineage, perhaps in hopes that one of her cousins might be located. It is not enough for Rose to be a good dog, she must be a particular breed of dog. She has been, depending on how one holds her in the light, a small Jack Russell, a large Chihuahua, a rat terrier, a fox terrier, and a Corgi with legs. Currently, she is a Portuguese Podengo, a dog that to the best of my knowledge was previously unknown in Tennessee. It is the picture she most closely resembles in our *Encyclopedia of Dogs*. We now say things like "Where is the Podengo?" and "Has the Podengo been outside yet?" to give her a sense of heritage. But really, she is a Parking Lot Dog, dropped off in a snowstorm to meet her fate.

I watch the other dog owners in the park, married people and single people and people with children. The relationship each one has with his or her dog is very personal and distinct. But what I see again and again is that people are proud of their pets, proud of the way that

they run, proud of how they nose around with the other dogs, proud that they are brave enough to go into the water or smart enough to stay out of it. People seem able to love their dogs with an unabashed acceptance that they rarely demonstrate with family or friends. The dogs do not disappoint them, or if they do, the owners manage to forget about it quickly. I want to learn to love people like this, the way I love my dog, with pride and enthusiasm and a complete amnesia for faults. In short, to love others the way my dog loves me.

When a dog devotes so much of her energies to your happiness, it only stands to reason you would want to make that dog happy in return. Things that would seem unreasonably extravagant for yourself are nothing less than a necessity for your dog, so Karl and I hired a personal trainer for Rose. We had dreams of obedience, of sit and stay and come, maybe a few simple tricks. (She didn't really seem big enough to drag the paper inside.) I was nervous about finding the right trainer and called my friend Erica for moral support, but she was too busy trying to get her four-year-old son into a top Manhattan pre-school to be sympathetic to my worry about finding the right trainer for my puppy. The trainer we ultimately went with was the very embodiment of a dog authority figure. After a few minutes of pleasant conversation, during which Rose jumped on his shoulder and licked the top of his head, he laid out the fundamentals of his regime.

Number one: The dog doesn't get on the furniture.

We blinked. We smiled nervously. "But she likes the furniture," we said. "We like her on the furniture."

He explained to us the basic principles of dog training. She has to learn to listen. She must learn parameters and the concept of no. He tied a piece of cotton rope to her collar and demonstrated how we were to yank her off the sofa with a sharp tug. Our dog went flying through the air. She looked up at us from the floor, more bewildered than offended. "She doesn't sleep with you, does she?" the trainer asked.

"Sure," I said, reaching down to rub her neck reassuringly. She slept under the covers, her head on my pillow, her muzzle on my shoulder. "What's the point of having a twelve-pound dog if it doesn't sleep with you?"

He made a note in a folder. "You'll have to stop that."

I considered this for all of five seconds. "No," I said. "I'll do anything else, but the dog sleeps with me."

After some back-and-forth on this subject, he relented, making it clear that it was against his better judgment. For the duration of the ten-week program, I either sat on the floor with Rose or Rose and I stayed in bed. We celebrated graduation by letting her back up on the sofa.

I went to see my friend Warren, who, conveniently, happens to be a psychologist, to ask him if he thought things had gotten out of hand. Maybe I had an obsessive-compulsive disorder concerning my dog.

"You have to be doing something to be obsessive-compulsive," he said. "Are you washing her all the time? Or do you think about washing her all the time?"

I shook my head.

"It could be codependency, then. Animals are by nature very codependent."

I wasn't sure I liked this. Codependency felt too trendy. Warren's sixteen-year-old daughter, Kate, came in, and I asked her if she wanted to see the studio portraits I'd had taken of Rose for my Christmas cards. She studied the pictures from my wallet for a minute and then handed them back to me. "Gee," she said. "You really want to have a baby, don't you?"

I went home to my dog. I rubbed her pink belly until we were both sleepy. I imagine there are people out there who got a dog when what they wanted was a baby, but I wonder if there aren't other people who had a baby when all they really needed was a dog. We've had Rose a year now and there has never been a cold and rainy night when I've

resented having to take her outside. I have never wished I didn't have a dog, this dog, while she sniffed at each individual blade of grass, even as my hands were freezing up around the leash. I have never minded picking the endless white hairs off my dark clothes. All I had ever wanted was a dog who would sleep in my lap while I read and lick my neck and bring me the ball to throw eighty-seven times in a row. I thought a dog would be the key to perfect happiness. And I was right. We are perfectly happy.

(*Vogue*, March 1997)

The Best Seat in the House

W<small>HEN</small> I <small>WAS</small> six and seven, my older sister and I often stayed with the family of a man who was the house doctor for the Grand Ole Opry, back when the Opry was still in downtown Nashville at the Ryman Auditorium. This was 1969, 1970. On Friday and Saturday nights Dr. Harris would take us along with his two youngest daughters to sit backstage while he tended to whatever star needed tending, though most nights no one needed tending and he was free to drink and tell stories in the greenroom, where the best music was actually played. All the while the clutch of small girls, of which I was a member, sat in the dark wings and watched the high-haired men and women go back and forth in their spangles and fringe. We all liked Roy Acuff best because he had a yo-yo.

This should have been the moment of my musical birth. I was a child with the best seat in the house, but even in those early days country music and I were a poor fit. I can remember the hats and the boots, the rose-colored lights and the snakelike electrical cables, but I don't remember a single song. Opry is what I was born to; it would

take me another twenty-five years to figure out that my heart belonged to that from which Opry was derived.

My friend Erica Schultz lives on Manhattan's Upper East Side. She has hauled her boys to the Metropolitan Opera the way we were taken to the Ryman, as little kids. She got them in the children's chorus so that they could walk onto the stage and sing. I wonder how differently my life might have turned out had I been lucky enough to be Alex Schultz. I was past thirty before I started research for a novel in which the heroine, an opera singer, is held hostage in an embassy in South America. It wasn't until I was doing the research to write *Bel Canto* that I heard my first opera. The love that I came to feel was not immediate, but it was slow and deep and permanent, a love that could never be undone. Everything in me leaned forward then. This was my music, my destiny: coloratura instead of twang, *"Dove sono"* instead of "Stand By Your Man."

The problem was I lived in Nashville, and true love, it has been my experience, never asks to see the check. I started buying opera tickets in other cities, and plane tickets to get myself to those other cities, and when I added on hotel rooms and cab fares and a snack I quickly found myself with a habit that would make most drug addictions look manageable. I couldn't get enough of the stuff. But, figuratively speaking, I had arrived at the theater well after intermission. What chance did I have for proficiency when there was so much I hadn't seen? Listening was satisfying—yes, I was grateful for those Saturday broadcasts from Texaco; and, yes, I bought CDs—but opera is a dramatic art, and in many ways a visual art. It is sidelong glances as well as the E natural. I wanted to watch Violetta grow pale.

And then Peter Gelb got the job of general manager at the Met. He understood that people like me couldn't always come to the opera, and therefore created a system by which the opera could come to us. The Met began to broadcast live high-definition performances into movie theaters across the country. I didn't catch on until the second

show of the first season, so I missed Julie Taymor's production of *The Magic Flute*; I still haven't gotten over that. But on January 6, 2007, I wandered into the Regal Green Hills Stadium 16 cinema and put down $20 for a ticket to *I Puritani*. I had read about this movie-theater thing, but I still didn't really understand how it worked. There, in a comfortable fold-down seat with a whiff of popcorn in the air, I watched Anna Netrebko lie on her back, dangle her head down into the orchestra pit, and sing Bellini like her heart was on fire.

Are there words for this? I was in Nashville watching the Metropolitan Opera. I was seeing it on a screen so large that the smallest gesture of a hand, the delicate embroidery on a skirt, was clearly visible. I could see Netrebko's tongue inside her mouth and see how it shaped the air that made the note. I could see the conductor, yes, the crisp gesture of his wrist, but my God, I could see the French horn player as well. I could look into the eyes of the chorus one by one, every man and woman focused in their part. It was Opera Enormous, every note utterly human, simultaneously imperfect and flawless. It was opera the way Alex Schultz saw it, which is to say, right there onstage.

If the opera itself wasn't enough, there were perks besides: at the Met, the patrons killed time between acts by waiting in insanely long lines to get a drink or use the facilities. They reread the program, or stared aimlessly at the heavy velvet curtain. Those of us in the Regal Green Hills Stadium 16, on the other hand, got to go *behind* the curtain where Renée Fleming, armed with a microphone, stopped the soprano and tenor as they came offstage, and asked them why they liked Bellini and how hard it was to sing bel canto. Imagine getting to see Paul Cézanne interviewing Camille Pissarro over a half-finished canvas, getting to see them talk casually, intelligently, about technique. Imagine Cézanne pointing to a small smear of bright paint on a Pissarro pear and saying, "I love how you did that! I always struggle with the light on a pear!"

After *I Puritani*, I bought my tickets in advance and came to the theater early. Everyone came to the theater early. The place was packed but we all felt compelled to pretend we were season-ticket holders. We tried to sit either in the same seat we had sat in for the last showing or the one as close as possible to it. I am the second to the last row on the left-hand side, five seats over from John Bridges, five rows back from Eugenia Moore. We all know each other now and chat about what's coming next while we wait for the giant countdown clock on the screen to hit zero. We watch the patrons in New York, people who have paid ten times more for their tickets, and some more than that, as they make their way to their seats. Like us, the audience members on the screen stop to greet the familiar people around them, and like the audience in New York, we clap for both arias and curtain calls. We call out *Brava!* and *Bravo!* The rational mind understands the singers can't hear us, and yet we are living so completely in our high-definition moment it is easy to forget.

The second season of Met simulcasts was for me a breakthrough in the language I so desperately wanted to speak. I was seeing enough opera to develop a sense of Ramón Vargas. I had seen him live several years earlier in a production of *La Traviata*, but there he was again in last year's broadcast of *Eugene Onegin* and this year's *La Bohème*. I thought that Maria Guleghina had been the highlight of last year's *Il Trittico*, and when she came back as Lady Macbeth my pleasure felt almost proprietary, as if I had been the one to discover her in the first place. The same was true with Juan Diego Flórez, who had been so dazzling in *Il Barbiere di Siviglia*. Three days before the broadcast of *La Fille du Régiment*, the *Times* ran an article about Flórez hitting the nine high C's of his aria and then repeating the feat in an encore, the first Met encore in almost fifteen years! Two years ago I would have read the article with a certain numb acceptance, knowing that this was the sort of miracle a country girl was never going to see, but instead I came even earlier to the following Saturday's broadcast,

where we as an audience speculated in the aisles as to whether or not he would do an encore again or if it would seem, well, too obvious on a broadcast day. (Alas, I guess it was. No encore of the encore.) But still, even to hear it once was brilliant. We got to see the powerhouse performance of Natalie Dessay, who is herself proof that it isn't enough just to listen. We did a lot of grumbling over the fact that her *Lucia di Lammermoor* wasn't broadcast. (How quickly we turn from grateful to greedy.)

A real opera fan, the kind who is born into it, revels in obscurity. They are choking on *Carmen*. At thirteen, Alex Schultz is more interested in a production of Janáček's *Jenůfa*. Remedial fans like myself who have long lived with the burden of limited access are always playing catch-up. In the past, when I was out of town and had the chance to see an opera, I would choose, say, *Madama Butterfly* over Prokofiev's *Love for Three Oranges*, because I was trying to lay down the bedrock of my education. (I still haven't seen *Rigoletto*, for heaven's sake!) But the broadcasts have run the gamut from warhorses to world premieres. I didn't love *The Last Emperor*, composer Tan Dun's 2006 world premiere, but it made me feel cutting-edge to have seen it. I had never felt even remotely cutting-edge where opera is concerned. If I lived in New York and had all the time and money in the world, I doubt I would have gone to see *Hansel and Gretel*, but I live in Nashville and so I went. I have to say those giant fish in tuxedos will stay with me until the end of my days. The music was as haunting as the sets, and I will be so glad the next time I see the marvelous Christine Schäfer on the screen and can say, "Gretel! It's Gretel!"

As time goes on, the Met has dug down deep to keep the intermission features interesting. While fifty teamsters roll giant sets around him, Joe Clark, the indefatigable technical director, explains how snow is made. Renée Fleming interviews not only the soprano and the conductor but the people who handle the horse in *Manon Lescaut*. The

horse was a consummate professional, but Karita Mattila dropped into the splits in the middle of her intermission interview, and then, to keep things even, came up and slid down on the other side.

That we are kept so well entertained between acts is a bonus, but not a necessity. The necessity is opera itself. The way I cried at the end of *La Bohème* was expected, and when my friend Beverly called later that night to tell me how she had cried in her theater in Texas, we both said, "Mimi! Mimi!" over the phone and started to cry again. The crying I did in *Suor Angelica*, the second act of *Il Trittico*, took me completely by surprise; that final image of the luminous child coming in through the doors at the top of the stage forced the audience into a great, collective sob. But nothing really touched *Eugene Onegin*—the staging, the music, the glory that Dmitri Hvorostovsky and Renée Fleming made together. As wonderful as Fleming is as a guest host, the sight of her anywhere on the Met stage makes one feel she should go zip up her costume and sing. (I saw that same production three days later in New York, where part of my view was obstructed by a tree onstage. Even though my seat was good, I couldn't see the nuances of joy that had radiated so clearly from Miss Fleming's face in the movie theater as she wrote Onegin her letter, or the crushing humiliation and grief that passed through her eyes when he rejected her. Had the opera been better on the screen? I won't go as far as that, because there is, of course, the magic of proximity, but I will say it was at once a different and equal experience.)

On the last day of the season, in April, the Met put a list up on the big screen of the next season's coming attractions. Ten operas *plus* the opening night gala! The crowd at the Regal 16 broke out in a cheer, I swear to you, a *cheer*, when we heard that news. There had been only eight operas this year, and only six last year. In Nashville we had become ravenous. All we wanted was more.

What if culture turned out to be like vegetables, and we were told it was better to consume only that which was locally grown? Could I

have learned to embrace the Opry the way I have managed to make peace with okra? I doubt it, but these broadcasts have given me the best of big-city life without the strain of bearing up under the big city's weight, a task for which I know myself to be fundamentally unsuited. Implicit in my love for Tennessee has always been the understanding that certain needs were going to have to be met elsewhere. But these days, it seems, not so much.

Like any other monkey on your back, no addiction ever feels complete until you can pass it on to your friends. I have tried mightily, and in a few cases I've been successful, but for the most part I find it surprisingly difficult to get people to spend their Saturday afternoons in a movie theater watching opera. I am, I would guess, about twenty years below the median age of an operagoer at our local cineplex. Peter Gelb knows his audience, and he knows he needs to cultivate a new crop. I feel certain this will happen over time. People like me, the opera converts, we never shut up, and sooner or later you'll go and see one, if only for the sake of appeasement. Once you get in there you'll get it, and it will get you, and then, my friend, there is no going back.

(*Wall Street Journal*, June 21, 2008)

My Road to Hell Was Paved

———————— • ————————

IF YOU'RE NOT from Billings, Montana, you don't expect to run into people you know at the Billings airport, but over at the luggage carousel is a doctor-friend of Karl's from Nashville and his teenaged daughter. They're meeting up with the rest of their family for a two-week vacation. The doctor asks about our plans.

Karl clears his throat. "We're going out to the Badlands," he says. "And then over to Yellowstone."

"Camping?"

Can we call it camping? No, let's call it what it is. "We're renting a Winnebago," I say.

"A Winny-Baaa-Go?" the doctor asks.

"We hate them," the doctor's daughter volunteers, in case I missed the gist of her father's pronunciation.

The doctor nods, his expression grim. "They clog up the parks. They go five miles an hour. They're everywhere. I hate those damn things. Why would you go out in a Winnebago?"

I tell him it's an assignment—which, frankly, is the only circumstance under which I'd get in a motor home. This is not a vacation.

This is undercover journalism. My plan is to infiltrate RV culture and expose it for the gas-guzzling, fitness-eschewing underbelly my editor knows it to be. But this is not the sort of thing I can confide while waiting for my suitcase.

Karl shifts uncomfortably, not wishing to be implicated. I do not remind him that he was never invited on this trip in the first place. It was my intention to drive the motor coach alone when he stuck his foot in the door. Karl and I have broken up, which makes this trip a grudging opportunity to consider reconciliation. But of course we're not going to tell that to the doctor from Nashville either, since he never knew we'd broken up in the first place. Karl tries to steer the conversation by asking a question about his friend's mother, when suddenly the doctor's face lights up. He turns to his daughter.

"Do you remember the one that burned?" he asks, touching on a treasured family memory.

Enormous smile. "There was smoke everywhere," the girl says.

"This was a couple of years ago," he tells us, and for the first time he is fully engaged in our conversation. "We passed a Winnebago in Yellowstone, creeping along, and then coming back later on we see it again, the same one, on fire. That siding burned fast." He makes a gesture with his hands to indicate shooting flames. Then he sobers himself. "The people got out fine," he says. "But it sure was great to watch that thing burn."

The daughter nods. "We got out of the car. We were dancing."

I wonder if the people in that burning Winnebago had broken up at some point. I wonder if they were heading into America to see what of their love could be salvaged, only to have the whole thing burst into flames.

The first night is simple: one hotel room, two beds. In the morning we head down to Pierce RV in Billings to pick up our twenty-nine-foot Winnebago rental. Over the phone, twenty-nine feet sounded like a

whole lot of vehicle, but standing in the lot we see it's just a bantam-weight. There are thirty-three-footers here, thirty-four, thirty-six. Everywhere I turn I see big tires and endless expanses of glass and steel and aluminum. Our coach is fresh off the factory line, and because it must be returned in perfect condition, the entire interior is covered in plastic—the floors, the booth table with bench seats, the driver's seat, the bed. It smells not unpleasantly of polyvinyl chloride. Paul, the pale and amiable young man charged with setting us up, asks if either of us has driven a coach before.

"No," Karl says.

I shake my head.

"Not to worry." He smiles, not worried at all. "I've taken a thousand people through this."

Our Winnebago says "Minnie" on the side in sweeping, wavelike letters because motor homes have cute names (Holiday Rambler, Alpenlite, Southwind, Prowler) which fit in nicely with the spare-wheel covers that say things like "Gone Fishin'" or "Hardly Working." Paul demonstrates how to roll down the awning out front, a long and complicated process vaguely akin to setting up a gigantic ironing board. Paul gives detailed instructions for emptying and filling tanks (104 gallons for water, fifty-five gallons for gasoline, averaging just under ten miles to the gallon). He hands over the keys and I climb into the driver's seat because this is my assignment, my job, and I was fine to go alone. Karl is riding shotgun.

In Albert Brooks's 1985 film *Lost in America*, a couple cashes in everything they own to tour the country in a giant motor home. Brooks, behind the wheel while Julie Hagerty makes toasted cheese sandwiches in the microwave, is funny. The long shots of the lumbering whale creeping uphill in traffic—funny again. Two people driving a Winnebago was such a riot it merited an entire film, and still I am not laughing. While I'm sure I could take this thing forward, I have serious doubts about backing it up. After a moment of

interior wrestling I slip the motor home back into park. "I can't do this."

Karl doesn't make my admission into anything other than what it is. He just steps back from his seat, lets me cross over, and gets behind the wheel. Karl knows a thing or two about backing up, and he is a stone-cold genius at parking. This is not enough to make it work between us. Once he gets the thing turned around he doesn't ask me if I want him to drive the first leg, because I want him to drive the first leg, and he knows it.

We ease into the late-morning traffic of downtown Billings, the plastic-wrapped captain's chairs cradling us like La-Z-Boys. Two blocks out, a black-and-white dog runs into the street and heads straight for our front wheels. Karl slams on the brakes. We then discover the First Great RV Truth: Like ocean liners and oil tankers, RVs do not stop. While Karl grinds the pedal into the carpet, I scream at the dog, "Go! Go!" We might have clipped its tail but the dog itself is spared, and we, very nearly stopped now, are ecstatic. We did not kill a dog in the first five minutes of the trip! We say it out loud to one another. What a good omen! What a positive sign! Five minutes in a Winnebago and we haven't killed anything.

Here are the salient details of our personal life: Karl left when I didn't want him to go and came back right about the time I was no longer interested in having him back. He persisted. We argued. I told him to go and he would not go. Months and months and months went by and still he would not go. Now we are in a motor home heading east.

After stopping at the grocery store to stock up, we push the cart full of groceries across the parking lot and straight up to the side door of the Minnie. We have not used shopping bags. Karl takes the bananas out of the cart and hands them up the stairs to me. I take the bananas from Karl and set them on the kitchen counter. There is some bending in our upper bodies but our feet do not move. When

everything has been unloaded, we roll the cart back to the cart corral and return to sit on the couch, feeling like time itself is not quite right. Some essential step between grocery and kitchen has been lost. We unpack our suitcases and eat peanut butter sandwiches and we are still parked in the parking lot of the grocery store. I find that I am overcome by a powerful listlessness. Why bother driving anywhere? Why not just stay where we are?

Montana has no highway speed limit, and we are doing sixty. Cars in the fast lane shoot past like pinballs. Perhaps we could go faster, but there doesn't seem to be any point. Our vague plan is to head south on the interstate into Wyoming, then east to South Dakota, then ultimately wind up in Yellowstone. The Minnie is ours for a week so we have nothing but time. If I must drive a Winnebago, I'm glad I'm doing it in the West. It is big. We are big. We cut a meaningful silhouette against the expansive sky. Everywhere we look it is empty and gently rolling like an ocean and I feel like we are a schooner, a prairie schooner, clipping over the waves. It is a world completely divorced from the one we actually live in, the one in which we are responsible people with jobs and expectations and a shared dog who is now my dog because we are not seeing each other anymore. We don't talk about what went wrong with us or if we'll manage to fix it. We listen to the radio and discuss the passing scenery, and while I don't mention it, I have a powerful understanding of how odd it would be to drive this Winnebago alone.

After a while, we pull up behind a truck going even slower than we are, and Karl, after a long consultation with his side mirrors and plenty of discussion with me—his navigator and person whose name is on the insurance forms—opts to pass, which is when we very nearly take out two motorcycles sailing up alongside us.

We lumber back into the right lane.

The bikers look up at us, not with anger, but with bewilderment,

their lives still flashing before their eyes. A group of ten or twelve motorcycles follows behind them. My hands are shaking. Karl is shaking. He had been talking about buying a motorcycle himself. "I didn't see them at all," he says, bringing us to the Second Great RV Truth: There's a lot out there you just can't see. This lesson is important even if you never plan to drive one yourself. Give all vehicles containing showers a wide berth.

We have our route planned out, but then decide to take another highway. What's the difference? We have no hotel reservations. Our hotel is with us. Our restaurant is with us. We are turtles, carrying our world on our backs. Once we leave the interstate we don't have to worry about driving too slow for the cars behind us. We don't see a car again for the next two hours.

Do not mistake eastern Wyoming for western Wyoming. There is no one here. There are cows standing mid-road, still far away. This time, we know to start slowing down long before it would seem necessary, and eventually we stop, waiting for the cows to amble off. We are nowhere, but we are nowhere with fifty gallons of gas and a hundred gallons of water.

When it is good and dark, we find ourselves not far from a ranch I used to visit years ago, and I tell Karl the owners wouldn't mind if we park by the barn and spend the night. (In the parlance of RVers this is known as "boondocking.") When we arrive at the ranch, no one is home. Karl lowers the shades and I flick on the generator, and the lights inside the Minnie are bright, and everywhere there is a humming like an industrial refrigerator. We crawl into bed and try to read and try to sleep but can do neither. We turn off the generator and the silence and the impenetrable darkness pour in through the windows and cover us up.

"This is the weirdest thing I've ever done," Karl whispers. "I feel like I'm sleeping in the trunk of a car." We each stay on our own side

of the bed, and when we shift in our spots the plastic-covered mattress crunches beneath us.

"Let's go outside," I whisper back.

And so we go outside, climb the ladder to the top of the Winnebago, and stretch out flat on the metal roof to look at the stars. So many stars fall on this night it's impossible to think we won't eventually run out of stars. After the deaths of a million stars we are sleepy, and we climb back down to bed.

During the night a storm wakes me. Every time the lightning flares, the sky stays bright for several seconds. Thunder rocks us and the rain is deafening, and then hail starts clattering against the fiberglass siding. It sounds like peach pits thrown by Sandy Koufax. Inside our tin house we are snug, and I roll over and fall asleep again.

The next day we drive to Devils Tower to see that astonishingly weird monolith of rock. We hike farther than we mean to on a day that is hotter than it seemed. We make it back to the Minnie, and drive for half an hour before we realize that we're wrung out, exhausted. We limp into a rest stop, turn on the generator, crank up the AC, and then fall into a coma-like sleep. This illustrates the Third Great RV Truth: Wherever you are, you are no more than fifteen feet from bed. For all of my bone-deep distrust of motor homes, they do combine two of my favorite pastimes: driving and napping.

When I raise the blinds an hour later, another motor home is parked snugly next to ours, and a boy eating a sandwich at his diner-style table looks through his window into mine. He waves and I wave back, and a few minutes later I get behind the wheel and drive away. Now that I'm used to the RV, driving doesn't seem so bad. Trips to the gas station, however, are stressful. We're spending around $50 a day on fuel, and as I stand at the pump watching the numbers roll up I have to remind myself that I have an expense account. When the news talks about America's dependence on fossil fuel, it's talking spe-

cifically about me driving the Minnie. I am the person for whom the Gulf War was fought and won.

Late that night we have a hard time finding the Badlands Interior Campground, where we have a reservation, and it's long past dark when we finally arrive. Overhead, the South Dakota stars—the ones that did not fall last night over Wyoming—glitter in bright abundance. Up and down the aisles, RVs glow with cool blue television light. Children cluster around citronella candles on picnic tables. I think we could be on any suburban street in the world.

But in the dawn's early light, it's clear this motor park is nowhere near a suburb. We are definitively in the Badlands, and the razor-blade bluffs cresting over so many neatly parked RVs are indeed a sight. By six o'clock the sun glares as brightly as noon, and the RV world is up and about. Karl spots Tennessee plates on a big Allegro Bay RV coach. It is all the encouragement he needs to knock on the door. Karl is friendlier than I am, braver, and better at backing up large vehicles. I make a note of everything. The Allegro contains a couple in their seventies, along with their daughter and her husband, who are also from Nashville. The older man is in the process of emptying out his "black water" sewage tank into a discreet metal hole in the ground. I ask if perhaps it got cramped in the Allegro, traveling with four adults. The son-in-law tells me that he and his wife sailed from Nashville to South America and then to Europe and then back. They were gone six years. *That* was cramped.

It's possible to sail from Nashville to South America? You can do that?

"Take the Tims Ford River," the son-in-law says. "When you get to the Mississippi, go left."

Karl and I have done very well in our Winnebago so far, I will admit it. We discuss the possibilities of our getting along for six years on a boat. He is heartened. He thinks we would do fine. We go to the pancake breakfast at a cluster of tables next to the office. Across the

driveway, a child in a bright orange bikini leaps into an aboveground pool over and over again. The pancakes are two for $1.05. We sit down with Rodney and Ronda, who are on their way to the Sturgis Motorcycle Rally from Minnesota. Ronda is wearing a bra made out of chamois cloth and leather cord. She is wearing black leather chaps with long fringe down the sides. She is young and tan and lean with an abundance of curly gold hair. Rodney, who is very much in love with her, looks painfully average in his khakis and polo shirt.

"Are you bikers?" Rodney asks us.

"Of course they're not bikers," Ronda tells him. "Look at their hair. Their hair is too nice."

I think she means that I look like a member of the Winnebago set. I am neither windblown and bug-splattered like the bikers, nor rumpled and tanned like the campers. My shirt and nails are clean. Suddenly I feel I represent things I do not mean to represent: wholesomeness, family values, docility.

They want to know if we're going to the motorcycle rally in Sturgis, and we, who have no plans and no bikes, say yes.

"Rock and roll," Ronda says, showing her pretty teeth, her pretty everything. "I'll give you a ride."

And so Karl gets on the back of Ronda's Harley. He puts his hands behind him and she reaches back and pulls one of his arms around her narrow, naked waist, right above the chaps. "Hang on!" she cries, and so he does, he must. Out of the Winnebago and onto a Harley, Karl roars away with Ronda and I watch him go. And I feel something, something that is like jealousy and loss and pride at his bravery. They weave away from us down the narrow road towards the mountains in all that gorgeous light. Karl and Ronda. Gone.

Rodney shakes his head. "She's really something," he says wistfully.

"She's your girlfriend?" I ask, knowing that she isn't his girlfriend, not in a million years.

"She's my neighbor," he tells me, his eyes still on that point on the

horizon where the person he loves and the person I love were last seen. "She lets me come to Sturgis with her. It's a long way to come alone."

Ronda, he tells me, is a receptionist in a dental office.

Rodney and I finish our pancakes and pick up the paper plates, and right about the time I think they are never coming back, they come back. Karl's smile is enormous and when he gets off the bike he pats Ronda's shoulder and comes straight to me. "She's going to take you now!" he says. His joy vibrates in the heat of the day. I am sitting on the picnic bench, paralyzed by the offer. Karl is the one who jumps on the bike. I am the one who stays behind and finishes pancakes. "Go!" he says.

"She just went out," I say, sounding lame even to myself.

Ronda revs her engine and makes a great sweeping motion with her tan arm, and I go to her and get on the back of her bike and put my arms around her waist. "Hang on!" she calls to me, and then we're gone.

How you ride says everything about how you see the world. In the Winnebago we see the world from inside our house. We watch it as it rolls sedately past our living room window. But on the back of Ronda's bike, leaning deeply from side to side, I am the jutting purple mountains. I am the asphalt and the birds in the sky. I remember everything about the twenty minutes I spent in the blown-back cloud of Ronda's hair. People are more than willing to die on motorcycles because for that moment in the Badlands of South Dakota they are truly and deeply alive.

"That man loves you!" Ronda screams back at me.

"So he says!" I scream to her.

By the time we return to the Badlands Interior Campground, the RV herd has cleared out. Picnic tables sit empty on grassy slots between strips of gravel and sand. Connection poles for water and electricity stick out of the ground like speakers at a drive-in. Where there should be a movie screen, there is nothing but mountains and sky.

We say goodbye to Rodney and Ronda, and say that maybe we'll

see each other at Sturgis, though we never do. We go to the motor-cycle rally in our Winnebago, parking as far away as possible and walking in. One motorcycle in a national park at dawn is a beautiful thing. Two hundred thousand motorcycles with their concomitant two hundred thousand motorcycle guys is something else entirely. Within ten minutes my romantic ideas about bikes have disintegrated and once again the motorcoach and the promise of the open road call my name.

Our Winnebago is the warm nest, the mother ship, and when we return from a hike or a run through some small town, I am glad to see that great whalelike mass parked on the roadside. We become adept at hookups and feel like geniuses. We empty black-water tanks in the driving rain. We sleep in a beautiful tree-shaded KOA in Sheridan. We sleep in a crummy campground in Cody ("Closest to the Rodeo!"). But wherever we pull down the shades and stick the popcorn bag in the microwave, it is the exact same place. Getting out of the rodeo at eleven p.m., I am glad not to have to find a motel or pitch a tent. I am glad not to eat a bad dinner or unpack my suitcase or try to start a fire.

Finally we reach Yellowstone, which is to Winnebagos what up-stream is for salmon. All have come and all are welcome—the modest conversion van is parked between the luxe models with tricked-out interiors worthy of a mafia wife. We are all brothers beneath these towering pines. A number of people have mounted a map of the United States and Canada on their vehicle's side, with a colored insert for every state and province they've visited. Under various awnings there is indoor-outdoor carpeting, potted plants and wind chimes, patio furniture, and, on a folding chair, a large stuffed bear holding an American flag. In the morning the air fills with the smell of eggs and sausage. It's like a neighborhood in an imaginary version of the 1950s, with a virtuous respectability so kitschy, so obvious, one longs to mock it, except I can't anymore. I am trying to remember how to pull my awning down.

On a cruise-boat tour of Yellowstone Lake I meet Pat, a retiree in her mid-sixties who has been traveling in her thirty-seven-foot Winnebago for eight years. Her husband died last January, and she's driven alone ever since. When I ask where her home is, she tells me she doesn't have one. "My children live in southern California," she says. On this day Yellowstone Lake is a postcard, with sculpted clouds and diving ospreys. I ask Pat if she comes here a lot, but she says no, it's been years. When her husband's health was declining, he couldn't take much elevation. Now that she's alone, she's seeing the mountains. Life is short, she tells me. She plans to go from a motor home to a nursing home.

Karl and I drive along the Madison River on our last night in Yellowstone and see people swimming. We pull into a parking lot and put on suits and walk down to the water. We wade into the cold and swim and let the current carry us around until we're tired and hungry. Then we go back to the Minnie and take showers. I make a fairly decent dinner in our play-house kitchen and we wash the plates and put them away and drive on.

I believe the Winnebago has set me free. It has made me swim in cold rivers and eat pancakes with strangers and turn down obscure roads with no worry about where I have to be or when. I believe it has set many people free, old people and people with children who go off and see what this country has to offer because of their motor homes. Maybe they don't hike, maybe they don't shoot the rapids or explore the wilderness, but they are out there. Who am I to say how others should spend their vacations?

I believe this is the Fourth Great RV Truth: People who don't like them have never been in one.

I feel like I went out to report on the evils of crack and have come back with a butane torch and a pipe. I went undercover to expose a cult and have returned in saffron robes with my head shaved. I have fallen in love with my recreational vehicle.

And I have fallen in love with Karl, which I can see now was the point of the story. The vast open spaces of America, as experienced through the twenty-nine confining feet of motor home, have restored us, though we both feel worried when we drive back to Billings and turn the Minnie in. We walk over to the sales lot, full of ideas. We could drive home, or drive in the direction of home and see where we end up. There is a beautiful thirty-foot Airstream Classic on the lot, and for a minute we think an Airstream would be just the thing to keep us like this forever. But at some point before we pull out a credit card we come to our senses. We know we have to make this work without a motor home, which, after all, is nothing but love's powerful crutch. I know what would happen if we bought that Airstream, what our friends would say. We would never be welcome to park in front of their homes. We would be drummed out of polite society. We would be refugees on the road. We wouldn't mind.

(*Outside*, June 1998)

Tennessee

<center>❋</center>

I'VE BEEN TOLD that the secret to making money, big money, is to find the place on the edge of town where the real estate stops being priced by the square foot and begins to be priced by the acre. The idea is then to buy as many of those acres as possible and wait for town to creep towards you so that you will be there, ready and waiting, when those acres are converted down into square feet.

Having lived in Nashville for most of my life, I have seen this theory put into cash-making practice time and again. Acres that once were home to lazy cows and nibbling deer are now the physical underpinnings of sprawling shopping malls and housing developments and golf courses—thickets of blackberries mown under to make way for irrigated expanses of manicured greens. The cows and the wildlife, not unlike the urban poor, were forced from their neighborhoods and herded off to distant pastures.

Nashville is not a city that can take any pride in its urban planning. Lovely old homes are knocked down, appalling condominiums spring up in their stead, traffic multiplies geometrically, mom-and-

pop operations issue a mouselike cry trying to hold back the big-box chains, and then are devoured by those chains in a single bite.

But for every way this city has changed for the worse, there is some other way it has changed for the better. When I was a little girl, the Klan marched down at the square on Music Row on Sunday afternoons. Men in white sheets and white hoods waved at your car with one hand while they held back enormous German shepherds with the other. My sister and I pushed down the buttons of our door locks and sank low in the backseat. Those men are gone now, or at least they aren't out walking the streets in full regalia. If growth and modernization means getting rid of the Klan while bad condos spread like lichen over tree trunks, well then, let's hear it for modernity.

There was a time when Nashville cared more for genealogy than character. (In some very limited circles this may still be the case.) If your family hadn't been in the state long enough to remember what Lincoln had done to it, then you might be politely tolerated but you would never truly be accepted. I knew this, having moved here just before I turned six. We were Californians, and we may as well have been Martians. But then there was a shift—too many people moved here in the last two decades to keep up with who was from where. Somewhere in all the confusion I became a local.

If the changes that Nashville has seen just in my lifetime could all be put together and then averaged out, I would contend that this place is more the same than it could ever be different; because while Memphis has changed and Nashville has changed and Knoxville has changed, the state of Tennessee has not changed. To understand this you have to go back to that place where real estate prices out by the acre. Plenty of people made a killing on those deals, but don't be fooled: many, many more are still holding on to their land. And yes, the cities do push out, but down here the cities are islands surrounded by an ocean of country, and the country pushes back hard. There is a powerful root system that reaches far beneath those mall parking lots,

and the minute we stop hacking away at it, the plants come back. This sounds metaphorical. It isn't. For all its briskly evolving cities, Tennessee is first and foremost a trough of rich soil sitting beneath hot, humid weather. Its role on earth is less to be the home of country music and the meat-and-three, and more to be a showcase of rampant plant life.

Between the ages of eight and twelve, I lived with my family on a farm in Ashland City outside of Nashville. We called it a gentleman's farm, which meant that the only thing we did to the land was look at it. The daringly modern house my stepfather had built was as substantial as a sheet of folded notebook paper. Whenever it rained the dirt in the basement turned to mud and poured beneath the laundry room door. Mushrooms the size of salad plates popped up overnight— entire mushroom cities—in the shag carpet of my sister's bedroom. All the doors had been stained outside the summer the house was being built and were covered in petrified insects. The shallow swimming pool was so burdened by frogs that even if we had done nothing but haul them from the water with the skimmer net night and day we couldn't have saved them all. We kept a couple of horses that could be ridden only if they could be caught, and a very large pig that fell into the same category. (There is a picture of my sister sitting atop that pig, her knees together, riding side-saddle without the saddle.) There were banty chickens named after members of Nixon's cabinet; the dogs had an uncanny knack of eating them just as their namesakes fell before the Watergate committee. Alongside the well-fed dogs there was an endless parade of cats, rabbits, hamsters, and canaries, but the most abundant form of life was the flora that sprang from our untended ground: all manner of trees—eastern redbud and tulip poplar, frothy seas of white dogwoods, all types of maples, red oak and white oak, black locust, red cedar, enormous black walnuts. In early fall those walnut trees began to drop their smelly green-hulled nuts the size of baseballs, and we tripped on them and squashed them with the car.

Once a year in a fit of boredom or optimism we would forget everything we knew about black walnuts and scrape off the filthy husks and dry the nuts on the front porch, thinking we would eat them, but they were impossible to get into, yielding a tiny bit of meat for an enormous amount of work. Before we ever got enough together to make a quart of ice cream, the squirrels would come and carry our burden away.

My childhood was spent with the dogs, hacking my way into the thick undergrowth of woods with the single parental admonishment that I should watch out for snakes. I didn't much worry about snakes. We had thirty-seven acres—so much room, so much leaf and bark and trunk and bloom—that it seemed impossible that any snake and I would arrive in the same place at the same time. This was the seventies, and I ran a terrarium supply business—digging up moss and selling it to a flower shop in town. The land was my office, my factory, and beneath the shade of endless leaves, spade and shoe box in hand, I would go to work.

In Nashville we have a Tiffany's now, a J. Crew, countless Starbucks. But drive out to Ashland City sometime. Go down River Road to what used to be Tanglewood Farm and I can promise you that not one thing has changed, except that maybe by now the house has rotted away, and the roots under all those trees have dug themselves down another twenty feet or so. Every year the country grows thicker. Every year it inches closer to town.

Tennessee, with its subtropical summers and mild winters, has a perfect climate for almost any sort of plant. The non-natives thrive alongside the natives. The kudzu vine arrived from Japan in the late 1800s as part of a poorly thought-out plan to help slow soil erosion. It has since spread an impenetrable web over the South, draping fields, billboards, barns, and forests. If left unchecked—not that anyone has had much luck keeping it in check—it would take out the interstate system. Kudzu exploded, but then Tennessee excels in the explosive

growth of plant life. "Think of those plants in the California deserts," a botanist friend said to me, and I picture the succulents and flowering cacti that thinly dot the vast stretches of sand. "Those are the plants that can't compete."

Tennessee's plants are so competitive that every day is a slugfest: a deciduous tree blocks the light to a shrub, a tendril reaches from beneath the shrub to pull down the tree, insects bore into bark, birds fill out the branches, worms as blind as Homer chew through the soil, crunching the fallen leaves into a thick layer of duff that coats the forest floor. Among the hale and hearty, one of the uncontested kings in the Volunteer State is poison ivy. It sweeps over everything and we leave it alone. We're supposed to leave it alone. The counselors at Camp Sycamore Hills for Girls, not fifteen miles from the farm where we lived, made the point so clearly we could not possibly claim to have misunderstood. "This is poison ivy," they said, during a long, hot hike at the start of my second week of camp. They pointed to what seemed to be an entire field. "*Leaves of three, let it be*. Do not go near it."

Lee Ann Hunter and I talked it over that night in our tent with all the balanced consideration of eleven-year-olds. We had heard about the plant but had never seen it in action. We felt certain we could ride those three leaves out of our miserable tents and back into our own beds. The next night after dinner we took a detour through the forest, back to the very field we had been warned against. Like virgins to a volcano, we threw ourselves in. We rolled in it. We picked it. We rubbed it in our hair and stuffed it in our shirts and ground it into our eyes. Reader, we ate it. What was so bad about camp? It was boring? We didn't like the food? Some other girl got the better bunk? I don't remember that part of the story. All I know is that we turned to a plant as Juliet had turned to a plant before us: to transport ourselves out of a difficult situation and into a happier one. Like Juliet, we miscalculated the details. I can't say the hospital was a better place to spend the summer, but we were out of Sycamore.

Plant life, like all life, is the subject of constant revision: one tree is hit by lightning, another is upended in a storm. I remember our Dutch elm succumbing to the blight that wiped out its kind and it seemed like the vacancy it left behind was filled in a matter of minutes. Even if this endless expanse of green is composed of different constituents over time, the land still pumps out plants faster than anyone can count them. The plants, I believe, have shaped this state more than people ever have. When the success of a crop determines where people will live, then who's making the choice as to where we settle? The hundreds of little towns that lie between the cities have hardly changed at all in the years I've been driving through them. If a silver oak grew up in the space that the Dutch elm left behind, then maybe a tanning salon took the place of a beauty shop, or a hamburger joint became a pizza shack, but as in the forest, these changes are negligible. For the most part people are poor. The last truly revolutionary thing to come into their homes was electricity.

On one particularly scorching summer afternoon, coming home from a trip to Memphis, I decided to leave the interstate and take the two-lane highway down to Shiloh to see the famous Civil War battlefield. The insects joined together in such a high-pitched screed I could hear it over the air-conditioning and through the rolled-up windows of my car. The bugs and the plants and I were alone on that highway. I didn't pass another car for ten miles, and then for twenty. The millions of leaves on either side of the road were so dense and bright I could almost feel them growing. And then I saw a man standing in the middle of the road waving his arms in crosses above his head. He looked like he was trying to land a plane. I stopped my car. It must have been 110 degrees on the blacktop. Not to stop for him would have been to kill him.

There was a woman on the side of the road, leaning against their car. The man and the woman were in their seventies. When I rolled down my window the man held an artificial voice box against his

throat. "Ran-out-of-gas," the machine said. I told them to get in quick before they melted; I would drive them to the station and bring them back.

But the woman didn't want to go. They both got car sick and neither one of them could ride in the back. My car was small. "I'll stay here," she said. "I'll be fine. There's plenty of shade."

So I drove the man fifteen miles to the gas station while he told me the unbearably sad story of his life in the flat monotone of electric speech. Cancer of the larynx. Once he was sick, his wife left him and took the kids. He got laid off from the factory. He had to go back to the country where he'd grown up, see if he could farm some on the land his father had owned. Hard times. This new wife was nice, though, that was a plus. At the end of every couple of sentences he'd thank me, and I had to tell him to stop. He told me I could drop him off at the station and he would hitch a ride back, but we didn't see another car the whole way there.

"I can take you back," I said. "I'm just out driving around. I don't have anyplace I have to be." It sounded suspicious, but it was the truth.

I waited with him at the station even though he kept trying to shoo me off. He thought there was going to be a car heading back in his direction but no one came; after a while there was no choice but to relent. He said he would take the ride only if I let him pay me. We argued politely about this. I reminded him that were the roles reversed—and they could be reversed—he would never take money from me. Reluctantly, he raised the voice box to his throat and agreed with that. I drove him back to where his new wife was waiting. Just as it was over and we had said our goodbyes, he leaned back in through the open window of my car and put five dollars on the passenger seat, then turned quickly away. It broke my heart in a way that was all out of proportion to the greater sadnesses of life.

It was lonely out there on the road after he was gone, lonely when

I pulled into Shiloh an hour before the park closed. More than ten thousand men from the Union and Confederate armies had died here in April of 1862. It took very little imagination to see this place the way it would have been that spring, dogwoods and cherry trees and apple trees all blooming in the mighty undergrowth, the energy it would have taken the men to fight their way through the trees in order to come to some sort of opening where they surely would be shot. The Union dead are buried on a hill with a view to the Tennessee River. It is a lovely spot, with a cool breeze coming off the water. There is a small white marker on every grave. Outside the gates of the cemetery is a copy of the Gettysburg Address on a metal plaque. The Confederates are buried in a mass grave that lies at the bottom of the hill, but they at least are all together, and they are home. I did not pass another soul in the park save the ranger at the gate. He asked me to leave when it was dark.

If anybody tells you Tennessee has changed much, tell them to come out to Shiloh. Tell them to listen hard to the stories of the men you pick up on the road on your way there.

Had I grown up in the city, I might feel the loss of my early life. I might look at one building and wish for the happier day when it had been something else. But I grew up in Tennessee, by which I mean the country, and out there everything stays exactly as I remember it. The plants are the enforcers, they keep it this way. The only story they're interested in is their own.

(from *State by State: A Panoramic Portrait of America*, 2008 [Ecco])

On Responsibility

·

I AM NOT RESPONSIBLE for much. I do not have children who have to get to school on time and wear matching shoes and be taught the difference between right and wrong. I do not have a job in which the well-being of a company or the safety of the nation or the health of anyone at all is resting on my shoulders. I have a couple of plants I must remember to water. I make a point of paying my taxes on time. I take care of myself, but that's not worth mentioning. I pitch in and help other people when I can, but they are people who could find the same help elsewhere if I went on vacation. When I think of whom I am responsible for, truly responsible for, I can whittle the list down to my dog and my grandmother, and it just so happens that last week they were both sick.

Rose is white with ginger ears and an extremely alert tail. She weighs seventeen pounds even though she should probably weigh sixteen. She had some angry-looking lesions on her pink belly that made me take her to the vet two months ago. I gave her the prescribed antibiotics wrapped in cream cheese or peanut butter, depending on

what was around. But the inflammation lingered and then flared, exacerbated by Rose's very focused licking, and I decided we should go back and try again. I had heard there was a dog dermatologist in town with a three-month waiting list, but thought it best to give my regular vet another try. I'm quite certain I wouldn't go to a dermatologist if I had pimples on my stomach, and so I didn't see why I should make my dog go either.

My grandmother is ninety-four, a mere thirteen in dog years. She lives in an assisted-living facility three miles from my house and four blocks from my vet. Sometimes I take her with us to the vet, even though it is a lot to navigate a scared dog and a mostly blind, very confused grandmother into the waiting room. Still, she likes the excitement of the barking, snuffling dogs, and the chance to comfort Rose, who inevitably trembles with her head pressed beneath my grandmother's arm. Rose doesn't like the vet, which would be a point too obvious to include were it not for the fact that my mother's cat worships his trips to the doctor. They are his fifteen minutes of fame. He purrs for hours after coming home at the mere thought of having received so much attention.

"It's okay," my grandmother told Rose last week, and rubbed her ears. "Nobody's going to eat you."

But Rose, for all her incalculable wisdom, was still a dog, and we could not reassure her that something really hideous wasn't about to happen. Maybe she did think that, behind the door of examination room number three, an enormous, drooling animal was waiting to chew her up. She vibrated with fear, tucking her head down and her hindquarters in until she was the size of a grapefruit. How could I explain that this was all for the good, that I would never leave her here, that I would protect her with the same ferocity with which she protects me from the UPS truck? We have such a language between us, Rose and I, but in this case it failed us and all I could do was pet and pet.

My grandmother had told me that her leg had been sore all week. There was a bruise behind her knee, a funny place for a bump, and so my mother and I had kept an eye on it. As soon as my mother flew off for her vacation, I received a phone call from the assisted-living nurse. My grandmother needed to go to the doctor, immediately.

"Are we going to your house?" my grandmother said, once I had wrestled her and her suddenly useless, painful leg into my car.

"We're going to the hospital," I told her. "The doctor needs to see your leg."

"My leg is fine," she said.

"It's fine because you're sitting down. Do you remember it hurting before?"

"My leg doesn't hurt," she said.

Her leg was blowing up like a summer storm, dark as an eggplant now behind her knee and getting green in the front. Her skin felt tight and hot. How did it get so bad so fast? After the examination, the doctor said her blood was too thin. She'd had a bleed into her leg, which was better than a clot, and was admitted to the hospital.

If twenty minutes in the vet's office could turn my bounding, snarling terrier mutt into a cowering grapefruit, three days in the hospital would cast my sweetly confused grandmother down into the lowest circles of dementia.

"Where are we?" she asked.

"In the hospital."

"Are you sick?"

"No," I said, leaning over to lightly tap her leg. "You have a sore leg."

"I've been here before."

"A long time ago."

"There weren't all these pots and pans then," she said. "Not so many red squirrels."

"That's true," I said.

"Where are we now?"

"Still in the hospital."

"Do you feel sick?"

And so we went on in our circle, hour after hour. We had stepped outside of the routine we knew and found ourselves in a place where language was utterly useless. Still, we could not stop talking, the same way I talk to Rose while we wait for the vet. "It's okay. I'm right here. You're a beautiful dog. There was never such a good and beautiful dog as you," I whisper to her over and over again while I pet.

I could not call Rose and tell her I was at the hospital, and I could not leave. I had already found out that IVs could be pulled out much quicker than they could be put back in. Every five minutes my grand-mother swung her feet to the floor. "Let's go now."

I picked them up and put them back in her bed. "You aren't sup-posed to walk."

"Where are we?" she asked.

Is it wrong to tell a story about your grandmother and your dog in which their characters become interchangeable? My sense of protec-tiveness for the two of them is fierce. They love me, and because their love is all they have to give, it seems especially pure. I love them too, but my love manifests itself in food, medical care, rides in the car, grooming. On Tuesdays I bring my grandmother to my house and give her lunch, and she always claims to be too full to finish her sandwich so that she can give half of it to Rose, who does not get sandwiches at other times, especially not straight from the table. I look the other way when my grandmother whispers to my dog, "Don't worry. She doesn't see us." My grandmother longs to have the ability to spoil someone again. My dog is the one mammal left who is unconditionally thrilled by her company. I wash my grandmother's hair in the kitchen sink after the dishes are done and Rose sits in her lap while I blow it dry and pin it up in a twist. Sometimes, when I've finished with my grand-

mother's hair, I'll wash Rose in the sink and use the same damp towel to rub her dry. Then they lie down on the couch together and fall asleep, exhausted by so much cleanliness.

Back in the hospital, I covered my grandmother up with a white blanket.

"Your little dog sure did give me the cold shoulder," she said, her voice full of hurt.

"What?"

"She didn't even come over and say hello."

"Rose isn't here," I told her. "We're in the hospital."

My grandmother's eyes moved slowly from the window to the door, then back again. "Oh," she said, glad to know she was wrong. She took the white blanket up in her hands.

Three days later, my grandmother went home, her leg still sore but stable. I tell her she was in the hospital, but she doesn't believe me.

Rose, on the other hand, remembers her antibiotics. After dinner she sits in front of the counter where the bottle is kept, wagging her tail. She thinks only of the cream cheese, not the medicine, because she knows that part of it is my responsibility.

(*The Bark*, Winter 2003)

The Wall

It is May 1992, a month after the Rodney King riots, and on the television, Ted Koppel is picking his way through the wreckage of South Central Los Angeles. Twenty miles away in Glendale, my father and I are in the den of my father's house, watching, drinking gin and tonics. As Koppel speaks, my father explains. My father knows these people—not the reporters, but the ones being discussed. He knows some better than others. Most of the young ones he's never met, but he knows their type, and he knows how their type thinks. My father worked for the Los Angeles Police Department for thirty-two years, retiring in 1990 at the level of Captain Three. That was a year before Rodney King was beaten by a group of Los Angeles police officers, before the videotape was shown, before the officers were acquitted after a lengthy trial and sections of Los Angeles went up in flames.

As Police Chief Daryl Gates comes on the screen, my father nods at the television. "There's a guy who wouldn't listen to anybody, never wanted to take anyone's advice. He did a lot of great things for this city and he made a lot of mistakes, but all that's gone now. Now he'll only be remembered for one thing."

I look at my father, who looks at the television, and think that it isn't just Gates. My father will be remembered for this one thing as well, even though it happened after he was gone, even though he was a good cop and very possibly a great cop who came up in the better days of Chief Parker and *Dragnet*. My father was still a man who had put in thirty-two years with the police department in Los Angeles, which at the time had meant he was courageous and devoted to serving his city, and which now meant he was a racist thug.

When I was growing up there was no place better than the Police Academy, the stone stairs and red tile roof, the long blue swimming pool stretching out beneath the shade of eucalyptus trees. The Academy is carved into a hillside above Elysian Park. I liked to imagine my father there, years before I was born, young and handsome and running up all those countless stairs to class. We went to the Police Academy for lunch whenever I was in town. It was the first place I wanted to go. I loved the pictures of Jack Webb in the display case across from the cash register in the coffee shop, and I loved the cadets in their navy-blue sweatshirts, eating salads at the counter (salads, my father would tell me, because anything else comes right back up when they had to run twelve miles in the heat of the afternoon). We had tuna melts and french fries and malts. Mostly, I loved all the cops who stopped by our table throughout the meal to pay their respects to my father. For the most part they called him Captain Patchett. A few called him Cap, and fewer still, his equals, called him by his given name. After each one left, my father would tell me his or her story, how this one had just passed his lieutenant's exam, how the next had done such a brilliant job in juvenile. He would tell me about the cases they had worked on, the risks they had taken, the crimes they had solved. The men and women who came to our table were funny and smart, occasionally dashing. I'm sure this lunchroom exposure was far from fully representative of the entire police department. Maybe the

bad ones stayed away from our table, or maybe my father chose not to recount their failings to me. Still, my view of the institution was shaped by my own privileged vantage point, and based on what I saw, I grew up believing that police officers were hardworking and brave, people like my father.

This episode of *Nightline* would prove to be a blockbuster for ratings. I was hardly the only one ruminating on Los Angeles and its police force at the time. They held a special place in the collective imagination of the country. There is as much comfort in knowing what to hate as there is in knowing what to love, and that summer the LAPD was reviled. Gone were the days when we knew the police from *Dragnet* and *Adam-12*. Now we knew them from a minute of videotape that played in a continuous loop on the nightly news.

Just a month ago I had gone into a Baskin-Robbins wearing an old LAPD T-shirt. This was in Tennessee. I had been out for a run, and I hadn't thought about what I was wearing, but the young Caucasian man behind the counter said he wasn't so interested in giving me my ice cream. Then he asked me, loudly, if I was a member of the Klan. It was a hot night and the store was crowded and everybody turned to stare at me. I left without ice cream, and ran a little faster on the way home, no doubt giving the man behind the counter the chance to feel he had stood up for what was right. I had seen the videotape. I possessed a full understanding of bad police officers. But my failure to speak up in Baskin-Robbins (and what would I have said, anyway?) felt like a failure to defend my father.

My father, he would be the first to tell you, does not need defending. He was the third of seven children, and the first of those seven to be born in this country after his parents immigrated from England, the first to be born in Los Angeles. The neighborhood where he grew up near MacArthur Park was crowded and Catholic and poor, and the priests and the cops were local heroes. As a young man my father had

briefly experimented with the seminary and soon discovered its disadvantages. He then turned to the police. In the years that followed, my father drove a squad car and a drunk wagon. He was Chief Parker's bodyguard. He was a detective, worked in narcotics, and ran Internal Affairs. He headed several divisions, including Newton in South Central, which is not a job to want. He made the connection between the Tate and the LaBianca murders, and went into the desert for Charles Manson. He picked up Sirhan Sirhan the night Bobby Kennedy was shot and worked the investigation that followed. He served his city, and attended the funerals of friends who had also served their city. The videotape that ran on the evening news told a true story, but it was not the only story.

And yet despite the rage of a nation against a police force, the Los Angeles Police Academy remained the most competitive in the country. People are still lining up to get in. I have always understood why my father had wanted to be a policeman in Los Angeles, but in the present climate I am mystified as to why anyone would want the job now. It wouldn't be just the people in your own city who would hate you. People in New York and Chicago—homes to notoriously corrupt police departments—would hate you as well. To embark on a career that was both thankless and dangerous does not seem worth the promise of a pension.

This, I think to myself in a snap of revelation, is a great idea for a book. It would be my first book-length work of nonfiction. I'm one gin and tonic down. Ted Koppel is still talking as I begin to outline my idea to my father. I'm making it up as I go.

"You want to be a cop?" my father asks me.

"Not at all," I say.

"But you want to try out, take the test?"

That he sounds pleased is something of a surprise to me. I tell him yes, I want to take the test, I want to go through the Police Academy, I want to write about it. I am interested in the job these people want,

but I am also interested in the job my father had. I am interested in my father, whom I am very close to, but have seen remarkably little of in my life.

At the end of my visit with my father I go back to Cambridge, where I am on a fellowship at the Bunting Institute at Radcliffe College. While Harvard students spend their days in class and their nights in the library, I begin my own course of study. My objective is to find something stronger and sterner in my body than was there before. I swim in the Blodgett pool until I think I'll sink, and then I run along the Charles River. I come to know the distance between the bridges. I nod briskly at the people I pass at the same time every day. People warn me about running. They tell me to avoid hours that are excessively early or late, to stay away from any path not filled with other runners, but their advice means nothing to me. I am just beginning to see the thing I should be afraid of, which is trying out for the Los Angeles Police Academy.

Studying, which once meant the memorization of battle dates and the order of presidents, now means clearing a six-foot wall. The big sticking point for getting into the Police Academy, especially for women, is the wall, and so I begin to hunt up practice walls around Cambridge, a low one to start. I pick the wall outside the Cambridge Public Library. It is a sunny weekend and, from across the street, I wait for the traffic to clear and then take a flying run at it. It's not a natural thing, jumping over a wall, and more often than not I smack straight into it. My hands bleed. My legs and arms bruise. A small crowd of interested onlookers assembles and moans at my failures until, finally, I give up. I want what anyone would want when trying to learn how to scale something, which is privacy, but I don't know of any six-foot walls in Boston built in the middle of a lonely field. The best wall I can find, the height of which I measure with my hand above my five-feet-seven-inch self, surrounds the Harvard Divinity

School. I go there late at night, earnestly fiddling with my Walkman until the strolling couples and dog walkers have passed, and then I run as fast as the narrow street allows and I hit it in a jump, my fingers curling around the rough edges. I pull and pull up until, amazingly, I am on the top. I sit for a minute and look down at the gardens on the other side and think about my father at twenty-five, out of the Navy and working in a liquor store, wanting nothing more than to get a good job as a cop in Los Angeles. I am thirty.

My self-directed course in wall jumping soon becomes second nature. Once I've learned how to jump over walls I can do it in a skirt. I impress friends with my cool new trick. Having mastered what is considered the biggest obstacle, I progress to grip strength, because hanging from a bar is another part of the test. Like an inverted bat, I hang as motionless as possible from jungle gyms in children's playgrounds and watch the tendons pop inside my wrists. A strong grip should one day translate into my ability to shoot a gun. I buy a set of grip strengtheners, two plastic handles on a tight metal coil, and I keep them on my desk and squeeze and squeeze. The high squeak they make, like springs in an ancient, painful mattress, remind me of staying with my father for that one week every summer. My sister and I would know that he was awake when we heard the skreich of the grips that he kept on his bedside table. We would go into the back porch room where, in the early years after our parents' divorce, my father slept in his father's house. He would sit on the edge of his made-up bed, wearing a white T-shirt and sweatpants, crunching his hands in a steady rhythm until I can see the strain in his arms. The squeak of the coils in my own room in Cambridge makes me miss him.

"Don't be fooled," my father tells me long distance. "The springs on those things wear out fast. You should buy a new set every couple of weeks."

"They're killing me just the way they are," I say, though this is not

the point I have called to make. It is the memory I want to talk about, not my grip.

"You think you're getting stronger, but it's just that the coils have broken in. Squeeze a quarter between the handles and hold it for sixty seconds," he says. "That's what makes the difference."

And I do, or I try to. I try to hold the coin in place while I stare at my watch but my hands start to shake and I have to let go.

When it's time to go back to California for the test, my father wants me to come out early. This has always been the case. Any trip west should start sooner and last longer. He says he can drill me for the oral exam, but what he really wants to do is to watch me run. The morning after I arrive, we walk over to Glendale Community College and I run laps on the track while my father stands at the grassy edge looking at his watch. "Fifteen seconds," he yells at me when I pass, which is how much time he wants to see come off the next lap. Fifteen seconds is a lifetime, and I reach down deep within myself to give it up. My father has at different times in his life been proud of me, but this morning he is thrilled with me. While I kick my heels up towards my back and cut past the other runners, my father, looking at me and his watch in equal measure, is a policeman, and I am the best cadet in his class. He shouts for me to sprint—*sprint!*—the last hundred yards, and I rip holes in the soft dirt. "Jesus, Ann," he says when I stop. He comes to me and hugs my shoulders hard while I pant. "You're going to kill them."

I am no great athlete, but at this point in my life I am a very good student. This is the test and I have been studying for months.

My father wants to go to the Police Academy to see me jump the wall. When we arrive, we find the practice wall occupied by a group of women in matching sweatshirts, their last names printed large across their backs. They are in a special training class for their physical abilities test. An officer with a whistle hanging around his neck barks at them encouragingly. He tells them how to get over the wall

and then proceeds to demonstrate. Television notwithstanding, I have never actually seen a person jump over a wall, and he does it in a way that has never occurred to me, grabbing on to the top with his hands while one foot is up near his chest. He then kicks over rather than pulling up. My father tells me to get in the line with the sweatshirted group, but I hang back, suddenly self-conscious. Even with such clear instruction, many of the women flounder and fall in their attempts to get over. I wait until they are dismissed before I go and try. Now that I am relying on physics and not just upper-body strength, I jump over again and again without even having to run.

In the evening, we sit in the backyard of my father and stepmother's house, a house I lived in briefly when it had been my mother and father's house. (For years after my parents' divorce, my father rented the house out, and then moved back in again when he remarried.) I can never remember my father being as happy with me as he is on this night. I ask him to tell me things: Who was his favorite partner? What was the best case he ever had? We talk about police work until it's dark and my stepmother, Jerri, gets tired and goes inside.

"You really are going to need to stay on for a year," my father says. "If you're going to get a feel for the thing. You need to give it that much time."

I tell him I am not going to be a cop. I want to write about it. I'm a writer.

He thinks about this for a minute. "If you stayed on for two, then you could go right in the FBI. Now that," he says, looking off past the lemon tree growing by the driveway, "that would be a hell of a book."

My father has arranged for me to go on a ride-along during my stay. Why cops would allow a total stranger to sit in the back of their squad car and ask questions when they're trying to work is beyond me, but it's not an uncommon practice in Los Angeles, where directors are always looking for ideas and actors are trying to hone an authentic edge. My ride-along is with Sergeant John Paige and Officer Ray

Mendoza of Newton, the station where my father had been commander years before. When my father tells me about these plans, I thank him. It sounds like a good idea. But as we're driving over, out of Glendale and into a part of Los Angeles I do not know how to find my way out of, I am more than a little nervous. When I tell my father this he says he doesn't understand. Why would I be nervous about spending an evening in the place he had worked for years?

My father wasn't pleased when I left the house wearing jeans, a white shirt (linen, buttoned all the way with a T-shirt underneath), and running shoes. He wanted me to look nicer. My father and Jerri are going to a cousin's wedding and they're dressed for it. At the front desk they turn me over to Sergeant Paige, who's wearing blues and a tattoo on his forearm. He is maybe fifty, gray hair, neat mustache. There's very little conversation at the handoff; my parents are in a rush to beat the traffic. I follow Sergeant Paige down the hall and along the way a few introductions are made. "She's Frank Patchett's kid. You remember Captain Patchett." "Jesus, yes, how is your dad?" Sergeant Paige has some paperwork to do before we go, including some forms that I must sign in order to relieve the City of Los Angeles of her responsibility to me this evening. Sergeant Paige suggests that I should go amuse myself, look around, make some friends.

Newton Station is near South Central Avenue on Fourteenth Street, a mile or two south of downtown Los Angeles. Its area of service covers approximately nine square miles and includes South Park and the Pueblo Del Rio public housing development. Inside, big bald spots break up the green indoor-outdoor carpet. The desks are in rows so close together that it requires some real maneuvering to squeeze past the chairs. I am told that what I'm looking at now represents an improvement. For a while, the desks were so tightly packed that two officers sitting back to back could not pull out their chairs to stand at the same time. This arrangement was eventually deemed a fire hazard, but even now the entire place strikes me as a fire hazard.

Cardboard file boxes are stacked along the wall to towering heights; above them there are a few dark windows too high up to see out of. The little bit of available wall space is covered in men's ties. It's a rite of passage to cut the ties off of the guys who make detective, guys who are promoted out of Newton Station, and tack them to the wall. A thin young black man in a thin red T-shirt, his hands cuffed behind his back, sits on the floor and waits. He answers the occasional question from the officer typing his report. He's polite about moving his feet to let me by.

There are only two holding cells in the Newton station. The lack of cell space is a problem solved by a long wooden bench, weathered and worn into something that could be sold in an antique shop in Colonial Williamsburg. That bench, which is located in a back hallway that leads out to the parking lot, is bolted to the floor, and a dozen pairs of handcuffs are bolted to it. Three men and two women, all black, are now physically attached to the bench. The bench itself wasn't attached to the floor until a few years ago, when a man who was cuffed to it walked out the door, dragging the bench with him. The cast of characters on the bench changes as I go down that hall several times over the course of the evening, and to a one they seem bored. The utter lack of emotion coming from all parties involved is strangely soothing.

Above every desk is a shelf pressed full of plastic three-ring binders. This is where they keep the dead people. Under the glass on one desk is a five-by-seven index card with a picture of an Ishmael Martinez, whose date of death came a few days past his fifteenth birthday. His face is thin and boyish, and although he is trying to look menacing for the camera, he does not succeed. The card includes his date of birth and home address, with *KIA* scrawled in thick red marker. I ask the officer at the desk about him and he seems glad to tell the story: four kids steal a car. During pursuit, the kids hit a light post. Two die on impact. Ishmael's arm is torn off and he's dead a couple hours later.

The fourth survives and will go on to operate a wheelchair with his tongue.

What I want to ask, but what I don't ask, is why his picture is under the glass on the desk.

After the completion of paperwork, Sergeant Paige and I leave for an early dinner with Officer Ray Mendoza, who is thirty-four and missing half a finger. We take an unmarked car and go for Mexican food. The day is still bright and not too hot. The restaurant isn't busy and the people who work there, who know Paige and Mendoza, are happy to see us. The woman with the menus gives us a deluxe booth big enough for a family of eight.

Paige wants to know if I'm thinking about coming on the job, joining the LAPD, and I tell him no, I just want to look around. They're fine with that. They ask what I do, and I tell them I'm a writer. "You should write a book about cops!" Paige says. Mendoza is quiet while Paige rattles on about how the job has changed. He says my father is one of the few who got out without being really screwed up. "The job didn't ruin him the way it does most guys," he says, piling salsa onto a tortilla chip. I wonder to myself if Paige is ruined. "Your dad was of the golden age," he says. "When this job meant something."

The waitress speaks to Mendoza in Spanish and he answers her in English. This will happen all night.

Officer Mendoza has been back on the job for four days, after having been out for nine months. He was ambushed in his police car and shot four times, not far from where we are eating. I know for sure he was shot in the hand and the knee. I don't ask him about the other two bullets. I ask him why he'd come back to work after that, but he seems not to understand.

"You can get a pension if you're traumatized," Paige interjects, and then points to his partner across the wide expanse of booth. "Mendoza here wasn't traumatized."

"I wish I was," Mendoza says. "I wish I could tell you I had bad

dreams or was afraid to go out, but I'm not. I'm a cop." He shrugs. "This is all part of it. There's a good chance that somebody is going to shoot you."

What upsets him though, the thing that might keep him from making it all the way to his pension, is working for an organization that would rather see a cop killed than a cop kill somebody. "It's cheaper for a cop to get killed," he says.

"Management," they say in unison, and not with a trace of goodwill.

"Williams?" I ask.

"Fat Willie," Paige says, just as my father would say. Willie Williams replaced Daryl Gates as the chief of police. He was considered by most to be a public relations gift to the city. "He didn't say a single word during the union negotiations. Nothing one way or the other. He isn't even a real cop. He's a management puppet, spending his time in Philly. He's not even legal to carry a gun in California. Chief of police, no gun." The idea being that while there are plenty of people to accuse the police, there is no one around to defend them.

Plates are put before us, shocking quantities of food that could feed as many people as this huge booth could hold. Paige says people don't want to know what cops do. They want it done and they don't want to hear about it. "We're hired guns, essentially," he says, cutting into his enchiladas with real enthusiasm. "That waitress," he says kindly to Mendoza, "doesn't she have beautiful eyes?"

Paige says people want them to be social workers, to reach out to the community, but that's not their job. Their job is to get the bad guys. This phrase—*bad guys*—will come up again. "If they want us to be social workers, fine, but don't tell us how to do it. Look the other way while we change the world for these kids."

My father was that guy, the social worker—forever starting up after-school programs, encouraging kids to volunteer at the police station. At Thanksgiving, he had cops drive food baskets to families in

the neighborhoods. At Christmas, he sent around toys, always in the black-and-whites to let people know who the good guys in the neighborhood were. Good guys, bad guys.

Paige owns property in Nevada and will retire in three years. The property, he tells me, is not too far from a Nordstrom. "My wife," he says, "couldn't go more than a week without shopping."

"We all want our patch of green grass," Mendoza says, though his will have to be in L.A. He was born here, he tells me pointedly, and his family is here. He doesn't know anything else, and doesn't have anyplace else to go.

My father has instructed me to pay for dinner, and they are happy to let me since the total bill comes to five dollars. I leave the rest of the money for the waitress with the beautiful eyes.

In the car, the two men never stop talking, joking, providing a running commentary on the world around them. (Paige's comments are often directed out the window.) The radio emits a constant stream of information. Even though Paige is behind the wheel, they share the driving equally, with Mendoza giving traffic updates: "Coming up on your left. Slow down a little. The light is yellow. Watch the car pulling out." It is exactly the way my father talks to me or whoever else happens to be driving. It is a consequence of the job. Paige and Mendoza ask me questions about myself, and in return I ask them questions about Newton. Fifty-five gangs have been counted in their nine square miles.

An ice cream truck goes by, tinkling out "It's a Small World." The houses are mostly neat. Many are owned rather than rented. It is Saturday, and the neighborhood's front yards are rife with weddings and presentation parties—*quinceañeras*. Little girls in pale green polyester taffeta swoop down the sidewalks like tropical birds. Men cluster in front of the garages, drinking beer. They watch us. The cops stare and the people stare and no one cares or is afraid or turns their eyes away. The high school girls in their bright purple crinoline

stare at me, the white girl in the backseat of the cop car, and wonder what I've done.

There are striking numbers of both children and dogs in South Central. Pregnant dogs. Dogs of all sizes with pendulous teats waddle slowly past. Young girls walk down the sidewalks with babies in their arms and young children hanging on their backs. A mother on her way to the laundromat is trailed by five children in a straight line, each carrying exactly the amount of laundry stuffed into pillowcases that he or she is capable of, a toddler bringing up the rear with the box of detergent. The air smells of eucalyptus.

We drive past the site of the 1974 shoot-out between the LAPD and the Symbionese Liberation Army. All that remains is an empty lot. *House, house, house, house, empty lot, house, house.* Two streets later we see a framed-out house with a pit bull on the second story, though I can't see any stairs. We go to Winchell's for coffee, forgoing the doughnuts, which Paige refers to as "fat pills." The coffee is awful and I drink it.

The radio spits out a constant river of information, unintelligible words and squawks that Paige and Mendoza ignore, until suddenly something is for us and we are speeding towards a set of bungalows. I have no idea what has happened or is about to happen. I imagine they'll tell me to stay in the car, but to my great surprise they tell me to come with them. I'm wondering if I should have actually read the hold-harmless forms I signed back at the station. Because they leave the doors open, I bring my purse, which is overlarge and full of note-books. Mendoza tells me to stay with him and I do. Guns are drawn. After they check out a one-room bungalow, Paige tells me to go inside. Two solid inches of broken glass blanket the floor beneath a naked plastic baby doll. That's it. Other officers materialize, though nothing is happening. We talk for a while and then head to our cars as if we've come to the end of a picnic.

The nonevent of this first call has somehow changed the chem-

istry of the evening. Once we are driving again, Paige and Mendoza start looking for trouble hard. They slow for every group of young men and stare them down. "How you boys doing tonight? Are you getting into any trouble?" The cops, like the boys, are restless. They seem to want to find the very danger they are warning against. A thin boy, who could not be more than thirteen, with a spray of gang tags tattooed across his wiry stomach, aims his finger at us as we drive by.

When the next call comes, we speed into a park and drive directly through a softball game while the game continues around us. People make small allowances for the police car, but they do not stop or look or care. Several other officers are on the scene but there is no disturbance, only the crack of the bat and the cheering that follows.

At dusk we see a man running past a McDonald's. Paige and Mendoza are both out of the car, but after four steps, Mendoza limps back. "I got shot in the knees," he tells me, as if he's only just remembered this. "Can't run."

Paige tackles the Latino man after half a block of chase and cuffs him. I watch it like television. A black-and-white is there instantly and takes the man from us. Back at McDonald's, we're told there was a hit and run. There is a magazine of bullets in the car that was left behind, and so everyone is convinced a gun must have been thrown into the bushes near the drive-through. We begin to stamp around in the bushes, and I secretly hope to be the one to find the gun and so make my uselessness useful. Despite all the action in the parking lot— police and police cars and a man in handcuffs—the drive-through business stays brisk. Mendoza tells me he's seen bodies with tape outlines lying out on the asphalt, and it still didn't slow.

Witnesses materialize from nowhere. Latino men tell the officers a black man in a striped shirt took the gun. The one who does the most talking continually pulls up his shirt to his neck and strokes his round stomach. We drive around until we find a black man in a

striped shirt. Paige and Mendoza separate him from his two older companions.

"He's been with us all night," the older men say.

"Sure," the cops say.

"Put your hands over your head," Mendoza says.

"Why do I got to put my hands up?" the man asks.

Mendoza's voice is light and firm. He does not threaten so much as edify. "Because I said so."

As quickly as the man is cuffed he is released, and then we are driving again. It is dark now, and the people who stare are no longer people I can exactly see. When we finally return to the station, six hours after we left, there is a new crew of men and women handcuffed to the bench. Paige, who seems disappointed that my ridealong was so quiet, starts pulling down the binders over his desk to show me pictures of dead young men. I know that every binder that winds around this building contains more of the same. Polaroids. The gun fired so close to the face that it scorched the skin. A bullet in an ear. Countless pictures of bodies face down in pools of blood. Paige tells me about a mother who killed her kids by putting them in big garbage cans and pouring cement over them. She beat them first, but didn't kill them. "I mean," he says, "of course they died. Ten kids." He shows me a filing cabinet with miniature drawers like a library card catalogue, each drawer crammed with cards like Ishmael's. Every person on every card is dead.

At home that night, I go over the details with my father, who wants to hear all of it. He likes Paige and Mendoza. He owes them one now for taking care of me. When I tell him the story about looking for the gun at McDonald's, he nods. "But you can't write about that," he says.

"The point is to write about it," I say.

"Some of it," my father says. "Not all of it."

I have no idea why it would have been wrong to look for the gun at McDonald's.

I want to write about the police in Los Angeles. I want to tell a story about people who do hard work. I want to explain that living beneath the weight of all those three-ring binders filled to capacity with the neighborhood dead takes a toll after a while, that being the one to discover the children entombed in cement wears you down. I have no intention of exposing anyone. It had been my intention to show what's good. But good, like police, turns out to be complicated.

First there is a written test. Even though my father has given me directions a dozen times on how to drive to the Police Academy from the house, on the morning of the test he changes his mind; he wants to drive me over and pick me up. He says it's the only way he can participate, and I say fine. This is, I believe, something we are doing together. When we arrive at the Academy at 7:40 for the 8:00 a.m. test, a line of people is snaking all the way down the driveway. For that minute I remember that I don't actually want to be a cop. A van pulls up beside us. The man who gets out leans back in to shake hands with someone inside. *Way to go. Good luck.* My father, who has not taken me to school since I was in the early weeks of first grade, kisses me and drives away.

In line, I am given a blue card on which to write my name, address, and where I heard about the LAPD. I print my father's name. I also get handouts about career opportunities and how the order of tests will progress. An attractive black woman wanders back and forth through the line, repeating over and over again in a loud voice that we *must* have a picture ID and be at *least* twenty and one-half years old as of today. A few people peel away from the group and slink back towards their cars. Most of the nearly two hundred people in line look like they've barely scraped in under the wire for age. Logo T-shirts are the order of the day: *House of Pizza, Nirvana, Toad's Gym* (a drawing of an especially well-developed, slightly menacing toad). It's a shorts-and-running-shoes crowd. Everyone wears sunglasses and is polite

about sharing pencils. Less than ten percent of us are women, and less than ten percent, I would guess, are older than twenty-five. At eight o'clock on the nose, three white girls click-run across the parking lot—high heels, ruffled miniskirts, Lycra tank tops, and shoulder-skimming hoop earrings. Their big hair is long and full of loose, shiny curls. They have Natalie Wood's eyes, red lips, foundation makeup. The woman wrangling the line clucks at them, "You girls didn't want to get up too early now, did you?" They fill in their blue cards using each other's backs for desks. It occurs to me that this line wouldn't be a bad place to meet a certain type of guy.

I am far enough up in line to get a spot in the last row of the first classroom, which seats 102. It is a regular classroom with green chalkboards and rows of identical desks. There is a lot of information to cover. The test is being given by a black woman named Desrae from personnel. She has a certain movie-star quality with her high-heeled mules and chenille top. We are given a score sheet and told to fill in our name and then wait. Fill in our address and wait. We are not to get ahead of ourselves on any line. The last time I took a test, it was the Graduate Record Exam and it was ten years ago. Four number codes are printed on the chalkboard that correspond to our race and gender categories. We are to write down the one that applies to us on the top of our score sheet. The categories are: black males; Hispanic males; all other males; all females. Desrae goes over this three times as she walks down the aisles, her voice so lyrical and clear that I cannot imagine anyone's misunderstanding the instructions. Could we be nervous enough to mistake our gender? After we darken in the circles comprising our social security number, we wait while another personnel department member comes around and presses our thumbprint on our test sheet.

The young man in the desk next to mine looks at my driver's license. "Montana," he says. "Well, you've come a long way." I lived in Montana last year; I just never got around to getting a new license. It occurs to me I may have broken some law by not attending to this. I

tell him I live in Boston now, even farther away, and he tells me he lives in Mesa, Arizona, where he's a police officer.

"And you want to be a police officer here?" I ask him.

He shakes his head. He's from Los Angeles originally and his best friend wants to be LAPD but his friend couldn't pass the test here—or in Mesa for that matter, where, he informs me, they really need cops and are hiring like crazy. He wants to take the test just to prove to his friend that he can waltz into town and pass it without even wanting the job. He asks me what I do for a living now; I tell him I'm a writer.

"Oh," he says.

We stop talking for a minute, and then he leans over again. He wears his sunglasses on the back of his head, hooked behind his ears in the wrong direction. His hair has the bristly nap of freshly mown grass. "I got a commendation," he says. "For a report I wrote on a convenience-store robbery. Do you want to see it? I brought it along in case it would help."

I do want to see it. In his file he has his certificate of graduation from the Mesa Police Academy and a letter of commendation, as well as his well-written report. His name, I see, is Todd White. Todd White has the kind of round, cursive handwriting that was praised in sixth grade. I am just on the first page, barely into the description of what the suspects were wearing, when it's my turn for the thumbprint. I don't take enough ink and have to do it again. "Don't do it like they do on television," the woman with the ink pad tells me, "don't roll it side to side. It's straight down, top to bottom."

There is a slight, sick feeling that comes from giving up my thumb-print to the LAPD. I'm on file now. I'm in the machine forever.

We are told to put all materials under our desks, and there, sadly, goes Todd White's packet of letters. We are told to put away all dictionaries and grammar handbooks, all calculators, watch calculators, slide rules, and compasses. I could not pass any test in which a slide rule might help even if I owned one and were allowed to use it. The

test booklets are passed out, face down, along with pencils. We are told that if these numbered test booklets are removed from the room we will never be able to try out for the LAPD again. We have forty-five minutes, which should be plenty of time to finish. *Start. Go.*

The test includes four different ways to spell "calendar" and "attitude"; choose the correct spelling. Four different sentences, each saying the same thing in a slightly different way, in which we are to choose the most grammatical. Reading comprehension, in which none of the four answer options (choose the one that best describes the role of the police officer in a burglary) really describes what I've read. Vocabulary words: *incarcerate, felony, misdemeanor*. The test would be difficult for non-native speakers or anyone who slept through high school. I take my time and read everything twice. The proctor calls five minutes.

Once the test booklets are collected, we fill out anonymous questionnaires: *Where did we hear about the LAPD? What is our current income?* Then the out-of-towners are told to go to a separate room. As we gather up our things, Todd tells me that later, when they come in and call a list of names for people to meet in the hall, those are the people who failed the test, a detail that must have come from his friend who couldn't even make the cut in Mesa.

There are forty people in the out-of-town group. The out-of-towners are better-looking than the teeming masses from the test: We have not shown up on a dare after a night of drinking games. We have not shown up wearing questionable T-shirts. There are still fewer than ten percent women in the room. This session will be run by Officer Crane, a very slim black man with a mustache. His uniform is so tight I can make out his abdominal muscles. The sleeves ride his biceps like tourniquets.

"Everyone else has the chance to take a five-hour training class to pass the oral exam," he tells us. "You people don't have that advantage. So it's my job to tell you as much about the oral as I can in as short a

time as possible." He tells us that they will ask us why we want the job. "People will say, 'I want to protect and to serve.' 'I want a good career.' 'I want to serve my community and help people.' 'I want to be a part of number one.'" He stops to lift his chin and kiss the air. "Can you believe it? That's what everybody says. If you say this you'll get a high enough oral score to pass, but it won't be high enough to get in." (A score of 70 is passing, but rumor has it you need 95 to actually be considered for the Academy.) "What you have to tell them is how your being an L.A. police officer will benefit the community, the department, and yourself." Officer Crane has a large, neon-pink water bottle, which he drinks from compulsively as he paces to every corner of the room, forcing us to swivel in our stationary desk chairs.

"Ask yourself, how has your job experience prepared you for a career in law enforcement? Well, any job requires that you be a team player. Say you're working at the counter of McDonald's, Burger King, or whatever your local hamburger stand happens to be." He says this kindly. There is no condescension in Officer Crane. "And you're thinking, 'That hasn't helped me be a police officer at all.' But you tell them, 'I'm capable of making independent decisions with little or no supervision. I'm honest, trustworthy, and responsible. I deal with the public, people from all different ethnic groups, and I treat them all fairly. I have a good attitude towards customer service. I'm a TEAM PLAYER. This is true in any job."

I want to raise my hand. *Except for novel writing, Officer Crane.*

"Show them you know something about the city. Tell them there are eighteen different geographical regions, that eighty-eight different languages are spoken in the schools. Tell them you know all about the different careers in the LAPD, narcotics, child abuse, dog patrol. Tell them this is a career that would allow you to have a comfortable middle-class lifestyle. Tell them that to prepare yourself you've gone into the military. Don't just say you work out, tell them you have a customized training program: 'I build up my endurance through run-

ning and swimming.' 'I build upper-body strength by lifting weights.'
'I could use force that was reasonable to overcome a suspect.'"

He talks about the integrity that is required at all times. While I
believe I am the only person in the room planning on writing about
my experiences, I am not the only one furiously scribbling into a note-
book. He maps out possible scenarios and we listen. "You and your
son are at a Raiders game," Officer Crane begins, "and a rowdy group
wants to fight a cop, and your son says, 'Hey, Dad, you're a cop, go get
'em.' But you have to go and call security. No heroics." He turns and
paces quickly to the other side of the room. "You're out with your kid
and you stumble onto a robbery in progress at a convenience store.
The gunman is holding a gun to the cashier's head. You go in and pull
your gun, they shoot you *and* the cashier. You had figured your kid
was safe in the car, but there are other guys working outside and they
shoot your kid."

The aspiring cadets inhale sharply at their desks.

"You *have* to *call* for *backup*, the guys in the car. You get a good
description of the suspect and wait to direct the officers when they
arrive after the suspect has taken off. You'll do more good this way.
When you're off duty, your role is to be the best witness."

A woman enters the room and Crane gives us the "time out" signal
I've seen my father make so many times. She has a thick stack of blue
cards, and announces she's going to read some names and those
people should gather their things and meet her outside. Todd White
gives me a conspiratorial nod. She has to read the names of everyone
who failed from the entire original group of nearly two hundred be-
cause she doesn't know who is in the room. Every time she reads an,
"Anthony" or "Andrew" I hear my name. What if, after years of teach-
ing college freshman composition, I fail a grammar test for the police
department? How *do* you spell "calendar"? She reads about eighty
names, most of them Hispanic. Ten people in the room get up and
leave. Todd and I stay put.

Officer Crane appraises us coolly. "Now I know you're wondering, 'Do I want to be in the group that goes outside or the group that stays in here?' But I want to congratulate you people. You passed." We applaud ourselves heartily and then receive our oral exam times. Several people have to leave right away, but I have until one o'clock and wouldn't miss the rest of this talk for the world.

The LAPD appears to have no intention of tricking anyone. They offer a study group for the written exam. They will give you the best answers for your oral. They will show you how to get over the wall. The message is clear—they want to help us if only we will listen. Officer Crane proceeds with his lecture. "Next, *any* misconduct is to be reported to a supervisor. But first you have to verify the misconduct." His voice rises, his eyebrows go up. "You and your partner go to a robbery call on a computer store. Your partner, who has twenty years' seniority on the job, has a computer in his hands. He tells you to check the front of the store. You hear him leave the store, then you hear the trunk of the police car being slammed. He comes back empty-handed. You have to first *verify* the misconduct. Ask him about it politely. Maybe he's taking it in to be fingerprinted. Maybe he's putting it back in the stockroom. Maybe he says, 'Hell yes, I got one, now you pick out one for yourself, partner.' Call the sergeant immediately, have him come to the store."

Having prepped us for simple theft, Officer Crane ups the ante. "On this job you will have to deal with the worst of the worst of the worst." Once he says this he looks at us to see if we can take it all in, and then he repeats it, slowly. "You go on a rape call. It's a six-year-old girl. The paramedics are already there and they tell you she has a fifty-fifty chance of surviving. The mother is there and she is screaming. Other cops are already on the scene and the suspect is handcuffed. He can tell that you're a probationer and he starts in on you." Officer Crane then outlines all the vile things the suspect claims he will do to *your* children, and you, and various other people, until your

partner hauls off, *"POW!"* Officer Crane punches the air hard enough to make the whole room jump. "Clocks the suspect right in the solar plexus. And you say, 'Yeah!'" Crane gives the thumbs-up and smiles a Hollywood smile. "No you don't, not really, because the suspect is handcuffed already. The people on the street around you are clapping. They say, 'I would have done the same thing. If I was you, I would have shot him.' Your partner says, 'Oh my God, Buddy. I can't believe I did that. Twenty-five years on the job and I've never done anything like that. I just got so mad. That won't happen again.' Any misconduct," Crane repeats. "Say you let it go, and that night you're home and there's a report on the six o'clock news about police brutality and you sit down to watch and who's on television? You are on television, grinning and giving the big thumbs-up when your partner hits the guy. Then you lose your job. They don't talk about what the suspect did, they talk about those brutal cops. You are expected to be PERFECT. Once you are a police officer you are expected to be ERROR FREE."

I'm not entirely sure about the moral of the story, but I take it all down as Officer Crane brushes over traffic violations and the importance of a good closing statement. When we're outside, the rest of the crowd heads for the parking lot while I go to the pay phone to call my father for a ride. I've got an hour and a half before my oral exam, just enough time for lunch.

I look through the paperwork I've been given, and discover that before the oral I have to fill out a form listing every job I've had in the last fifteen years: locations (including addresses), months worked, monthly salaries, names of superiors, job descriptions. I sit on a curb and begin to make a list in my notebook: a teaching assistantship in graduate school, other teaching jobs. Is my publisher my employer? What about freelance writing? Houghton Mifflin, *Bridal Guide*, *Seventeen*, the Bunting Institute at Radcliffe, the University of Montana, Murray State in Kentucky, Book World in Nashville. My father and

Jerri arrive. At the restaurant I fill out forms like mad while they eat, finishing just when it's time to head back. A pamphlet on the oral has told us to dress well, and my father has thoughtfully brought my blazer. In the restaurant bathroom I borrow a lipstick from Jerri and smooth out my hair with tap water.

When I arrive for the oral, I see several of the people from my original group, now wearing stiff, ill-fitting suits. I give my employment form to the young woman behind the counter, a gum-chewer with spiked mascara. She wants to know how I am still working for Radcliffe College, Houghton Mifflin, and *Seventeen*. She wants monthly wages that I can't provide. I fill in a few more lines, she whites out the places I've written "Not Applicable." While I'm trying to correct my answers, she begins to pick apart the form of the next person in line. I take the opportunity to give my form to a woman at another desk, who seems to accept it for what it is and sends me down the hall to testing room B. It turns out there are more written tests to take, and while I hadn't understood that, I am glad to tackle anything that is not my employment history.

I'm sure that white men do not comprise the entire group who've made the cut, but that's the story in this room—white men in suits hunched over papers. A woman reading a Danielle Steel novel at the head desk, the proctor, gives me a copy of the test and a pencil and tells me I have forty-five minutes. I take my place at the table and read the instructions for completing Form P: "No dictionaries, no grammar textbooks allowed." Whatever this test is, it's worse than the last one. The men in suits seem close to tears. All around me a great deal of erasure is going on. I answer a set of questions on the first page about my conduct in the workplace: *Have I ever been fired? Have I ever had a fight of a serious nature with a co-worker or superior? Have I ever been praised for good work? If yes, tell the last time it happened.* All I can think of is an article I wrote about virginity for *Seventeen* that was popular. I mention the praise without naming the piece. I don't

mention that my first novel was a *New York Times* notable book of the year. *Have I ever been reprimanded for poor work?* Yes. I've had to rewrite countless articles in my life. I don't want to appear suspiciously eager to please by saying I've never done any cut-rate work. *Have I ever been put on probation?* The other side of the page is clearly what's got the suits sweating. *Write four sentences in which you describe three qualities that are important in a police officer. Next, write a mock police report about a disruption at a public event. It is not important to know correct police procedure. What is important is the quality and clarity of the writing.* I may not be able to outrun them, but chances are I can outwrite them. I have forty of my forty-five minutes left. I settle on a city legislature meeting about putting a homeless shelter on the outskirts of an affluent neighborhood. A shoving match ensues and I get down the details. I figure that anything concerning property values is a good choice.

After I finish, I'm sent back to the waiting room, where I review my notes from Officer Crane's lecture until I'm called for my interview by Gabriel Robles, a man in his early fifties wearing a mauve shirt and a gray ponytail. He is friendly, very warm. In the tiny interview room he pulls out my chair for me, saying it's quite heavy. Robles is from personnel. His name is printed on a card in front of him. The other member of my board is Detective E. Waters, a tall woman in her middle thirties. Her body has the same kind of chiseled perfection as Officer Crane's. I can see the muscles in her tan face. She is wearing a dress with a print of lavender hibiscus and a lace inset in the top that looks like something she must have bought for Easter Mass. My father has warned me in advance that the routine is pretty much the classic good cop/bad cop, and by the tension working in her jaw I can see which side she'll be coming down on.

"We were very interested in your employment history," Robles says.

I admit that it's not exactly conventional. It gets confusing, how much money did I make when.

"Don't worry about it," he says, smiling. "We're nontraditional. I have a degree in sociology. Detective Waters was a speech pathologist."

I nod appreciatively, wishing I could interview them.

"So you write novels," Robles says. "That's something. What are they about?"

I'm vague and he asks me to be specific.

"And do you know these people?"

"I make them up."

"Just out of your head? Out of nothing?"

"That's right."

"So you just sit down to write," he says, leaning towards me. Detective Waters looks bored, but I'm not the one encouraging this line of questioning. "No one tells you what to do, you pick all that out yourself?"

"That's right."

Then they talk about how interesting that is, how much fun it would be, and it's true. It is fun.

"So what have you done to prepare for the Police Academy? Have you read your father's reports?"

I tell them I have not.

"Your form says you swim and run. Why don't you tell us about that."

I skim over the details of my new physical life, knowing that it must all seem like small potatoes to Detective Waters.

"How do you think your work experience has helped to prepare you for a job with the LAPD?"

"I'm very self-motivated," I say. "I'm great at making decisions. I think things through. I'm rational and calm."

"Yes," he says, "but have you thought about the fact that you're joining an organization that is nearly paramilitary? That you have to operate in a system of authority where you always have to do what someone tells you, even if you don't think they're right?"

"Yeah," Waters adds, not so nicely. "I was wondering about that."

"I've thought about it," I say, "and it concerns me. I went to Catholic school for twelve years. I have some experience with authority. I haven't taken a lot of orders as an adult. All I can say is that I've thought about it and I'll try."

"Why do you want to be an officer now?"

I tell them I'm not getting any younger. I tell them about my family, how I have recently realized that I want to follow my lifelong dream to be a cop. Do they buy this?

They want to know if I've had any experience with real danger. How do I know I'd be so calm? Again, Waters nods in an exasperated way.

I make a quick mental scan through the safety of my life. There is not a flicker of danger, the slightest threat of injury. The truth is I loath danger. I avoid it at all costs. "I've lived in and out of New York over the last ten years," I say helplessly. "I've ridden the subway at night. I know from crazy."

They like this answer. To an Angeleno, New York is still two steps removed from a Mad Max movie. I tell them I know who to face down and who to ignore. I consider telling them that I know whom to face down and whom to ignore, but even though it would be grammatically correct, I don't think it would further my case.

They give me two scenarios that are straight-up Officer Crane, one a mild infraction urged by an older partner, the other a case of violence against a child. I give the right answers. I would have given them without the prep session. I know what my father would have said.

They ask for my closing statement. I tell them my father, as they know from my paperwork, was a police captain. I have an uncle who is an assistant district attorney and an uncle who is a firefighter, all in L.A. I tell them I have civic blood and my time is now.

"Off the record," Robles says, "how does your father feel about all of this?"

Leave it on the record: he's thrilled.

I return to the waiting room, where I wait about sixty seconds before getting the news that I've passed the oral and should go back to room B. The Danielle-Steel-novel proctor tells me to show up for the physical abilities test—the PAT—at six o'clock the next morning. Yet more paperwork: she gives me a medical form, a background form, and a Xeroxed letter of congratulations from Willie Williams that tells me not to quit my present job until I have been officially accepted. In the time I've been off in my oral exam I feel a shift has occurred between me and the police department—we've gone from me wanting them to them wanting me.

In the car, I tell my father everything and he nods enthusiastically. He tells me stories about oral boards he's been on where people sweated through their suit jackets, or when a candidate was so top flight they wouldn't give him a chair so as to make the interview that much more uncomfortable, or half the board would face the wall and never look at him. By my father's reckoning, Waters and Robles were my friends.

We eat a salad that night and sit outside after dinner while Jerri waters the plants. We talk about police brutality during investigations. I ask my father questions, personal questions, and he answers them all readily. "But that's not something you can ever write about," he says.

I am starting to see how this is going to be a problem.

I am in bed by a quarter past nine. At ten o'clock I take a sleeping pill.

The alarm goes off at 4:45 a.m. My left leg has been tight for three days from the sprinting I've done and I try to stretch it out. My father knocks on my door at 5:20. He wants to go. Am I sure I don't want breakfast? He has made me a little bag on a string to wear around my neck, not much bigger than a quarter, to put quarters in so that I can call him when the test is over. Every year when my sister and I left

California, he made index cards for us. He wrote down every phone number where he might possibly be reached and taped a dime next to each number. After we got back to Tennessee, I would peel the dimes off my card and spend them. My sister saved her cards just the way they were. She still has them, dimes and all, one from every year.

I think we're leaving the house too early, but when we arrive at the Academy at 5:35 the parking lot is already full. Cars are parked down either side of the street. All week, the Jehovah's Witnesses have been having a convention in Dodger Stadium, which is across the road and an ocean of asphalt away from the Academy. They've been baking in the bleachers in their white shirts and dark suits. Early as it is, there are women standing on the sidewalks holding signs in both English and Spanish about the fate of our souls. They proselytize in our general direction, not because we are trying out to be police officers, but because at this hour of the morning we are the only available audience.

My father kisses my cheek, wishes me luck.

Two hundred fifteen people have come to take the PAT this morning. The test is given every two weeks, and the last time only forty people showed up. There's no telling why this has happened. Not only is the crowd of test takers record-breaking, several of the instructors are no-shows. We wait in lines that wind around the picnic tables, swatting at the gnats. All decked out in our running shoes and running shorts, we look like a cattle call for a Nike commercial. I make friendly chat with the young women on either side of me. I lend them my pen. One tells me a long story about trying out for the police academy in another city but that her last employer, Robinson's department store, wouldn't release her work records because she'd had a fight with her boss on leaving. She had to hire a lawyer to sue them, but by then it was too late and she had to start the process over.

The two black women who ran the show yesterday are back. We move wherever and whenever they tell us to. One walks back and forth on top of the picnic tables. "I don't want to see your green cards,"

she says, waving a stack of green cards. "You don't need them, don't show them to me. You need a picture ID, people. Don't tell me you don't have a driver's license. You drove over here, you better have a driver's license."

I wonder if I'm the only person here who got a ride from her dad.

We fill out white forms confirming we feel well today and understand that we do not have to take the test now. It describes what we will be asked to do. The girls from the training-prep class whom I had watched go over the wall are there in matching T-shirts this time, their names on the back. They lean against each other, making jokes. "See the arms on that one," the Robinson's girl beside me says, and points to the girl who looks like she's made a commitment to one-handed push-ups.

After an hour we are told to go down to the parking lot, and the neat line breaks apart. People who got there at five a.m. are no longer in the front. In the parking lot, the instructors beg us to leave. *Anyone who leaves will have priority next time. Go. Go.* About twenty-five people bail out, including the girl beside me who says she didn't know about the six-foot wall and figures she should practice anyway. They ask for people who are from out of town and will be flying out tonight. A preposterous number raise their hands. "We'll be doing spot checks on airline tickets," they threaten, and the crowd laughs. Next they ask for anyone who lives north of Fresno. I raise my hand and say I live in Boston. This qualifies me for the north-of-Fresno group. We go back to the picnic tables and form a new line.

Behind me are a group of Marines who've already had their background checks. They make no attempt to lower their voices. "The officer asked me, 'How many times have you driven drunk?' and I said, 'Officer, I am very unlucky. The only two times in my life I ever drove drunk I got caught.'" Another pipes up. "You want to know how many times I drove drunk? 'I'm a Marine, sir, do you mean how many times did I drive my own vehicle while drunk or how many times did I drive

a military vehicle while drunk?'" They talk about their time in Somalia. One admitted during his oral to stealing two sleeping bags from the Navy and was told he had to return them with a letter of apology and get a letter of receipt.

After we sign in there is more waiting around. Today's T-shirts are esoteric: EXPLOSIVE ORDNANCE DISPOSAL "PAU HANA" MOBILE UNIT ONE. I am wearing a shirt from the University of Iowa, a reminder to myself that I went to graduate school.

The track at the Police Academy has been ripped out to make way for a new drainage system, and so we'll have to run in the parking lot at Dodger Stadium. We file out the front gates of the Academy and make our way up a long and steep drive. This is the day the World Cup soccer match between the United States and Romania will be played in Pasadena. At noon it will be 120 degrees on the field. At 8:00 a.m. in the parking lot of Dodger Stadium, I'm guessing it's already 95. The smog is a thick woolly blanket over the city. It hurts to breathe and I'm not doing a thing. There are approximately 180 of us in the parking lot. No shade, no water. They call out names and numbers, one to thirty. I am twenty-eight. This is a brilliant piece of luck—it means I will run with the first group when it is 95 and not 110. I pick up my neon-orange rubberized vest with a giant "28" on the back and snap it on. I turn around, as per instruction, and my name and number are recorded. We are to run around pylons that form a circle in the parking lot. One lap is one-tenth of a mile; we must complete a minimum of ten laps in order to qualify, and we must not stop running for the entire twelve minutes. They will shout out our number every time we pass. When they call stop, we must stop dead in our tracks or be disqualified. Go.

I begin to run with the pack. Did I ever compete athletically in high school? Did I run against another Catholic girl? I can't remember. If I did, it was a long time ago. I know this: I have never run against Marines. On the first lap I begin to pant in shallow breaths. I

feel faint, not from the heat or exertion, but from the fear of fainting. I am going to faint in the parking lot of Dodger Stadium in front of cops and Marines during the first lap of the first event of the test. I never wanted to be a cop. Dizzy and nauseated, with lungs full of L.A. smog, I trot. "Twenty-eight!" they call when I pass. People pass me. I pass people. I have not kept count of my laps. I try to remember the Charles River, the shady banks sloping down towards the water. Every pylon I corner is a deal with God. I no longer care about passing this test or pleasing my father. I care nothing about writing this book. I care about not passing out. When they call "Stop" I stop and put my hands on my knees and begin to hack. I cough continually for the next half hour. The Marines are coughing, too. I spit into my hand because I taste something so acrid I think it must be blood. No blood.

We are told to stand still and straight with our backs to the proctors so they can record our numbers. I have completed eleven and one-eighth laps. The best of our group did thirteen and a half laps. Two of the four women in our group didn't make ten. We unsnap our vests and lay them on the ground in numerical order for the next group. It is eight-thirty. This means that the last group of runners waiting in that shadeless parking lot will finish at eleven-thirty, about the time the soccer players are beginning to bake in Pasadena.

An event must be completed within the stated time in order to receive a qualifying seventy, though as many as a hundred points can be earned for exceptional speed. There are four events, meaning a minimum combined score of 280 is needed to pass. Hypothetically, one event can be failed completely if the others are completed in such astonishing time as to gain the needed extra points, but it is clear to all of us that failing one event means failing everything.

The wall jump is next. Our group of thirty trundles back across the road to the Academy, hacking. Our leader is Desrae, the woman who gave the test yesterday in her smart mules. She's wearing tight, cuffed denim shorts today and a midriff top. She tells us to move it. One out of three of all women tested do not make it over the wall, as

compared with one out of twenty men. As number 28 I have a prime spot, enough time to rest but not dead last. We have seventeen seconds to run fifty yards, with a hairpin turn around a pylon, then jump the wall without touching the metal posts on either side, then run an additional ten yards (this last, I assume, prevents people who fall over the wall and can't get up from passing the exam). Desrae trots over the path and makes a small hop in front of the wall to imply getting over. We are all clear. She holds up her stopwatch, saying very politely, "Jim, are you ready?" When he says yes, she says Go.

This is my first chance to really get a good look at my group. Of the twenty-six men, I would guess twenty are currently either in the military or in another police force. Twenty-five of them are in extraordinary physical condition: tall, broad-shouldered, young. Of the women, two are roommates in Oakland and play on the same softball team. Of these two, one is a remarkable athlete, a small, wiry Latina who goes through the paces effortlessly. Her friend is larger, paler, and wears glasses. She came in under ten laps on her run, as did Janet, the fourth woman, who is also soft-looking and tall. Though I don't take a poll, I strongly suspect I am the oldest person in our group. The men are vaulting the wall. The pale Oakland softball player hits the blue guardrail with her foot and is disqualified. The group is extremely supportive, clapping politely and giving the occasional cheer for a job well done. The crowd roars with encouragement as I pull over the wall. I complete the course in sixteen seconds. The men and the Latina woman do it between ten and eleven seconds.

For the next event, the bar hang, we head down to a set of obstacle courses carved into the side of the hill. I had thought this would be my worst event, though now I'm convinced nothing will be as bad as the running was. We have to run fifty yards around a pylon to the bar, jump up and grab it, and then hang for one minute. The timing begins once we stop swinging. This is harder than it sounds. There are three fixed bars, not unlike the ones I hung from in school yards back in Cambridge, with runners going out in a staggered order. The first bar

has tape on it, making it the most desirable, but that's just luck of the draw. The women from Oakland tell me to crush a leaf on my hands to make them sticky, that it will help keep me on. I wonder which leaf is sticky enough to glue my body weight to a bar for a minute. The real problem seems to be the swinging. Jumping means swinging. The trick seems to be briefly hitting your foot against the pole to still yourself. When the Latina woman is called, she hangs so effortlessly we are mesmerized. She looks like she's just standing there with her arms raised. There is no strain on her face. "It's because she's so little," the huge Marine next to me whispers. One Air Force man stationed in Savannah has been exceptionally nice to me. "It's all in your head," he says after coming off the bar. "You just have to clear your mind. Count slowly, one, one thousand one, two, one thousand two . . . by the time you get to thirty in your head it's time to drop." And people are dropping. Men struggle, grab and slip off. One falls at 59.4 seconds. The temperature is rising by leaps, and I leave my hands open in my lap, palms up, hoping to keep them dry. The crowd cheers people according to their bar number. "Hang on, number one!" they shout. "You can do it!"

Desrae calls me. "Ann, are you ready now?" I tell her yes and take off. I'm on bar number three, the farthest one to run to, and no tape. Still, I take my time getting on. I tense everything I have to stop swinging and then count, one, Mississippi, one. I close my eyes and it seems like the crowd is talking to me in a dream. *You look great, number three. You look great, sweetheart. Your hands don't hurt. It's all in your head. Think about a nice cold beer, number three. I'll buy you a beer, Iowa.* They're wrong about one thing: my hands do hurt, but what pain is so bad for a minute? When I get to one, Mississippi, nineteen, the officer brought up to time the event calls, "Number three, drop."

"Why?" I say, not dropping. Is there blood running down my arms? Have I been disqualified? I'm only on nineteen.

"Drop, three, and hold your place." I drop and hold. It does not occur to me that my minute is up, which it is. I had done my run to the bar in 16.4 seconds, leaving myself a comfortable margin of just over half a second to spare.

The final event, the 160-pound weight drag, is the easiest. This is the one where you must prove you are strong enough to pull your shot partner out of traffic. Run twenty-five yards, then pull a rope attached to a lead weight about the size of two stacked copies of the Los Angeles Yellow Pages (who knew something so small could be so heavy?) for another twenty-five yards, backwards, through deep, soft dust. When Desrae calls our name, we are to say *left*, and go left; the next person is to call *right*, and go right. The idea is to divide us into two even groups to pull the weight from one side of the course to the other, but the group seems to be utterly stumped by this one. Three people in a row insist on saying *right*.

"You people have to pay attention," Desrae says. "They don't put up with this kind of foolishness once you get into the Academy."

Eventually, we all manage to count off correctly. There is a great deal of cheering for this event, since by now we've got some first names down and can yell, "Go, Nathan! Go, buddy!" I clap along. This will soon be over and I will pass. When it's my turn the crowd goes wild. I am the mascot, the favorite girl. No sense cheering for the two who won't pass or the one who might beat your time. Cheer for the scruffy one who barely clears her time but somehow, miraculously, manages. I am the long shot, the dark horse. My legs are rubber as I pull the weight backwards. It would have been a piece of cake three hours ago, but now I'm going slow and the giant men begin to chant my name, dragging one syllable into two so it sounds something like "Ay-un, Ay-un, Ay-un." This will never happen again, and I try to hold on to it. This course is nearest the picnic tables where we began, under the pine trees, in the shade, in the soft dirt where the Police Academy looks most like the friendly summer camp I remember from

my childhood. When I clear the finish line I'm laughing. "You guys are like a fraternity," I say to the men who are clapping my shoulders and patting my head.

"You just wait," a cop from Utah tells me. "Wait until you're in the Academy. It's like this every day. This is what it's all about. There was a girl in my group who couldn't finish a run once and me and another guy came up on either side of her and hooked her arms and we ran carrying her."

I know that there are many different jobs on the police force, many positions better suited to women, but at this moment I am of the opinion that only men should be cops. They're built for it. They can carry people while running. They can vault the walls.

We go back to the picnic tables to wait for our scores. Everyone comes by to congratulate me. A man named Jim, from Larchmont, New York, tells me he bought out his father's insurance company last year, that he has a wife and two kids and a good business and he has come here to try out for the Academy. That was all he wanted to do, and his wife was supportive. I ask him why he didn't go to the NYPD.

"Not a chance," he says. "They're all fat. LAPD is the only place to be a cop."

There are two types of people in the world: those who want to be cops more than anything and believe that everyone else secretly wants to be a cop as well, and those who cannot imagine it. Twenty-nine of the first sort are in my PAT group, and one of the second. I feel like I'm betraying their optimism and good nature just by being there. I pass the test with a score of 288. Most of those who have passed have scores well over 300, one at 360. I run to the pay phone and call my father to come and get me. By the time I get back to see my group again, everyone has left. Desrae is drinking lemonade at a picnic table with some other people from personnel. I thank her, and tell her she gave me my test yesterday, too.

"Yeah," she says, "sure."

I wait for my father near the guard shack at the front entrance. A young black man from my group is also waiting there. He must be six feet six. He sailed over the wall like a gymnast clearing a vaulting horse. He asks me how I did.

I shrug. "Passed," I say. "Not great, but I passed."

He tells me that's all that matters.

I ask him where he's from, and he tells me Jackson, Mississippi. He tells me he graduated from Mississippi State and got into law school at Ole Miss but he wants to be a cop in L.A. "My parents want me to go to law school, but I'm doing this for me," he says. "I was going to be a cop in Mississippi. I almost dropped out of college, but I didn't. I stayed in. Now I'm going to do it here."

I want to tell him to listen to his parents, but he's having a good day and doesn't need my input. We congratulate each other, wish each other well. Then my father is there to pick me up.

What I have learned today is that I couldn't get through the Police Academy. I am not made of sterner stuff. Later, I will be less clear on this point. I will not remember my fears and inabilities so well. Later, I will remember only that I passed. Other people will tell me I could have done it but chose not to. Still, driving back home that afternoon with my father, driving down through Elysian Park, I know the truth. Not a chance. Figuring there is no time like the present, I tell him so.

"Wait and see," my father says.

But after I take the longest shower on record and eat the breakfast he's made me, he says he has something to tell me. "If you really aren't going to do the job, if you won't be a cop, then I think you shouldn't go through the Academy. I'm only saying this because you said you didn't want to go, but I don't think you should take up the spot of somebody who wants it so badly."

"But I told you I was never going to be a cop. I told you it was all for writing."

"I didn't believe you," he says.

Later that afternoon my father gives me two presents, a medal of the Virgin Mary given to him in school by his favorite nun, and his wedding ring from his marriage to my mother. "There's a lot of good metal in there," he says. "You could melt it down and make something nice out of it."

How could my father have believed that I didn't want to be a cop? It was all he ever wanted. My father tried for three years to get into the Police Academy. Time after time he appealed and was denied because of a heart condition. When he finally found a doctor who would slip him through, he never gave them an opportunity to ask him to leave. He went thirty-two years without taking a sick day because he was afraid of having to get a doctor's note in order to be able to go back to work. That's what it meant to him. Why wouldn't he think I wanted his job?

For some time after I took the test, I felt as though I'd failed— although I'd passed, and my oral exam score came two weeks later and it was a perfect 100. My father said he'd never heard of that happening before. I didn't have what it took to make it through the Police Academy, to do what my father had done, and even if I had, I could see now that the book I had wanted to write would have been impossible. When I thought about the people I had taken the tests with, about their deep and abiding desire for this job, I knew I could never have followed Officer Crane's admonishment to report any misconduct, especially not in writing. I was an insider, even if I wasn't a cop, and my affection for the institution was inextricably bound to my affection for my father. My father was never in favor of my telling any story that didn't have a happy ending.

And so I put my notes away, finished up my time at Radcliffe, moved back to Tennessee. I went back to writing novels. Other than occasionally jumping over a six-foot wall, a skill I have maintained, I remembered this experience as something I didn't do, a book I didn't

write. But in 2007, an editor for the *Washington Post Magazine* asked me for an essay about something I had done one summer, and so I said I would write a piece about the summer I tried out for the police academy. Sifting through the notes I had taken years before, I remembered the basic point behind my intentions, and all these years later that point has never changed: I am proud of my father. I am proud of his life's work. For a brief time I saw how difficult it would be to be a police officer in the city of Los Angeles, how easy it would be to fail at the job, as so many have failed. My father succeeded. He served his city well. I wanted to make note of that.

(*Washington Post Magazine*, June 24, 2007)

Fact vs. Fiction

The Miami University of Ohio Convocation Address of 2005

I'VE MADE A point of not giving talks about *Truth & Beauty*. When it was first published, I didn't go on a book tour or give interviews the way I would have with a novel. It's not that I mind talking about Lucy, or that it upsets me; it doesn't. In fact, I love to talk about Lucy. But I didn't want to go around telling the same stories over and over again until they felt worn-out and common, like part of a routine you use to sell books. I decided to come to Miami of Ohio because I was so glad that you wanted to read our two books together. I've always pictured them traveling as a pair, the same way Lucy and I were a pair. Still, I can't help but think how nice it would be if Lucy were around to do the speaking instead of me. It would be a better arrangement, since writing made Lucy especially miserable. In the best of all possible worlds, I would write the book and she could go out and give all the talks. She adored being up onstage. Lucy would accept any invitation to speak for the price of a plane ticket. She had a remarkable ability to connect to people. Everywhere she went people loved her and she was able to soak up all that love. Then again, she often missed her flights

or forgot what time she was supposed to show up to give a lecture once she had arrived. I'm sorry to say you've gotten the less colorful, more reliable member of the team, which I suppose is a mixed blessing. Had I been the one to die first I feel certain that Lucy would have wanted to write a book about me. I'm just not entirely sure she would have gotten around to it.

I knew Lucy for years before she knew me. The first time I saw her was the first day of our freshman year at college. I don't remember any one person telling me her story but still I knew it, the same way you know intimate details about the lives of movie stars. You don't go looking for them, they just seem to enter your consciousness by osmosis. Lucy had had cancer as a child. She had lost half her jaw. She was one of the first children to have chemotherapy. She had very nearly died. I watched her from a distance, curious but not wanting to intrude. During those first few weeks of classes she was often alone, a tiny thing with her head bent down to hide her disfigurement beneath a long curtain of hair, but very quickly she became the center of attention. She cut her hair off. She moved in the middle of the most popular students, older students who asked for her opinions and laughed at her jokes. Even though part of her face was missing, I thought she was glamorous. Without ever realizing I was doing it, I made up a story about Lucy, and then that story took the place of knowing her. I made her into a brave and glamorous girl. She was like a character in a novel who brushes up against her own death and then walks away stronger, forged in the fires of her own experience. I would say hello to her sometimes when I passed her in the cafeteria, and she would look at me as if we had never met and say nothing at all.

In fact, we hadn't met, but I forgot this in the wake of knowing so much about her. Later on, when we did become friends, I was surprised to find how much of her story I'd gotten wrong, and equally surprised by the ways in which I'd gotten it right. When we went to graduate school together in Iowa, Lucy was a poet and I wrote short

stories. The poets and the fiction writers would play softball against each other in the fall, before the snows covered over the field. Lucy and I would sit along the baselines, the only fiction writer and poet who sat together. The poets always won and the fiction writers never minded. The poets may have had a stronger pitching style, but their lives would be harder. Poetry is not a business that anyone would recommend if what you're hoping for is a living wage. After we left Iowa, Lucy decided to take a crack at telling the story of her life, the story that so many people had so freely told for her for so many years. First, she published an essay in *Harper's Magazine* about the freedom that came with wearing a mask on Halloween. That essay led to a book deal, and that book was *Autobiography of a Face*. Lucy burst onto the literary scene just as she had always planned to; the only difference was that she did it with a memoir instead of a book of poetry.

People used to ask Lucy and me if we were competitive with one another. We were both writers, after all. We attended the same schools, won many of the same fellowships; at times we had the same publisher. Could best friends wind up on the same playing fields again and again without having some tension over who was going to win? Certainly there were some things we could be competitive about: who was actually getting more work done or who looked better in a certain pale-green dress we shared, but we were never competitive when it came to the external markers of success. After all, what we did was so different: I was a novelist; I drew from my imagination. Lucy was an essayist, a writer of nonfiction; she worked from her experience. In short, she told the truth, and I lied.

Lucy was my closest friend for seventeen years. She was the person I knew best in the world, and she was certainly the person who knew me best. She was an extremely complicated person: needy and brilliant, demanding and affectionate, depressed and still the life of every party. I knew that I would never be able to hold her in my mind ex-

actly the way she was. I knew that every year she was dead her memory would become simpler, and I didn't want that to happen. Very soon after she died, I wrote a magazine article about her. I thought that if I wrote it all down, the story of the two of us, the story of friendship and what we had done together, that I could remember the truth about her. In the same way it had happened for Lucy, my article led to a book contract, and I was grateful for that. There was still so much I wanted to say. People kept asking me, "Are you feeling better? You seem better today." But I didn't want to be better. I wanted to stay with Lucy, and writing the book was the way I could do that.

So now there are three stories: the one I made up about Lucy before I knew her, the one she told about herself, and the one I told about her after she died. And in between those three there are three hundred more: stories Lucy told to guys she met in airports, stories that were written about her in fashion magazines, stories Lucy told me that I wouldn't tell and the things she never told me at all, gossip-laced-with-fact stories that her students told to one another or that fans wrote about her on websites. Every one of them was a portrait of a brilliant, complicated woman, but no two described exactly the same woman. All of which would lead a person to ask, *What is the truth?*

Lucy wrote the truth. I am a novelist. I make stuff up.

What exactly is a made-up story? I used to take a great deal of pride in the fact that people who read my novels, even all of my novels, wouldn't really know anything more about me or my life at the end of them than they had known when they started. I've written novels about unwed mothers in Kentucky and a black musician in Memphis. I wrote about a gay magician in Los Angeles and a hostage crisis in Peru. The amount of real knowledge that I had on any of these subjects would weigh in about as substantially as an issue of *People* magazine. In my books, I make up the experiences and the characters, but the emotional life is real. It is my own. I think this is probably true of

most novelists. The bright-green space alien with three heads and seventeen suctioning fingers in the latest science-fiction novel may be unrecognizable as a human, while in fact having the same emotional composition as the author's mother. One of the things I've discovered in life is that no matter how vastly different our experiences are, the emotional responses to those experiences are often universal. That's why we can relate to the story of a child suffering through the ravages of cancer and the humiliations and cruelty of the life that followed. We've all felt humiliated at some point. We've all felt that we weren't attractive enough or attractive in the right way. We've all felt misunderstood. We've all wanted a bit more love. So, even without the cancer, we can feel what Lucy felt. That is the hallmark of her art: she was able to take something impossibly specific and make it universal.

Do I make up the dialogue between fictional characters? Of course I do, but I truly believe that those are the words these people would say to one another in that moment. Did Lucy make up dialogue between her characters—real people who were there for real moments in her life? Absolutely. Who can remember what everyone says?

Who makes things up? Who tells the real story? We all turn our lives into stories. It is a defining characteristic of our species. We retell our experiences. We quickly learn what parts are interesting to our listeners and what parts lag, and we shape our narratives accordingly. It doesn't mean that we aren't telling the truth; we've simply learned which parts to leave out. Every time we tell the story again, we don't go back to the original event and start from scratch, we go back to the last time we told the story. It's the story we shape and improve on, we don't change what happened. This is also a way we have of protecting ourselves. It would be too painful to relive a childhood illness or the death of your best friend every time you had to speak of it. By telling the story from the story, instead of from the actual events, we are able to distance ourselves from our suffering. It also gives us the chance to make the story something people can hear.

There were plenty of things Lucy left out of *Autobiography of a Face*, mostly how relentless and long her illness was, how violently, boringly sick she would be for weeks and months at a time. She understood exactly how much the reader could stand without turning away. She didn't write the story of what she had had to endure; she wrote the story she thought the reader could endure.

Just as every story we tell bears our own distinctive slant on the experience, every story we read bears someone else's. Whether it's a story in a newspaper or a chapter in a history textbook, the writer has made the decision of what to include and what to leave out. It doesn't mean he or she isn't telling the truth; it simply means that events can't be recorded exactly. They can only be interpreted. Even a photograph reveals only part of the picture. The frame is defined by its own four edges. Whom do you choose to leave out of the portrait? Whom do you choose to include?

It was a subject that fascinated Lucy. Making art was much more important to her than making an accurate record of fact, especially since she understood that that was something that could never be fully accomplished. She wrote about it in an essay entitled "My God." She wrote,

Vincent van Gogh, in his letters to his brother, Theo, outlined a life filled with the tangible. Vincent loved to look, to touch, to smell, and to taste the world about him. Most of all, he loved to look, and then *feel*, with his hands grasping the charcoal or brush, what he had just seen. His hands roamed all over his mind, trying to decipher the different grains of thought and emotion, the thin line between the actual and the imagined, between light and the things he saw with light. Though he never lived to hear of either wave or particle theories of light, Vincent understood that one doesn't just simply "see" a chair or a table, but rather that one's eyes are actually caressed by the light that bounces off them.

Color, while being the most visible thing we can know about a tree, is also created by that part of light that the tree has cast off. The tree absorbs all the other light waves of color, welcomes them as part of itself; the green we see is the negative, the reflected-off reality it wants no part of. Where its definition of itself ends, our definition of it is just beginning.

There are two kinds of educational experience you can have in college. One is passive and one is active. In the first, you are a little bird in the nest with your beak stretched open wide, and the professor gathers up all the information you need and drops it down your gullet. You may feel good about this—after all, you are passionately waiting for this information—but your only role is to accept what you are given. To memorize facts and later repeat them for a test might get you a good grade, but it's not the same thing as having intellectual curiosity. In the second kind, you are taught to learn how to find the information, and how to think about it, for yourself. You learn how to question and to engage. You realize that one answer is not enough and that you have to look at as many sources as are available to you so that you can piece together a larger picture. With *Truth & Beauty*, I have not written the definitive truth about the life of my friend, because that would never have been possible. I told one version of her complicated life. She told another, her family tells another, her readers tell yet another. Everyone adds a chip of color to the mosaic and from there some kind of larger portrait begins to take shape.

I hated high school. I spent a great deal of every class period imagining myself jumping out the first-floor window and running and running until no one in high school could ever find me again. Part of this had to do with my frustration at the one-question, one-answer, no-discussion method of education that was deemed appropriate for southern girls in a Catholic school. Part of it was feeling misunderstood, alone, and vaguely persecuted, a state fairly common among teenagers. When Lucy and I became friends and started spending

long nights discussing the unhappinesses of our youth, she was thrilled to find out that I had hated high school too. To her, this was a great bonding point, something important that we had in common. I, on the other hand, felt my teenage angst was a trifle in the face of what she had experienced. Of course she hated high school, filled as it was with savage mockery and cruel exclusion. When she complained to a teacher that none of the other children would let her sit with them at lunch, he said she could take her sandwich to his office and eat by herself—which she did, for years. But even though our circumstances were dramatically different, the emotional outcome was very much the same. This was a great help to me as I started writing fiction. I might not have experienced what happened, but chances were at some point in my life I had felt the emotions.

There is something so irresistible about delivering a convocation address. You are a captive audience, you haven't settled in yet, you're probably more open to advice at this particular moment in your life than you're going to be a month from now or at the end of this semester or in four years when you file out of here. Both *Autobiography of a Face* and *Truth & Beauty* are books about how much compassion is needed to get through a life. They are also books about the value of friendship. Long after you have forgotten the classes you have yet to take, the books you have yet to read, and the papers you have yet to write, you will remember your friends. Some of the most important people in your life are sitting in this room with you today, and there's a perfectly good chance you haven't met them yet. But you have time. Time is the most extraordinary gift for friendship. You'll get to eat your meals together and study together; in some cases you'll even sleep in the same room. You'll have time to waste on each other. You'll find out every single thing you have in common and still have time to catalogue all of your differences. Don't underestimate the vital necessity of friendship in your life because it is the thing that will sustain you later, when there will be considerably less time.

After *Truth & Beauty* came out, I received hundreds and hun-

dreds of letters, and they basically boiled down into two groups: the first group said they were very sorry for my loss because they too had a best friend and they didn't know what they would do without him or without her; the second group also expressed sympathy, but that sympathy came with a sad sort of puzzlement. These people wrote they had never had a truly close friend before, and even though I had lost my best friend they still thought I was luckier than they were for ever having had the chance to love someone so much in the first place. Both of the groups were right.

Some people have said they didn't want to read *Truth & Beauty* because they thought it would be too sad, but for the most part it isn't a sad book at all. It's sad that Lucy died, it's especially sad that she died young, but the truth is that every life ends. The quality of a life is defined not by its length, but by its depth, its actions and achievements. It is defined by our ability to love. By these criteria Lucy did a very good job with the life she was given. She soldiered through a terrible disease. She wrote two great books. And she had more friendships, more deep and lasting friendships, than anyone I have ever known, which isn't a bad list of accomplishments for thirty-nine years.

I wrote this book because I missed my friend, and I wanted everyone else to miss her and love her as much as I did. I wanted to extol the virtues of friendship, both ours specifically and as a good idea in general. I wanted to encourage people to ask questions, which is exactly what Lucy would have done. I appreciate your inviting me here today. I wish you and your friends a very successful four years of college.

My Life in Sales

THIS IS A story about traveling salesmen, and so it begins in a bar at the edge of a hotel lobby in Mobile, Alabama. The hotel may or may not have been a Hyatt. My memory can only separate hotels into three categories: those that are disgusting, those that are very nice, and those that may have been Hyatts. What I am sure of is that I was sitting in that hotel bar with Allan Gurganus and Clyde Edgerton on the last day of the Southeastern Booksellers' Association conference. We were drinking, and we were talking about book tour. We all had books that had recently been published, or were about to be published, and now was the time for us to go out into America and sell them. None of us felt particularly energized by this prospect.

"You've got to drink plenty of water," Clyde said and pulled a bottle of Evian from his bag to make the point. He had decided that the reason his last tour had been so hard was that he must have gotten dehydrated along the way (all that flying). He believed it was a lack of water that had led to his prolonged post-book-tour despair. *Post*-book-tour despair, that surprising companion to the despair one feels *during* book tour, was then discussed at length. Of the three of us, only Allan

was sanguine. "The only thing worse than going on book tour," he said, "is not going on book tour."

Last week I e-mailed Allan to ask him if he remembered this conversation, and, if he did, was I right in thinking it had taken place in 1994? He wrote, "I think our meeting must have been in 1992, when I was out on tour with White People. War stories, those many miles. I didn't drink till Book Tour." Clyde said he also remembered the conversation: " . . . tho I was thinking 1997 or 8 was the date of the tour when I drank so much water and walked so much and meditated so much to avoid depression." The fact is, I was on book tour in 1992 and 1994 and 1997 (and 2001, 2002, and 2007, for that matter), so anything is possible. Like the hotels, the tours all start to blend together. The books, the cities, the stores, the airports, the crowds, or lack of crowds, all fall under the heading "What Happened While I Was Away." What I always remember clearly are the times I saw other writers, the way pioneers rolling over the prairies in covered wagons must have remembered every detail of the other settlers they passed, cutting through the tall grass from a different angle. "How was it back there?" you shout out from your wooden perch.

"Rough," your fellow homesteader calls back, and raises his bottle of Evian in warning. "Be sure to drink your water."

And I do. The reason I have so assiduously followed Clyde's advice (I drink water by the bucketful whenever I'm out on the road) and chanted Allan's words like a mantra in my head (It is worse not to go. It is worse not to go . . .) is that these are pretty much the only guidelines I've been offered on what is a very important aspect of my life. Even the ever-professional Iowa Writers' Workshop, where I was a student in the mid-1980s, doesn't have a seminar on book-tour techniques, though the thought of them having one is more chilling by far. Sometimes in life you're better off not knowing what's coming.

When I published my first novel, The Patron Saint of Liars, in 1992, I was told there wouldn't be much of a budget for publicity. Of course,

I was free to stretch that budget: to drive rather than fly, go cheap on motels and food, keep the collect calls to a minimum, and therefore get to more bookstores. As green as a soldier first reporting for duty, I practically leapt to my feet. "Oh, yes!" said I. This was my book, after all, the physical manifestation of all of my dreams. I was willing to do anything I could to help it make its way in the world. My publicist at Houghton Mifflin set up my itinerary. I covered about twenty-five cities and kept my expenses under $3,000. With one good dress in the trunk of my car, I would drive to Chicago, find the McDonald's closest to the bookstore, change clothes in the restroom (say what you will about the food, they have the cleanest restrooms), go to the bookstore, and present myself to the person behind the counter. That has always been the hardest part for me, approaching the stranger at the cash register to say that I am the seven o'clock show. We would look at each other without a shred of hope and both understand that no one was coming. Sometimes two or three or five people were there, sometimes they all worked in the bookstore, but very often, in the cities where I had no relatives to drum up a little crowd, I was on my own. I did freelance writing for *Bridal Guide* in those days, and more often than not there was a girl working at the store who was engaged. We would sit and talk about her bridesmaids' dresses and floral arrangements until my time was up; then she would ask me to sign five copies of the book for stock. This, I was told, was a coup because signed copies could not be returned to the publisher, so it was virtually the same as a sale. (Please note: this is not true. I have pulled ostensibly brand-new copies of my novels from sealed cartons and found my signature in them. Somebody shipped those copies back.) But none of that mattered, because my publicist told me that the success of book tour wasn't measured in how many books you sold on any given night. What mattered was being friendly, so that the girl at the cash register, and maybe even the store manager, would like you, and in liking you would read your book once you had gone, and by reading your book

would see how good it was and then work to hand-sell it to people for months or even years to come. And I believed this because if I didn't, I had no idea what the hell I was doing out there. After saying all my warm goodbyes, I would leave the store in the dark, drive the two blocks back to the McDonald's to change out of my dress, and put in a couple of hours on the road to Indianapolis, where I was scheduled to appear the next night at seven. I was exhausted and embarrassed, and yet I told myself the experience had been worthwhile because I was friendly and would be remembered for that.

And who knows, maybe that's what did the trick. While I was out with my fifth novel, *Run*, I routinely had audiences of two hundred people a night. As those patient readers stood in line and waited for me to sign their books, I realized for the first time that book tour really is more than just a goodwill gesture. It's about selling books.

In book-tour lore—the publishing equivalent of urban legend— Jacqueline Susann is given credit for the idea that authors should not only write their books but also personally hand them out. She showed up with her husband, Irving Mansfield, at stores all across the country to sign copies of *Every Night, Josephine!* (the one about her poodle). By the time *Valley of the Dolls* arrived, she was lounging on Merv Griffin's couch and keeping up a publicity schedule that allowed her book to sit in the No. 1 spot on the *New York Times* list for a record-breaking twenty-eight weeks.

Signing books in a store is one thing, but book tour in its more advanced form is credited to Jane Friedman, who until recently was the CEO of HarperCollins (my present publisher). She had started out as a twenty-two-year-old publicist at Knopf, where she was assigned to work with Julia Child for *Mastering the Art of French Cooking, Volume Two*. Julia's cooking show was doing well on public television in Boston, and so Friedman decided to contact all the public-television stations in the major markets. After that, she

scheduled appearances at the big department stores (which, in 1970, had significant book sections). "I said, 'I'll bring Julia to your town, we'll work with the local public-television stations, we'll get newspaper coverage, and then she'll do an autographing in the department store.'"

What followed was a perfect storm of media and retail, and it established the gold standard that publicists still work for today. The stores were full of signs. The cities were full of buzz. Nothing had been left to chance. At the first stop, in Minneapolis, Friedman looked out of her hotel room window at seven-thirty in the morning and saw a thousand women lined up outside the department store. "It was a Cecil B. DeMille moment," she remembers. "We had parted the Red Sea. Julia made mayonnaise in a blender. We sold five hundred books." The formula paid off in city after city: Julia cracking wise and whisking eggs, while ladies waited in line to buy the merchandise. Any modern author short of Stephen King and John Grisham might feel a quiver in his lower lip to think of such large numbers. "Today you're competing with six other authors on the *Today* show," Friedman says, and suddenly she is speaking as the publisher of my books. The CEO who still has a publicist's soul is shoring me up for my own next show. "What hasn't changed is the connection between the author and the reader. If anything, it's even stronger. The people who come out to your signings are real Ann Patchett fans. I'm *glad* I wrought that. It was always my intention."

And yet I struggle with my own intentions. I can never get very far from the niggling belief that there is something inherently wrongheaded about book tour, that the basic premise of authors selling their books is a flawed one. Most people who are capable of sitting alone day after day, year after year, typing into the void are probably constitutionally ill-suited to work a room like a politician (though I am not, in fact, afraid of public speaking, and I'm good at it). We're a country obsessed with celebrity, and trying to make authors into small-scale Lindsay Lohans does nothing but encourage what is already a bad

cultural habit. No matter what book clubs tell us, reading is a private act, private even from the person who wrote the book. Once the novel is out there, the author is beside the point. The reader and the book have their own relationship now, and should be left alone to work things out for themselves. "I love the way you read," a woman in a signing line said to me recently. She told me about a favorite author whose books she had loved for years. But when she heard this author read, she couldn't stand her voice. "She was awful. I haven't touched her books since then." I told her with no small amount of passion that this woman, this author, wasn't important and should be forgotten. "Keep on loving the books," I said. "You don't have to love her." "I know," the woman said, "I know, but I can't get that voice out of my head."

The author's voice isn't the only thing that can be misleading. Chances are I can explain, in the course of a Q&A, my novel's dis-satisfying ending or my character's cloudy motivations, but who's to say I'm right? Once the book is written, its value is for the reader to decide, not for me to explain.

Of course book tour isn't just a month of living out of a suitcase, eating in airports, and cracking your forehead open against a wall in the middle of the night because you've forgotten where the bathroom is (I've done it twice). It is, if you are very lucky, also the excruciating repetition of interviews. I can do three radio shows, a ninety-second spot on a noontime local TV talk show, and telephone in two inter-views for two newspapers, all before showing up in a store. If the timing can be jiggled in the right way, I might even squeeze in a pod-cast. Ninety-five percent of the questions will be exactly the same. I don't expect them to be otherwise. But the twenty-eighth time I find myself in a glass booth with a microphone and a headset and someone says, "So tell me where the idea for this novel came from," something in my brain starts to come loose. "The book is about *you*," I want to scream. "I've been stealing your mail for years." Instead I dig down for my inner Laurence Olivier and try to *act* like a novelist. There were,

after all, many years that no one wanted to interview me, and then all the years when people interviewed me without reading the book. (You know when the interviewer hasn't read the book because the first question is always, "Let's talk about this really great cover.")

Excepting the consistent success of Jane Friedman and Julia Child, selling books isn't much of a science. Although you appear to be promoting your new novel, you never really tour for the book that's just come out. You tour for the book before that, the one people have read and want to talk about. Unless, of course, you're on tour for your first book, which no one has read or wants to talk about. A column in my local paper, the *Tennessean*, recently reminded me of that. The reporter remembered my appearance at a book-and-author dinner in Nashville in 1992, during which I sat alone at a signing table while huge crowds assembled for the other authors, Ricky Van Shelton (a country-music heartthrob who had written a children's book), Janet Dailey (the best-selling romance author), and Jimmy Buffett (no explanation necessary). The editor of the paper felt so sorry for me he quietly instructed twenty-five members of his staff to buy my book, stand in my line, and get my autograph, something I never knew had happened until I read it in the paper fifteen years later. All those dutiful employees were later reimbursed for the price of a hardback.

A few of the people who did eventually read *The Patron Saint of Liars* (whether they were paid to or not) came to hear me when I went out with my second novel, *Taft*. Then both *Patron Saint* and *Taft* readers came when I was in town with my third book, *The Magician's Assistant*. *Magician's Assistant* people came to see me when I toured for *Bel Canto*. There was a great deal of weeping on that tour. I kept extra tissues in my purse. People wanted to talk about the death of Parsifal, the magician, and what had become of Sabine, his assistant. No one wanted to talk about Roxane Coss, the famous soprano held captive in a nameless South American country. They wanted to talk about *her* six years later, when I went out with *Run*.

I sometimes think I should put my novels in a sample case, the

expensive new hardbacks on one side, the smaller, friendlier paper-backs on the other, and go door-to-door through some neighborhood in St. Louis with my wares. If someone wanted me to stand on the sidewalk and read to them, I would read. If somebody wanted his or her book gift-wrapped for the holidays, I would wrap. If they wanted to cry in my arms, I would hold them. The door-to-door sales perfected by Fuller Brush and various encyclopedia companies seemed to operate on a more reliable formula than the marketing schemes of publishing houses. Even as my audiences got a little bit bigger, most hovering in the fifteen-to-twenty-five range by the *Magician's Assistant* days, I could still fly halfway across the country to a room full of empty chairs. Who knew I was scheduled to read in Chicago on the night of an NBA playoff game (back in the days when that meant something substantial), or that Ethan Hawke would be reading from *his* new novel in the room across the hall from me at the Texas Book Fair? I never minded reading to three people. I had plenty of experience. The key is that all of you must sit very close together.

All this raises the question: Why don't I just stay home? Believe me, I've asked myself that many times, mostly in dark hotel rooms when the alarm goes off at four-thirty in the morning because I have a flight to catch. The answer is partly that touring is in my contract; selling is part of the job. But more important, I really do believe Allan Gurganus. Watching a book wither on the shelf would be worse than never having the chance to fight for its success. The market out there is big and crowded, full of noise and hype demanding the reader's attention. The book, not weighing much more then a pound, with no jack to plug it into, can use all the help it can get. I know a lot of writers whose publishers, whether for lack of funds or confidence, don't send them out. I don't know any writers who wouldn't jump at the chance to go.

Jane Friedman says what matters to her is that the tour is successful for the author, which means sending out people who have an established fan base. Gone are the days of simply dropping a newly

minted novelist into the ocean to see if she can swim. The process is too expensive, and too emotionally damaging, to replicate the kinds of tours I lived through in the early nineties. Yet I wonder who I would be, and where I would be, without those early, soul-crushing tours of duty. It would be like opening directly on Broadway without the formative years in vaudeville, where I was, quite literally, getting my act together.

Late one night, I was reaching the end of my signing line for *Run*, after having given a talk at Washington National Cathedral. A woman came up to the table with a girl who might have been sixteen, though I doubt she was as old as that. "It's awfully late for you to be up on a school night," I said to her.

"And it's going to be a lot later before she gets to bed," the mother said. The daughter was looking at the floor. "We've got a four-hour drive back to West Virginia tonight." She beamed at me. She was a mother, after all, and very proud of what she had accomplished for her child. "I knew you would tell her something she needed to hear, something she'd always remember, and you did. You're her favorite writer, you know. She's going to be a writer, too."

I wished to God I had something to give that child, an amulet or a golden compass, something that would have proved just how completely I believed in her. She didn't say a word to me, and I put my arm around her so that her mother could take our picture. I wrote her name and my name in her copy of my book. I thanked them both for coming, but there was no way to thank them enough. It was late, and people were still in the line behind them, and they had a long drive ahead.

(*Atlantic Monthly*, October 2008)

"The Love Between the Two Women Is Not Normal"

My sister, Heather, first broke the news about my pornography in the middle of last July. She lives in Spartanburg, South Carolina, where she was able to get her information from a couple of newspapers, the *Greenville News* and the *Spartanburg Herald-Journal*. My sister doesn't watch television, but a friend e-mailed her a link to a local TV news story and she watched it on her computer. She then sent it on to me with the attached note: *You've just got to laugh.*

As I didn't have to make my appearance at Clemson until the latter part of August, I had five weeks to decide whether or not to laugh.

This is the story: Clemson University, located in the button-sized hamlet of Clemson, South Carolina, had assigned *Truth & Beauty*, a memoir I had written about my friendship with the writer Lucy Grealy, to the incoming freshman class of 2006. Such reading programs are popular nowadays. The idea was born of the book club, a social activity in which the book is often nothing more than an excuse

for getting together with friends. Since Oprah took the book club na-
tional, entire cities have decided to read a single book, high schools
and colleges have picked one book as a way of bringing students to-
gether. Discussion groups are organized, papers are assigned, and
then, if all goes well, the author is brought in to give a talk, do a sign-
ing, meet and greet.

I know this drill. I have been the all-city read and the freshman
read and the radio-book-club read, as both a novelist and memoirist.
It's good work for an author: lots of books are sold, and an audience
that might otherwise have never thought of you starts searching out
your backlist. My extensive prior experience with one-book programs,
both civic and academic, had been uniformly positive, so when a
panel of Clemson administrators and faculty voted to assign *Truth &
Beauty* some ten months in advance of the late-August engagement,
I agreed to attend, marked it on my calendar, and then forgot about it.

I went back to my computer and watched the news clip again. The
reporter shook my paperback at the camera as if it were a bloodied
knife. "This is the book," she said. "And for at least one parent, there's
nothing beautiful about it."

That parent turned out to be Ken Wingate, a Clemson alum, a
lawyer, and a member of the South Carolina Commission on Higher
Education. His own children were not members of the Clemson in-
coming freshman class, but two of his nieces and a nephew were. On
the news, he outlined his problems with the summer-reading com-
mittee's selection. "The book talks in graphic terms about pornogra-
phy, about fetish, about masturbation, about multiple sex partners . . .
The book contains a very extensive list of over-the-top sexual and
antireligious references. The explicit message that this sends to stu-
dents is that they are encouraged to find themselves sexually."

Then the screen was taken over by a sleepy-looking coed who
seemed to have been stopped and questioned on her way to class. She
was a Clemson junior but her little brother was an entering freshman.
"I've heard that there's girls that are doing drugs and having sex at

early ages," she said in heavy South Carolinese, "and it's just not good for people to have to read."

In the Greenville paper, Mr. Wingate furthered his views. "I'm certainly not anti-Clemson," he said. "In fact, I love Clemson, which is why I've waded into this sewer, both in terms of reading the book and being an outspoken advocate for an alternative book, because this is inappropriate to shove down the throats of incoming freshmen."

"Did he call me a sewer?" I asked my sister.

"I think he's saying the book is a sewer," Heather said. "Or the circumstances are sewer-like. I don't think you yourself are a sewer."

Either way, the battle had been launched to keep the youth of Clemson and, I imagine, other citizens of South Carolina safe. From me. Ken Wingate had lost his bids for both the state senate and the governor's seat (for which in the 2002 primary he garnered a total vote of four percent) and had now turned his attention to me. To save the parents of freshmen and other concerned citizens the trip through the sewer that he himself had endured, he posted excerpts from my book on a website: every instance of profanity, every reference to body parts and their uses and to pharmaceuticals and illegal drugs that appeared within my pages was on his list. That way the citizenry could be fully informed without having to go to the bother of reading the book for themselves.

Nothing about this seemed especially shocking to me. I live in Tennessee. We're the people who brought you the Scopes Monkey Trial. I never did meet Ken Wingate, but I have been meeting people like him all my life. Still, his attention grated. To be charged with a crime you've committed is one thing, but a special kind of bewilderment comes of being wrongly accused, and I believed I had been wrongly accused.

Where Truth & Beauty errs, it errs frankly on the side of sweetness. It is a book that appeals to high school girls. In 2005, it won an award from the American Library Association for being one of ten adult books most suitable for teenaged readers. It is my own story, the

story of Lucy and me meeting in college, becoming friends in graduate school, and trying to find our way in the world as writers. Lucy, who had lost part of her jaw to cancer at the age of nine, had endured years of chemotherapy and radiation. She had thirty-eight reconstructive surgeries over the course of her lifetime. She was a spectacular person, brilliant and difficult, demanding and talented. She was capable of great love and tenderness, as well as great suffering. She was my best friend for seventeen years. After her death, at the age of thirty-nine, I wrote a book about us. I wrote it as a way to memorialize her and mourn her, and as a way of keeping her own important memoir, *Autobiography of a Face*, alive, even as I had not been able to keep her alive. This was a story of a Herculean effort to endure hardship, and to be a friend. Even when the details of our lives became sordid, it was not the stuff of sewers.

My friends from New York offered to go with me to South Carolina, expecting a gladiatorial match I would surely win. My friends from home read drafts of my speech and howled over the ever-growing stack of newspaper clippings. My friend from Mississippi told me not to go. "Cancel," she said. "Cancel, cancel, cancel." Mississippians tend not to be cavalier about the dangers of bigotry in the Deep South.

"I never cancel."

"There's a first time for everything."

Over at Clemson a hue and cry was being raised from a quickly gathering organization of concerned parents, who had read all the juicy highlights on the Internet. Not only were they calling to have the assignment rescinded, or, at the very least, to have a more appropriate book like *To Kill a Mockingbird* serve as an alternate choice, they also appeared to want me barred from campus.

"At a minimum," an alumnus wrote the university's president, "I trust that the current assignment will be pulled immediately and that the author's visit to Clemson will be cancelled. If not, shame on you and shame on Clemson University."

In an article published in the *Anderson Independent-Mail*, head-lined "Protesters: Little Beauty in 'Truth and Beauty,'" a reporter wrote, "In the book, there is an implied lesbian relationship between Ms. Patchett and Ms. Grealy." The article went on to quote a seventeen-year-old Clemson freshman who had joined in the protest. "The friendship and the love portrayed in the book are not exem-plary," she said. "The love between the two women is not normal." The reporter and the seventeen-year-old had finally come out and said the thing that no one else had had the nerve to mention: Lucy and I must have been having sex with each other. That was the only possi-ble explanation for our loyalty, love, and devotion. Sex was the payoff for a difficult relationship, and without the sex the whole thing made no sense.

I drove to Spartanburg and picked up my sister on the way to Clem-son. "If it had been a couple of guys who met in college and saw each other through sex and drugs and illness, it would have been *Brian's Song*," she said to me in the car. "They would have made a Movie of the Week out of it and named the football stadium after you."

We had been hoping that the controversy would have spun itself out like a summer storm before my arrival. No such luck. Mr. Win-gate managed to keep his disgust and disappointment in the papers, culminating his efforts with an on-campus news conference the day before my arrival. Excerpts of all the bad reviews of *Truth & Beauty* that had been posted by readers on Amazon were assembled in a flyer and distributed to passersby, but if anyone missed them, they were also posted on the website of a faith-based organization called the Palmetto Family Council, under the heading "Praise Not Universal." The site also provided a Bible-study guide for the book. The local paper claimed that seven students joined about forty parents, grand-parents, and alumni to protest.

"It wasn't that many," a dean told me as I was whisked into an

office upon arrival. "And he brought most of them with him." Still, the people in the dean's office, the people who had worked so hard to get me there, looked nervous. They looked really nervous.

"He took out a full-page ad in the paper." An assistant woefully passed over that morning's edition of the *Greenville News*. It had been paid for by "Upstate Alive," an organization I had never heard of.

In big orange letters, the ad in the *Greenville News* asked: "Is CLEMSON trying to educate students or socialize them?"

The freshman reading project at Clemson University is:

1. A violation of academic freedom of choice because it's RE-QUIRED reading.
 It's not optional and denies students a choice, which violates the "marketplace of ideas" ideal of the University . . .
2. A violation of the University's own sexual harassment policy, which states that sexual harassment of university faculty, staff, or students is prohibited.
 Yet these freshmen are required to join in group discussions about virginity, pornography, masturbation and seduction . . .
3. Not in harmony with the values of South Carolina or the Clemson community.
 . . . Forcing this book on Clemson students now is particularly inappropriate and insensitive given the recent rape and murder of a Clemson student.
4. Not supported by a majority of Clemson's faculty and staff.
 A small number of instructors chose this book without the advice or consent from the majority of faculty and staff.
5. A squandering of University, taxpayer, and student resources.
 In a time of record tuition increases, when many students must borrow tens of thousands of dollars to pay for college, the estimated $50,000 to cover the cost of nearly 3,000 books, the

> *author's speaker fee and travel expenses is a gross misuse of*
> *taxpayer and student funds.*

I was now somehow an accessory to rape, murder, and sexual harassment, and charged with participation in a $50,000 swindle. The ad also included a copy of Mr. Wingate's original letter to the president of the university, with a suggestion that he "pull the plug" on the author's lecture. I stood in the dean's office wishing that someone had been able to do exactly that. Then I went off to meet with seventy-five honors students.

"This is a very good group of kids," my escort assured me. "Only one of them refused to read the book on the grounds that it was morally offensive."

I wondered if, as a student, I could have opted out of French or math on similar grounds.

The honors students were easy. Perhaps that was because their numbers were small, or because the room was open and bright, or because they were served cookies, or because they were simply smarter than the other kids. I don't know. They asked straightforward questions about the difference between writing fiction and nonfiction, the reliability of memory, how I felt about the protests. They lingered at the door to shake my hand and have me sign their books.

Maybe my visit wasn't going to be so bad. That's what I wanted to believe. The voice of an unpleasant minority had taken center stage. After all, who ever took out a full-page ad to say how thrilled they were about a freshman summer-reading program?

Clemson's is a pretty campus with redbrick buildings and old-growth trees. It sweeps along with just the degree of majesty that one looks for in a southern college. The worst thing I can say about the campus is that it was very difficult to find a restroom. When the school first opened its doors to women in 1955, they never did even out the number of bathrooms. So while it's easy to find a men's room in the older

buildings, the women's rooms required a great deal of hunting. "Couldn't they just tack the word 'Women' on a couple of the men's doors?" I asked. How hard could it be to attain equality on this very basic front?

"Oh, no," my escort told me in a whisper. "There are urinals in there."

And so my sister and I hiked up to the third floor, to a place were we could use the facilities without being disturbed by urinals.

Next we were off to a luncheon at the president's house. The faculty and trustees in attendance, as well as the president himself, were in full support of my visit. They had spent the last six weeks on the front line of criticism serving as my tireless defenders. The state legislature had been pressing for more control over Clemson's curriculum for some time, and the storm over *Truth & Beauty* had finally pushed the question of who made those choices out into the open. At the long dining room table, everyone seemed more than pleased that I was there to fight the good fight for higher education. The problem was, I was not inclined towards a fight. I hadn't been paid for one. I had only been brought in to talk to students about a book.

"If there's any problem during your speech," the president told me, "just step away from the podium. There will be someone there to take you off the stage."

"A problem?" I asked.

Over a salad of sliced chicken and fat berries, I was assured that problems were unlikely. Parents and protesters would be watching my speech as it was simulcast to them in an auditorium across campus. Only the incoming freshmen would be in the coliseum. And if a problem arose, I'd have a bodyguard.

I felt that someone should have mentioned the bodyguard to me sooner, as well as the protesters at their off-site location. It would have influenced my thinking on how to proceed, because while I believe in academic freedom and the right to chose a book without legislative

consent, I did not believe in them as much as I believed in my safety, at least not in the state of South Carolina. Maybe I could see laying myself down on the altar of higher education in Tennessee, but as far as I was concerned, South Carolina was on its own.

I was to address the incoming freshman class of nearly three thousand in the Littlejohn Coliseum, home of the Clemson Tigers. When I arrived, the place had the bristling energy of a rock concert waiting to happen. The arena had been cut in half by a series of high black drapes so that the students would fill every seat, shoulder to shoulder, all the way to the nosebleed section four tiers up. In the middle of the basketball court, near the toe pads of the giant orange paw print that marked the floor, was a boxlike stage, a temporary affair decked out with a few potted palms and a lectern with a microphone. Behind it was a projection screen that would have been a reasonable size in any suburban cineplex. The screen would show a giant movie of my face that could be clearly seen by both the students in the rafters and the angry mob on the other side of campus.

After the president had made his remarks about all the wonderful things the next four years of a Clemson education would bring, I walked through the pitch-black darkness, climbed the stairs, and stepped into the klieg lights. I received a very healthy round of applause. After all, only seven of the nearly three thousand students present had bothered to show up at the protest. I had never thought that Wingate and his people spoke for Clemson. I only believed he spoke loudly enough to drown out all the voices around them.

I put a ridiculous amount of effort into the writing of that speech, and no small amount of energy into the delivery. I made an impassioned plea for the right to read, for the importance of going to the primary source to form one's opinion and not to rely on secondary sources to make the decisions for you. These students were, for the most part, old enough to vote and go to war. They had seen cable television, vis-

ited Facebook, listened to rap music. To say that a book could be so potentially corrupting was to say we had no faith in their ability to make decisions for themselves. Would *Anna Karenina* lead them to affairs and then a tragic death beneath a train? I told them that the people who had tried to protect them from my book and from me thought they lacked the maturity and judgment to make their own decisions, and then I ran through a list of all the other books and authors and classes they would need to be protected from. Goodbye, Philip Roth! Farewell, *Lolita*. So long, Jay Gatsby. I explained how they could so easily lose science and history and art. On I went, a marvel of civility and common sense, while behind me the giant projection of my head kept pace. There in the blackened arena I raised a mighty cry for the right to read, and implored the students to never let anyone take their books away from them. It wasn't until later, weeks later, that the stupidity of my argument began to sink in. *Anna Karenina*? *The Great Gatsby*? How many of those kids even knew what I was talking about? Was it such a perilous threat to say, Let them take away *Truth & Beauty* and the next thing you know you'll lose a really great book like *Lolita*? Don't you have to first love *Lolita* to imagine the magnitude of that loss?

Back at the basketball court, we were experiencing technical difficulties. The question-and-answer portion of the event was falling apart. The microphones weren't working at first, and soon students were shouting out questions in the dark: *Is there anything you regret about your friendship with Miss Grealy? Do you feel differently about other friends because they'd never measure up to Lucy?* Some of the questions had a nasty edge: *Lots of people have friends and lots of people have cancer so why should we care about what you have to say?* Some of them were sweetly goofy: *Do you have any advice for finding true love?*

One kid found a microphone that was working. He wanted to know how long I'd known my husband.

"Twelve years," I told him.

"Well, after reading your book and hearing you talk, I just wanted to ask you, how many times have you cheated on him?"

I raised my hands up against the blinding lights. I had no idea where the voice was coming from. What eighteen-year-old asked this kind of question when the lights were up, when you could see him and knew his name? I asked what made him think I would cheat on my husband.

"Well, you seem to be okay with all that after writing your book."

I gave some decent-enough answer about compassion and not judging other people, the kind of answer you later rescript a thousand times in your head, but I didn't actually understand what he was talking about, not while I was leaving the stage, not during the mockery of a press conference that followed. I didn't understand him when my bodyguard put my sister and me in a van that had been driven up under the coliseum to speed us to the other side of campus and to my car so that we could get away before anyone figured out where we had gone. The rain, which had started at some point during my talk, was coming down in blinding sheets now, rendering the campus a muddy pit as we made our mad dash for the car. In three steps we were soaked through. We drove away as fast as the weather would allow, and still I didn't understand him. Not until the middle of the night, when I was back safely in my sister's guest bed, did I realize that he wasn't saying I was immoral for not judging Lucy. He was saying I was immoral for the things I had done myself.

Clemson was kind to provide me with all the documents I needed to write this article. They not only sent me copies of all the newspaper articles I'd ask for, but they also sent me letters that had been written to the president, cries of outrage and revulsion at the thought of my work and my person.

If Clemson continues to offer pornographic material such as Patchett's book, my daughter, and my money, will go elsewhere . . . I cannot fathom what led Clemson to build a class around this drivel.

For reasons I know you are aware of, it was an inappropriate selection. I've not read the book, nor do I intend to.

Surely the university could have picked other subject matter to stimulate the minds of entering freshmen, such as the AIDS epidemic on the continent of Africa, the ongoing Middle East crisis or the flattening of the world in respect to technology's effect on the global economy. [Why Africa? I wondered. This one was from a state senator.]

I believe in academic freedom. I believe however it is freedom to do good. After all, what is the basic original founding purposes of the institutions of higher learning in the United States of which I'm sure you are most knowledgeable?

I guess I am accustomed to hearing about cases like this at liberal havens like Harvard, or even Chapel Hill, but I am shocked that Clemson has now stooped to this. No matter what the supposed motive behind this assignment, it is nothing more than another attempt by liberal academicians, given over to depraved minds, to force a deviant sexual agenda on young students.

I am very proud of Clemson University for continuing to have a prayer before each football game even with threats of law suits from the ACLU. I do not have the same feelings about this summer reading assignment.

In 2002, right after 9/11, the University of North Carolina assigned a book composed of selections (or suras) from the Koran for its incoming freshman to read. UNC followed several years later

with a socialist tome (*Nickel and Dimed*, by Barbara Ehrenreich). Now Clemson is getting into the act. But instead of religion or politics, Clemson has chosen sex.

It was this last letter that made me realize the extent to which I had never understood the rules of engagement: if *Nickel and Dimed* was a socialist tome (albeit a slim one), then *Truth & Beauty* was pornography. Like beauty itself, pornography turned out to be in the eye of the beholder.

The only letter I kept was one written in pencil on a sheet of notebook paper. A student had slipped it to my bodyguard, who had given it to me: "Dear Mrs. Patchett, On behalf of the entire state of South Carolina, I am sorry for what happened."

After it was over, my sister told me I should look at the online Bible-study guide to *Truth & Beauty*. She had read it with plans to wage a battle against the Palmetto Family Council, but in the end she changed her mind. "It's not as bad as you'd think," she said.

Not as bad, but still, in my experience there is no equivalent to seeing yourself as a character in a series of Bible-study questions (helpfully accompanied by scriptural references), or in seeing a neat explanation of the suffering and death of your friend.

> Question Five: How would you characterize Ann and Lucy's friendship? In what ways was common grace exhibited in Ann's friendship toward Lucy? What is a friend? Describe the qualities.
>
> Question Six: When Jesus was accused of being a "friend to tax collectors and sinners," do you think Lucy would have been included in or excluded from His circle of friends? Why? Can you think of instances in which Jesus befriended the "Lucy's" of His day? How did He deal with them? What do we learn from Him?

Question Eight: Self-righteousness is an insidious spiritual disease which is a betrayer of the gospel of grace and a great hindrance to evangelism. What is self-righteousness? Why is it such a hindrance to evangelism? How does the gospel of grace enable us to repent of our self-righteousness and free us to share the gospel with compassion?

Maybe I was all right with it for a while. I read their answers, too, and in those answers Lucy and Jesus walked together as friends. The self-righteous exuded a condescending air of moral superiority that non-Christians are rightly repulsed by. I appreciated that. It was Question Ten that stopped me: "How would you share the gospel with Ann?"

I looked at that one for a long time, and I knew without checking that the answer sheet and I were no longer in accord.

In my better moments, I tell myself what happened was a noble battle between freedom and oppression, but I know it is equally possible that nothing so lofty occurred. Some people find sex and suffering and deep friendship between women unpalatable subjects, and seeing this book bearing down on their children, they no doubt felt they had to try and stop it. They didn't succeed, but I seriously doubt that anyone was harmed by completing the assignment. If I am the worst thing the students of Clemson have to fear, then their lives will be very beautiful indeed.

(*Atlantic Monthly*, October 2007)

The Right to Read

The Clemson Freshman Convocation Address of 2006

I WOULD LIKE TO thank the people at Clemson who extended this invitation to me, and I'd like to thank them for sticking by it. I am very glad to be here. I would like to thank my supporters for their kindness and my detractors for their patience. When I consider the state of our public education system, the state of health care, the facts of poverty and war that we live with, I would hope that the passions of protesters could be put to greater use, but I didn't get a vote on this one, so here we go.

Imagine if you will a very little girl of nine who gets hit in the head with a volleyball one day during recess. She goes to the hospital, and it turns out her jaw is broken. But it won't heal and it won't heal and her parents keep taking her back to the doctor, and finally, months later, somebody figures out that her jaw is full of cancer. It's a Ewing's sarcoma and it has a five percent survival rate. Nobody tells Lucy this because they figure she's a child and she's going to die anyway. Nobody tells her when she's going into surgery, or all that time after surgery that she has bandages on, that she's lost half her jaw. When she finally

gets out of the hospital, she starts chemotherapy. She's one of the first children in the country to have chemotherapy, and because chemotherapy then was a much stronger and less refined business than it is now, she described it as being burned alive. She goes in five days a week for a combination of chemo and radiation, and together they last for a total of two and a half years. All but six of her teeth fall out. For all of that time she is bald. When she finally goes back to school, none of the girls will sit with her at lunch. The boys wait for her in the stairwells to bark and scream and chase her. In the course of her life she has thirty-eight reconstructive surgeries. Muscles, bones, tissue, and veins are stripped from every part of her body to try to put her face back together again, but because of the enormous amount of radiation every graft eventually fails. And despite all of this, or because of it, she turns out to be the smartest person you'd ever want to meet, the most widely read, the most intellectually curious, the funniest, the best dancer.

When she got fed up with people staring at her, Lucy wrote a book called *Autobiography of a Face*. It's the story of what happened to her. It's about her belief that none of us ever really feels we are good enough, beautiful enough, loved and accepted enough. For a while she was a celebrity. She wound up on CNN and *Oprah* and the *Today* show. She looked straight into the camera and hoped that someone out there would fall in love with her. You have never known anyone so brave in your life. Not fearless, mind you, she was too smart, too experienced, not to understand how terrifying life could be, but she faced it anyway. I cannot begin to tell you how much I loved her and admired her, and when you love someone, really love them, it would never occur to you not to stick by them.

I stuck by Lucy after she died, too. Her death, like her life, was the subject of great rumor. I heard she died of cancer. I heard that she had overdosed over a canceled book contract. I heard she jumped from the roof of an apartment building where she no longer lived. I wanted to

set the record straight, to tell the truth about what had happened, but that's really only a small part of what set me writing. Lucy was as complicated as the giant books of philosophy she loved to read; I knew that I would never be able to hold her in my mind exactly the way she was. I knew that every year she was dead her memory would become simpler. She would be easier and sweeter, and I didn't want that to happen. It was, after all, Lucy's bravado and her ferocity that I loved so much. I thought that if I wrote it all down, the story of the two of us, the story of friendship and what we had done together, that I could press her between the pages of a book like a maple leaf and keep her.

Certainly even people coming from the most intellectually re-stricted backgrounds imaginable know that books far more salacious than mine have been published and widely read. The problem isn't that Lucy and I made the choices we made in our lives because, again, the faintest brush against society would show that plenty of people make worse choices. The problem isn't even that you read my book, because chances are you've played a round of Grand Theft Auto in your day. You're on Facebook, you've watched HBO, watched the news. No matter how pure your hearts are, I seriously doubt that anyone thinks that my book was the very first time you've seen any mention of sex, drugs, depression, or abiding friendship. People may not like the idea that these things are going on or that I wrote about them or that you read about them, but none of that is enough to start a protest or make the news. The problem here is that your chosen institution of higher learning has given you this book as an assign-ment. It's the fact that if you want to enter this freshman class at Clemson you pretty much have to read it.

The people who oppose the assignment of *Truth & Beauty* and who oppose my presence here on campus today do not do so for them-selves. After all, nobody's making them read my book. They are op-posing on your behalf. They want to protect you from me, even if they

were unable to protect you from Grand Theft Auto. Since you're just starting out as freshmen, let's take a few minutes to think of what else you're going to need protecting from. I used all possible restraint in making this list because I could go on for the entire four years you are in college: You don't want to pay good money to have to read about immoral behavior, so *Anna Karenina* is out. It's about adultery, a married woman's affair with another man, and her eventual suicide. It's scandalous, but it's also really long. *The Great Gatsby* has more adultery, in addition to alcoholism and murder, so that has to go as well. It will be harder to let go of that one because it's short, and you may have already read it in high school. *One Hundred Years of Solitude*? You've got incest, which is a shame, because it is a spectacular novel. My uncontested pick for the best novel of the twentieth century is Vladamir Nabokov's *Lolita*, and if I start talking about *Lolita* I feel certain the National Guard will come and remove me from this stage. Faulkner is gone. Hemingway is gone. Toni Morrison, John Updike, and Philip Roth, our greatest living American authors, are off-limits to you. There is so much sex and filthy language in their books that I should probably not even say their names.

But maybe those books aren't the problem because they're all fiction. Maybe what's upsetting about my book is that it's true. So let's make a pact not to read any nonfiction that could be upsetting. If stories about girls who are disfigured by cancer and humiliated by strangers, and turn to sex and drugs to escape from their enormous pain are too disgusting and pornographic, then I have to tell you the Holocaust is off-limits. The Russian Revolution, the killing fields of Cambodia, the war in Vietnam, the Crusades, all represent such staggering acts of human depravity and perversion I could see the virtue of never looking at them at all.

But it doesn't stop there. Almost every field you can think of has a history of controversy: art, economics, philosophy. Will you not read Nietzsche if he says there is no God? In which case science is out

because science can also conflict with faith. Math is fine. Calculus, physics, chemistry. Plan to take a lot of those classes.

The implicit assumption in trying to protect you from the likes of me is that you have no filters, no life experience, no judgment, and very little intellect. You are so malleable that reading an assigned book, one that mentions drugs and sex, will make you throw the book to the floor and rush out to engage in all of those activities yourself, the chances of which seem about as likely to me as the chances that reading *Anna Karenina* will make you throw yourself beneath a train. It also assumes that Tolstoy's book is not, more importantly, about the inherent beauty of life and that my book is not about the deep value of loyalty.

Since this is your first week of college, it's a good time for you to think about why you're here. Unlike your first twelve years in school, your education is no longer compulsory. What that means is that you are choosing to be here. No one, not even your parents, can make you go to college. Your education is an enormous privilege that sets you apart from most of the people of the world, including most of the people in your own country. Just over twenty-five percent of Americans your age will receive a college education. One in four. I want to emphasize this: higher education is a privilege and a choice. It is perhaps the first real choice of your adult lives. Many of you are taking out loans, getting jobs, and shouldering some or even all of the cost of this choice. The rest of you, I trust, are appreciative of the people and institutions in your life who are making this education possible. The number-one purpose of your time at Clemson is to broaden and deepen the scope of your intellectual ability. Everything else—sports, social life, fraternities, sororities, campus politics, everything else—comes behind academics. You are here to learn. The time-honored way that people learn is through apprenticeship. If you wanted to be a glassblower, you'd go and study with a master glassblower; you would follow his movements and try to

absorb his knowledge. A university is basically a large consortium of individuals who have expertise in their respective fields so that you have the chance to apprentice yourself to those who have done advanced work in mathematics and literature and economics. You can sample an enormous range of intellectual pursuits and in doing so you can discover who you are and what you're best at.

Unless, of course, you get into the business of being protected from what might offend you or upset you, of having other people decide what you can and cannot learn. The best answer to this I've found is in a convocation address given by the poet Adrienne Rich. She titles it "Claiming an Education," and in it she wrote:

> Responsibility to yourself means refusing to let others do your thinking, talking, and naming for you; it means learning to respect and use your own brains and instincts. . . . Responsibility to yourself means that you don't fall for shallow and easy solutions— predigested books and ideas . . . taking "gut" courses instead of ones you know will challenge you, bluffing at school and life instead of doing solid work. . . . This means seeking out criticism, recognizing that the most affirming thing anyone can do for you is demand that you push yourself further, show you the range of what you can do.

You have made the decision to go to college. You are old enough to drive a car, to vote, to pay taxes, and to go to war. You are not children, even if there are days it still feels that is the case. The best way to make sure that your parents and teachers treat you as adults is to act like adults. Take responsibility for your lives and your minds and ask that others respect your integrity. Be very proud that you have enrolled in an institution that considers you to be adults, that respects and defends your right to learn, and does not capitulate to forces that say you're not up to the task of making a decision for yourselves.

You are about to open your minds. A college education is about expansion. It's about seeing many different viewpoints, hearing many different voices. You will find that the more you learn, the more complicated things get, because you will have the intelligence to recognize many aspects of a single idea. You will learn to use your mind in the way an athlete uses her body. You will stretch and strengthen and grow. And this is precisely why so many people are afraid of higher education; it's simply easier for them to see the world in terms of right and wrong. They've got one clear answer for everything and they're sticking to it. But you have the chance to fearlessly move beyond that now if you are willing to explore what is available to you.

I have always been a fiction writer, but over the years I've made a lot of my living as a journalist, and one of the first things a journalist has to understand is the difference between a primary and a secondary source. If you can embrace this concept, much of what you do in college will be easier for you. A primary source is the thing itself and a secondary source is an interpretation of or a report about that thing. Say you're writing a paper on *The Great Gatsby*. The novel itself would be your primary source. Articles and books written about that novel would be secondary sources. CliffsNotes, heaven forbid you ever touch them, would be a secondary source. Say you wanted to write a paper on South Carolina's governor. Your best primary source is to get an interview with the governor himself; other primary sources would be people who actually know him: his assistant, his chief of staff, his wife. When you get your information from newspaper articles, then you're using secondary sources. Any teacher, and any journalist, will tell you that secondary sources are extremely important. You can look to other people's opinions to help you shape your thesis and to help you see other aspects of an idea you might not have considered. But whenever possible, you need to go to the primary source to make your decisions. Regardless of whether or not you're a student, it is never enough to rely on other people's ideas. You have to look at

the thing itself and make up your own mind. That's what it means to study and to learn. Some secondary sources proclaim their points of view so loudly and with such passion you might be tempted just to take their word for it. You might be tempted not to do the work of checking to see for yourself. But there can be a fine line between obedience and laziness, and if you go through life dutifully taking other people's word about what's right, you are putting yourself in the position to be led down some very dark roads.

After the opportunity to learn, the best thing about going to college is all the friends you're going to make. You may be feeling a little lonely at the moment, but that's about to change. There are people in this room today you've never met who will become some of the most important people in your lives, and long after you've forgotten the papers you wrote or the grades that you made, you'll still have your friends. It was my friends I turned to when I needed to sort through the things I wanted to say to you today. I was especially sorry that I couldn't give Lucy a call. In light of everything that's happened, I found myself losing sight of the fact that I was invited here to talk about the book I wrote about my best friend—dear, sweet, scandalous Lucy. She would have thought all of this was hilarious. She did not take her critics to heart. She had cut her teeth on criticism so virulent and vile that it would make what I have come up against seem like a walk in the park.

The ability to have a friend, and be a friend, is not unlike the ability to learn. Both are rooted in being accepting and open-minded with a talent for hard work. If you are willing to stretch yourself, to risk yourself, if you are willing to love and honor and cherish the people who are important to you until one of you dies, then there will be great heartaches and even greater rewards.

I am glad that I was able to give this controversy so much thought, and I'm glad that I've come to the conclusion that the objection was to the assignment of my book and not the actions of my friend. If you do

judge Lucy, then I suggest you go to bed tonight and pray that what happened to her will never happen to you or anyone you love. She was judged plenty in her life. She was judged every single time she walked out the door. I think that would be judgment enough.

In the opening pages of that scandalous classic *The Great Gatsby*, the narrator, Nick Carraway, says, "In my younger and more vulnerable years my father gave me some advice that I've been turning over in my mind ever since. 'Whenever you feel like criticizing any one,' he told me, 'just remember that all the people in this world haven't had the advantages you've had.'"

I was twelve years old the first time I read that book. I remember because I took it with me to Girl Scout camp. It was a grown-up novel about a young man who longed to fit in with everybody else. I'm sure there were parts of it I didn't understand, but I got most of it. Certainly I understood what he was talking about in that quote. I've read the book probably a dozen times since then, and every time it's meant more to me. I've come back often to the advice Nick Carraway got from his father, and it's helped me find compassion when I didn't think I had any. I will tell you I am leaning on it heavily today, because I have felt like criticizing, and then I stop and remind myself that maybe other people haven't had the advantages that I've had. I had the chance to learn from Lucy, from her failures and her successes, from her enormous capacity to love and be loved in return. I'm glad that no one took my book away from you, because now you've had the chance to learn from her too. Thank you for your time and attention, and no matter what anyone tells you, keep reading.

(*South Carolina Review*, Spring 2007)

Do Not Disturb

⸱

As a child I was slight and had a remarkable ability to hold still. These two features, coupled with a good imagination, meant that I was pretty much unbeatable at hide-and-seek. I could just stick a pillow in the closet, climb into the bed in its place, fold the bedspread neatly over my back, and stay there in a pillow shape for hours while other children called my name. All these years later it is appalling how much of my fantasy life has to do with hiding. I'm sure the witness protection program would be a terrible thing, and yet, when life threatens to overwhelm me, I find myself wondering if there isn't some mobster I could rat out in exchange for a false identity. The same goes for prison: dreadful, horrifying, surely, but the phone would never ring, and couldn't you get an awful lot of reading done? None of this is to say that I do not love my life; I do. But all those splendid guests who come for dinner, and then come back to stay for long visits (because they love you, because you love them) had turned my life into an overpopulated Russian novel. Sometimes it is the wonderful life, the life of abundant friends and extended family and true love, that makes you want to run screaming for the hills.

This is the point at which I become very clearly of two minds. One mind rejoices, *How rich I am to have the pleasure of a full house!* While the other laments: *If I am ever going to get anything accomplished, I'd better start packing.*

And so, feeling the end of my wits approaching, I am driven out of my home by the company, the laundry, the mail and the e-mail, and by my own stupid and compulsive need to keep baking the apple pie out of *The Pie and Pastry Bible*, even though it is labor-intensive beyond belief and only guarantees that everyone who drops by will drop by again. I make a couple of phone calls, drag the suitcases out of the basement, and offer some brief words of explanation to my husband, who knows me well enough to know that when it's time for me to go, it's better just to stand aside.

Then I fly to Los Angeles and check into the Hotel Bel-Air.

In many ways this is not the best choice: I know a lot of people in the Los Angeles area, many of whom are related to me, and none of them will be pleased to learn that I was hiding in their general vicinity without coming to visit. I simply decide not to tell them while temporarily deluding myself into believing that they'll never read this. For a fraction of what I'm spending on my stylish seclusion I could just as easily have booked into a Best Western in Omaha or Toledo, cities where I know not one single soul whose feelings I could hurt. Seeing as how my goal is to soak up some quiet and get a massive amount of work done, what difference would it have made?

A Best Western? The Hotel Bel-Air? I'm no fool. Life affords us very few opportunities to run away, and so if I'm going to do it I might as well do it up right. Besides, I love L.A., and even though I didn't grow up here, it is the city of my birth. I love the palm trees and the bougainvillea and the bright blue light of the late afternoons. I find the ways that it is exotic both comforting and familiar. Besides, I've been rereading all of Joan Didion's books lately and she always makes me want to go west. Checking into the Bel-Air for a while seems like

exactly what she would have done in the face of too many house-guests.

Because I have no plans to go anywhere, I do not rent a car. I have no desire to sightsee or shop. For one brief moment I think it would be nice to go to the Getty again, and then I put it out of my mind. I am the guest editor for this year's *Best American Short Stories*, and so I have arrived with a suitcase full of fiction needing to be read and a laptop computer containing a half-written novel that should be a fully completed novel by now. My idea of a vacation is getting my work done with privacy and quiet, not driving around. Whatever diversions I require will be provided by the sweet gum trees on the patio outside my room.

Californians are never comfortable with the idea of not having transportation. When the desk clerk checks me in, he tells me all the places the hotel car will gladly take me for free, over to Wilshire or down Rodeo Drive, where movie stars drink lattes with shivering Chihuahuas on their knees. I shake my head. "I don't want to go out," I tell him. "I've come to work."

"*Work* isn't a word we use at the Hotel Bel-Air," he tells me.

I make a mental note not to mention it again.

I haven't come to the Bel-Air because I'd stayed here before, but because my father had once brought my sister and me here for lunch when we were girls. I remembered how the grounds were like an over-grown jungle where steep ravines fell into streams and vines twisted up over every available surface. I remembered the swans, enormous floating ottomans with slender white necks that we watched from our table as we ate. It is where Marilyn Monroe used to come, and later Nancy Reagan, and in between them, many, many others who wanted to be left alone.

Upon my arrival, the Hotel Bel-Air sends over a pot of tea and a lovely fruit plate. My friend Jeanette, who stayed here once fifteen years ago, told me they brought the guests cookies and a glass of milk

every night at bedtime. The cookies were so beautiful she took their picture. But times change. There are no cookie-eaters left in the Bel-Air now.

On my first morning I hit the ground running, which is to say I roll over in bed and start right in on the pile of short stories. I eat the fruit for breakfast and drink the cold leftover tea and it's fine. The silence in the room is so intoxicating that I can't bear to leave it. At noon I take a swim in the pool, which is kept at a considerate eighty-two degrees. There is no one else in sight, and so, in accordance with the posted warning, I swim at my own risk.

After unpacking, I discover I have devoted much too much of my luggage space to short stories and not nearly enough to my wardrobe. When I turn up at the hotel's restaurant for lunch, looking neat and presentable but not the least bit stylish, the hostess wants to know about my reservation, which I do not have. It is late. People coming for lunch later than this must be very hip indeed. The terrace has half a dozen empty tables, but she seats me indoors, where I have the entire place to myself. I could complain, but I figure if I've come to be alone then I might as well be alone. From my table inside I watch the glamorous women outside lunching on spa Cobb salads with neither blue cheese nor dressing. The man with the bread basket wanders from table to table, lonesome as a cloud. When he comes to me his basket is full and perfectly arranged. He gives me a smile of deep and sincere pleasure when I tell him I will take both a sourdough roll and a cheese stick.

It doesn't take long to catch on to the fact that coming to this particular hotel for anonymity reflects a level of genius that I never knew I possessed. It is a hotel whose reputation was built on catering to people who are hiding, but those people hide in a much flashier manner than I do. They hide beneath hair extensions and giant Chanel sunglasses. The windows of their Jaguars are tinted. It is the

kind of hiding that demands and receives a great deal of attention, in contrast to my kind of hiding, which basically constitutes staying in my room and frustrating the housekeeping staff. The hostess at the restaurant gives me the word that if I want to eat there again tomorrow I'm really going to need a reservation, and so I make one, but when tomorrow comes I find that I don't have the energy for it. I stay at the pool and swim and read stories. The guy who brings the towels lets me eat all the fruit I want from the gorgeous basket beside the bottles of Evian. I'm still a little hungry but certainly not hungry enough to do anything about it. After a while a blonde who is somewhere in her late fifties takes up residence on the chaise longue next to mine. Even though there are probably forty empty chaises around the pool, these are the only two that bask in a slight shimmer of sunlight. The plant life at the Bel-Air is so teeming and lush, Tasmanian tree ferns and giant palms, towering camellias and gardenias, that the entire place is locked in shadow. The woman beside me is very beautiful, rather like an aging Elke Sommer or any of John Derek's wives. She has pretty legs and a soft middle and wears a tiny pink bikini that is trimmed in what appear to be closely placed pink carnations. Every fifteen minutes or so we pick up our towels and move two lounge chairs down, following the sun as best we can. "It is cold," she says to me in a Russian accent, and then returns to her sudoku puzzle. These are the only words any non-staff person has spoken to me. For a moment I imagine that she and I have come to the Bel-Air in hopes the air will strengthen our fragile nerves, or that we are guests at the tuberculosis sanatorium in *The Magic Mountain*, wrapped up in fur blankets and waiting to have our temperatures taken.

There are two sides to the Hotel Bel-Air. On one side is the busy restaurant, where well-groomed people have discussions, loudly and with great seriousness, about television shows. To make a sweeping generalization based on several days of captive observation, I would say that men have breakfast meetings and women have lunch meet-

ings and everybody talks about the Golden Globes, Ray Romano, and episodes of *Lost* and *CSI*—or at least those are the words I hear repeated continually while I butter my toast ("toast" being another word that is bandied around a great deal, as in "No toast" and "Egg whites, no toast"). After several days of being forced into the role of passive audience for everyone else's star turn, I decide I want a little attention of my own. If I were embracing my solitude as fully as I claimed to be, I would order the vegetable frittata, but I am so wild, such a spontaneous fool I am practically Anita Ekberg wading into the Trevi fountain. I tell the waiter I'll have the pancakes. This proves a mistake; they are bricklike and slightly sour. It is never wise to order the meal that no one else would touch. Still, there are plenty of wonderful things to eat at the Bel-Air. At dinner, the food is best when it is at its heaviest and most formal; the scallop fondue and the poached Maine lobster are as delicious as they are expensive. If you don't feel up to a very fancy meal you can slip off to the bar, where the waiters are friendly, the pianist is charming, and the food is very bad. If you accidently slip up and order the chicken pot pie do not, under any circumstances, eat it.

On the other side of the Bel-Air—you will know it when you see the sign that reads "Guests Only Beyond This Point"—are the hotel's guest rooms. Over there everything is perfectly quiet, so quiet that I sometimes wonder if I am the only person who is sleeping over. (I never see my friend in the pink bikini again.) One night, when I am returning to my room from dinner alone, a man in a suit hurriedly follows me towards this demarcation. "May I assist you with something?" he says pointedly. I feel a little bad about this, because I have gone out of my way to dress up for dinner and I believe I bear a remarkable resemblance to a guest, but I must be wrong. I explain that I am staying at the hotel, that I've been staying at the hotel for a while now, and while he doesn't look completely convinced, he allows me to cross over. Here the scent of the purple saucer magnolias blends with the whiff of chlorine coming from the burbling fountains. It is a smell

I have always associated with Southern California, and one that I dearly love.

What we want out of a vacation changes as we age. It changes from vacation to vacation. There was a time when it was all about culture for me. My idea of a real break was to stay in museums until my legs ached and then go stand in line to get tickets for an opera or a play. Later I became a disciple of relaxation and looked for words like *beach* and *massage* when making my plans. I found those little paper umbrellas that balanced on the side of rum drinks to be deeply charming then. Now I strive for transcendent invisibility and the chance to accomplish the things I can't get done at home. But as I pack up my room at the Hotel Bel-Air, I think the best vacation is the one that relieves me of my own life for a while and then makes me long for it again. I am deeply ready to be seen, thrilled at the thought of my own beloved civilization. I have done a month's worth of work in five days. I have filled up to the gills on solitude. I am insanely grateful at the thought of going home.

(*Gourmet*, August 2006)

Introduction to *The Best American Short Stories 2006*

————————— ○ —————————

THE SHORT STORY is in need of a scandal.

The short story should proclaim itself to be based on actual events and then, after a series of fiery public denials, it should hold a press conference in Cannes and make a brave but faltering confession: None of it actually happened. It was fiction all along. Yes, despite what's been rumored, it has always been fiction and it is *proud* to be fiction. The short story should consider staging its own kidnapping and then show up three weeks later in *The New Yorker* claiming that some things happened that cannot be discussed. Or perhaps the short story could seek out the celebrity endorsement of someone we never expected, maybe Tiger Woods, who could claim that he wouldn't dream of going out to the ninth hole without a story in his back pocket. They are just the right length for reading between rounds. It doesn't really matter what the short story chooses to do, but it needs to do something. The story needs hype. It needs a publicist. Fast.

I can speak to the matter with great authority because I've been

reading a lot of short stories lately, and the very large majority of them have been shockingly good. They are better than the novels I've been reading. They are more daring, more artful, and more original. Yet although I know plenty of people with whom I can discuss novels, there are only two people I know with whom I can swoon over short stories: Katrina Kenison Lewers (more on her later), and my friend Kevin Wilson, a young writer who reads literary magazines the way other people read pulpy spy novels, the kind of friend you can call in the middle of the night and ask, "Have you read the latest issue of *Tin House*?" As valuable as these friendships have been to me, I am sorry to say they are not enough. Since I have recently given my life over to short stories I need to find a larger audience than two. I have the zeal of a religious convert. I want to stand in the airport passing out copies of *One Story* and *The Agni Review*. I want to talk to total strangers about plot and character and language. I'm more than willing to take the message to the people, but the short story is going to have to work with me here. It has to be a little less demure.

The first thing the short story must consider is casting off the role of "The Novel's Little Sidekick," the practice run, the warm-up act. I was extolling the virtues of a particularly dazzling short story by Edith Pearlman to an editor friend at a major publishing house recently when she cut me off in mid-sentence, said she didn't want to hear it. "I'll only fall in love," she said bitterly, "and then I won't be able to buy the book, and if I do buy the book I won't be able to sell it." Short stories, it seems, are a dead-end romance in publishing. In the rare instance when a house finally does break down and buy a collection, the usual stipulation is that it must be followed by a novel, which is to say, something that might sell. But must you think so far down the road as to how things will end? Love the short story for what it is: a handful of glorious pages that take you someplace you never knew you wanted to go. The short story isn't asking to be a collection, and it certainly isn't trying to pass itself off as a potential novel. Who's to say

the short-story writer has a novel in him? Is a sprinter accepted to the team on the condition that he will also run a marathon? Certainly many writers do both, and some writers do both well, but it always seems clear to me when a novelist has turned out a short story or a short story has been stretched into a novel. There are a handful of people who to my mind are equal in their talents, John Updike leading the list, but then John Updike could probably win a hundred-meter sprint as handily as he could run cross-country.

It was a genuine challenge to select a mere twenty stories out of the more than 120 I received. So many of them were excellent, I would have been happier choosing thirty or even forty, and yet I know I couldn't put my hands on the twenty Best American Novels for 2006. So what accounts for so many accomplished stories? (Remembering, of course, that this is not actually a volume of the best short stories in America. These are the stories that I like best, and I am full of prejudice and strong opinions. The genius of this series, and certainly the reason for its longevity, is that it relies on guest editors who arrive every year with all their own baggage about what constitutes a wonderful story, and as soon as they feel comfortable in their role as the arbiter of "Best," they are replaced by another writer who is equally sure of his or her own taste. That's one thing you can say for writers—we know what we like when it comes to writing.) It could be that stories are easier to write than novels, but having taken a crack at both myself I am doubtful about this. I think it is more the case that short stories are expendable. Because they are smaller, the writer is simply more willing to learn from her mistakes and throw the bad ones and the merely pretty good ones away. Knowing that something can be ditched encourages more risk-taking, which in turn usually leads to better writing. It's a sad thing to toss out a bad short story, but in the end it always comes as a relief. On the other hand, it takes real nobility to dump a bad novel. A novel represents so much time and effort that the writer often struggles valiantly to get it published even

when it would be in everyone's best interest to chalk it up to education and walk away. I know a lot of people who published the first novel they ever wrote. I can think of no one who published his first short story.

So why, if what I'm telling you is true—and let's assume for the sake of this introduction that it is—why aren't more people running out to buy their copy of *Harper's* and turning directly from the table of contents to the short story? Short stories are less expensive, often better written, and make fewer demands on our time. Why haven't we made a deeper commitment to them? I am afraid it has something to do with the story's inability to create a stir. As a novelist, I would say I read well over the average number (whatever that is) of novels per year. It doesn't take much to get me to read something new. I'll pick up a novel based on a compelling review, the recommendation of a friend, even a particularly eye-catching cover. I troll the summer-reading tables in bookstores to fill in the holes in my education. I am forever picking up something I've always meant to read (*Zeno's Conscience* is waiting for me on the bedside table now, and there is still so much Dickens). But everything I mean to read, and nearly everything I *have* read, no matter how obscure, has first had some means of catching my attention. By contrast, the uncollected short story in its magazine or literary journal has nothing but its author's name and possibly a catchy title to flag you down. Only in its largest venues does a short story manage to score an illustration. It does not go out and get you. It waits for you. It waits and waits and waits.

Unless, of course, you have the extraordinary good fortune to be chosen one year as the editor of *Best American Short Stories*. Because while a single short story may have a difficult time making enough noise to be heard over the din of civilization, short stories en masse can have the effect of swarming bees, blocking out sound and sun and becoming the only thing you can think about. So even though

it goes against my nature to point out the ways in which I am luckier than you, I must say that in this case I am, unless you too have short stories mailed directly to your home. And even if you *do* have stories mailed to your home, you probably don't get them from Katrina Kenison Lewers, and that's where my real advantage comes in. These weren't just any short stories I received, the normal cross section of good and bad. These stories had been intelligently and lovingly culled from the vast sea of those that were published since the last *Best American Short Stories*. Katrina handles the part of this project that is work, hacking her way through all that is boring and poorly written in order to find the gems and send them to me. She read everything so that I could read what is good, and I read everything good in order to put together everything that I think is best. Stories showed up on my doorstep in padded envelopes, a steady stream of fiction that I piled in strategic locations near bedsides and bathtubs and back doors. When you get enough short stories spread around the house, they gather momentum. The more stories I read, the more I wanted to read stories, the more I recommended stories, the more the stories created their own hype simply by being so numerous and varied and extraordinary. The stories offered me their companionship, each one a complete experience in a limited amount of space. No matter where I went I did not mind waiting because I was rich in stories. I went ahead and pulled into the endlessly long line at the touchless car wash on Sunday morning, took a story out of the glove compartment, and started reading. I was able to put other work aside in order to read, because for this period short stories were my job. I did not have the smallest twinge of guilt about lying on the sofa for days at a time, reading. Could there be anything better than that? I felt as if I had spent the year in one of those total-immersion language camps, and in the end I emerged fluent in the language of short fiction.

Of course I was no beginner. I can trace my relationship with the short story back to my earliest days as a reader, but my true connec-

tion came when I was twelve years old, the year I read Eudora Welty's "A Visit of Charity." There had been other stories before that, stories I liked—"The Necklace" and "The Gift of the Magi," the stock assignments that were the backbone of every junior high English class—but "A Visit of Charity," even though it was a story about a girl, seemed infinitely more grown-up to me. It didn't reward the reader with a plot twist at the end or present a clear moral imperative. Even more startling was the fact that this author, whose photograph and biographical paragraph preceded the text, had only one date listed after her name: 1909, and then a dash, and then nothing. Again and again I returned to that photograph to look at the long, gentle face of the author. She was both alive and in a textbook, a coupling I had never seen before. As sure as I was by the age of twelve that I wanted to be a writer, I was not at all certain that it was the sort of thing the living did. The short-fiction market was cornered by dead people, and this Eudora Welty was, as far as I could tell, the first one to have bucked the trend. I decided at the start of seventh grade to cast my lot with the living, and chose Eudora Welty as my favorite writer. Four years later, when I was sixteen, Miss Welty came to Vanderbilt to give a reading. I got there early and sat in the front row, holding my big, hardback *Collected Short Stories of Eudora Welty*, which my mother had bought me for my birthday that year. It was the first reading I had ever been to, and when it was over I had her sign my book. I held it open to the wrong page, and she looked at me, and said, "No, no, dear. You always want to sign on the title page." And she took the book from me and did it right. For the sheer force of its heart-stopping, life-changing wonder, I will put this experience up against anyone who ever saw the Beatles.

The impressions we pick up as children, when our minds are still open to influence and as soft as damp sponges, are likely to stay with us the longest. Ever since I saw that picture of Eudora Welty, alive and well in my seventh-grade reader, I've never been able to shake the

notion that short-story writers are famous people and that short stories are life-altering things. I believe it is human nature to try to persuade others that our most passionately held beliefs are true, so that they too can know the joy of our deepest convictions. I was standing in my kitchen fixing breakfast the morning I heard on the radio that Miss Welty had died. It was July 2001, and I remember the room was full of light. I called my good friend Barry Moser, the illustrator who had worked with her on that most memorable edition of *The Robber Bridegroom*, and told him I was going to the funeral. He said he would meet me there.

I spent the night before her funeral in Meridian, Mississippi, with my mother-in-law, and in the morning made the short drive to Jackson. There was a rainstorm on the way that made the last leg of the journey harrowing, but just as I got to town the weather cleared and cooled. I picked up Barry and his wife, Emily, and the three of us went to the church together, a full two hours before the service was scheduled to begin. We went that early because we were certain it was the only way we would ever get a seat. I expected people to be waiting in the streets. I was ready to stand in the street myself, but we were the first ones to arrive, and while the church was full in the end, there were still a few empty seats around the edges. The coffin seemed tiny to me, but Miss Welty, never tall, had been shrinking over the years. There were plenty of stories about her being barely able to see over the steering wheel of her car.

If you have ever been to Mississippi in July, you know there is no reprieve from the heat, and yet on this particular day the rain, which under normal circumstances only makes the situation worse, had somehow made it better. When we went to the graveside it was no more than seventy-five degrees, and thus the closest thing to divine intervention I have ever experienced. When the hero of my life was buried, I had a discreet cry among friends standing there in the cemetery. A woman approached me and introduced herself as Mary Alice

Welty White. I knew who she was, of course. My beloved *Collected Short Stories* had been dedicated to her and her sister, Elizabeth Welty Thompson. I had seen her name every time I opened the book. Mary Alice Welty White asked me my name. She asked me if I was a friend of her aunt's, and I said I was not. I told her I was a great admirer and had come to pay my respects. She asked me where I was from. Then she took my arm. "There's someone I want you to meet."

We took small steps. The ground was soft and we were both wearing heels. She led me to the line of cars that had driven over to the cemetery, and to a group of teenaged boys who were leaning up against those cars. Their ties were loose and their jackets were off. They were ready to get out of there.

She introduced me to one of the young men. He didn't seem like he was especially interested to meet anyone. "This is Ann Patchett," Mary Alice Welty White told him. "She drove all the way from Nashville to come to your Aunt Dodo's funeral. She didn't even know her, and she drove all this way. That's how important your Aunt Dodo was."

The boy and I exchanged an awkward how-do-you-do and shook hands. Mary Alice thanked me for coming.

Even at the funeral of the greatest short story writer of our time, a member of her own family needed to be reminded of her standing. The short story never was one for calling a lot of attention to itself, but in the face of so much brilliance, I think it's time we started paying our respects.

Best American Short Stories is the short-story Olympics. It is the short story's moment in the sun. I am grateful to Houghton Mifflin and to Katrina Kenison Lewers for making sure that at least once a year we put the short story front and center where it belongs. As for the arrangement of this volume, I am partial to the democratizing effect of the alphabet. It seems to me the fairest way to line things up. However, this year the alphabet put Ann Beattie at the front of the

line, and while she certainly deserves to be there as a writer, her story, which is not exactly a story but maybe some sort of novella, performance piece, and massive example of creativity and nonconforming genius, seemed like the heft the book needed at its back end. By reversing the alphabet, Paul Yoon's beautiful story "Once the Shore"—which is the first story he published, and the first story I picked for this collection—floated effortlessly up to the front. When I was a girl in Catholic school, the nuns were forever doing that to us, getting everyone in a line and then making us reverse our places so that the first should be last and the last should be first. It seems like a good lesson for the short story. Enough with the humility. Move to the front of the line.

(from *The Best American Short Stories 2006* [Houghton Mifflin])

Love Sustained

PEOPLE ALWAYS WENT out of their way to tell me how lucky I was for being able to spend so much time with my grandmother. If I mentioned that I had to take her shopping or to the doctor or that she was waiting for me and so I had to rush away, someone would inevitably slip into a long revery on the subject of my good fortune. "My grandmother lives in Peoria . . . Tacoma . . . New Brunswick," they would say. "I only see her once a year. I haven't seen her for three years now. I couldn't make it home last Christmas, but I think about her all the time." Then there would be a great deal of pining and sighing. How sad it was that time and geography had separated the speaker from this baker of cookies and keeper of happy childhood memories! They would put a hand on my shoulder. They did not want me to miss their point. "Enjoy every minute of it. Soak up her wisdom. I only wish I were you."

Then they would go off to their lunch dates and tennis courts, and I would get in the car and go fetch my grandmother.

The counsel I received from nearly everyone (those with dead

grandmothers were as bad or worse) was a never-ending source of ir-
ritation to me, in the same way it's irritating to cook Thanksgiving
dinner while someone is leaning against the kitchen door telling you
what a pretty picture you make wrestling the turkey out of the oven.
Hard work is first and foremost hard, and whether or not it's ulti-
mately rewarding is very rarely the thing you're thinking of at the
moment. The worst of it was that I had planned to be one of those
people myself. I had planned to live far away from my family and miss
them terribly. I had every intention of feeling simply awful that I
wasn't with my grandmother in her years of decline, because I *loved*
my grandmother, loved her more than anyone, just as she loved me
more in return. In this faraway city in which I would always be com-
pelled to live due to some unknown necessity, I would meet perfect
strangers who took tender and constant care of their elderly loved
ones and I would feel such a pang of envy that I would be forced to
tell them, "Appreciate what you have! She won't be here forever. I only
wish that I was as lucky as you."

In 1994 I was thirty years old and finishing up a fellowship at
Radcliffe College. My grandmother was eighty-five and living in a
small apartment on the side of my mother's house. By then she had
been living there for eight or nine years. In all the time that I was far
away I wrote her letters and called her regularly. I went home to
visit. I sent books, thoughtful presents. If there was an average level
of long-distance involvement with one's grandmother, then I felt
safely above the median range. I gave myself a nice pat on the back
for it. But then something happened. On my way out to Los Angeles
to start work on a new book about the Los Angeles Police Depart-
ment, I came back to Nashville for a longer than usual visit. While
I was home, I went out on a date with a man named Karl. I liked
him, even though he lived in the city where I had grown up and
therefore planned on never living again. It was because of Karl and
the promise of something that could be fun for a while (and because

the book project I had been working on was falling apart) that I fi-
nally decided to put off the move out west. I saw it as a temporary
postponement. I rented a studio apartment for six months, took an
old bed and a desk out of my mother's basement, and started to
write another novel. I stuck my foot in the tar pit with every expec-
tation that I would be able to get out again.

The best thing about being back in Nashville was the time I got to
spend with my grandmother. I'd pick up the horrible fried-fish planks
from Captain D's she loved to have for lunch, and we'd watch her soap
opera together and then take a mile-long walk through the neighbor-
hood. Or we'd skip the walk and spend an hour pushing a cart through
the aisles of Target. "Heather always went to Wal-Mart," my grand-
mother would say wistfully, believing that Wal-Mart was less expen-
sive just because it wasn't as clean and was farther away.

"But Heather lives in Minnesota now," I said. My sister, who once
looked like she'd stay in town forever, had suddenly figured out how
to be the one who was far away. "You're stuck with me."

Her eyes fell on a package of washcloths, the thin kind she liked,
but she kept walking. "Heather really looked at things. We'd go to the
fabric store and look at patterns all day. You're not like that. You know
what you want and you go in and get it."

"We can go to the fabric store," I said.

But my grandmother wasn't paying any attention to me. She was
still weighing out the pros and cons of winding up with either me or
my sister, knowing good and well she'd never have both of us. She
decided to make the best of it. "You're always on time. If Heather said
she was coming at ten she'd never be there until noon. That drove me
crazy."

"Exactly."

"We'd always stop for ice cream on the way home. You never stop
for ice cream." This was a point she really worked on because she

loved ice cream. "But it's better this way. Neither one of us needed the calories."

In 1994 my grandmother was able to shop in Target. With an enormous amount of cajoling, she could be dragged into a department store once a year to try on clothes. My grandmother could walk a mile. She could follow a program on television and issue an opinion about what she wanted for lunch. She could think of her nieces back in Kansas, find their phone numbers in her address book, and call them up to talk. She did her own laundry, flossed her own teeth, caught a ride with a neighbor to a monthly Bible study meeting even though she was not a religious person. Every single one of these things seems so unfathomable to me now that I might as well say my grandmother did a high-wire act in her eighty-fifth year, or sat around in the living room writing out math proofs. Neither one of us knew it during those halcyon days at Target, but we were just at the beginning of the clearinghouse then, the time when every ability and pleasure my grandmother had would be taken from her, one by one by one.

As is true in every life, there was for my grandmother a long, slow pull up to the top of the hill before she began her rapid descent. She started out as Eva Mae Nelson of Ogden, Kansas, the second-to-last of nine children. The family lived in an abandoned hotel, and the children were forbidden even to open the doors to any of the rooms where the floors had fallen through. The younger children spent whole afternoons playing in the top floor of the hotel, which had once been a ballroom. On the top floor (which was completely intact) they could do anything they wanted. They could hoist up boxes of dirt and rocks from the ground on a long string or write on the walls. When Eva was nine, her mother sent her to live for several years in Kansas City with her older brother Roy and his wife, Sarah. Roy and Sarah had no children of their own and they needed one to keep Roy out of the draft for World War I.

Eva Nelson was a beautiful girl. I have seen the pictures. All the

soldiers from Fort Riley lined up to dance with Eva and her sister Helen on Saturday nights. They ran a laundry from home with their older sisters, Mary and Annie and Daisy, and they told each other jokes while they boiled vats of water and hung the heavy, wet sheets on the line to dry. Eva got a job in town at the Coffee Cup, working first as a waitress and then as the night manager. She loved to tell me a story about a doctor who ordered his piece of apple pie with a slice of cheddar cheese and how she refused to give it to him because it was illegal to serve pie with cheese in the state of Kansas because the combination was thought to be poisonous. Later on she got an even better job as a governess for a baby named Juanita. Juanita's parents moved to California, and it was Eva's job to take the baby later on the train. California is where she met my grandfather, a widower with two children who needed a nice reliable Kansas girl to look after them.

Every day I drove over to eat lunch with my grandmother while my mother was at work. I'd get a big sandwich somewhere on the way between my house and her house and we'd split it. Every day she'd tell me that I shouldn't be spending so much money on sandwiches. I'd take her to the grocery store and keep up a running dialogue through the aisles. "Do you need tuna? Do you need oatmeal? Do you need apples?" But before long that didn't work, because she wouldn't admit to needing anything. Nothing sounded good to her. Her sight was getting worse and she was terrified to have me walk away from her even to pick up a jar of peanut butter that was five feet away. "Do you think I'm going to forget that I brought you?" I'd say. "Do you think I'd leave you in the grocery store?" I would write out her check for her and she would sign it, but then that was too hard. She found it humiliating not to be able to keep her name on the line, or to run out of space before she'd finished her last name. More and more we relied on cash.

"This is my granddaughter," she'd say to the bored teenaged check-out girl. "I don't know what I'd do without her." I'd give a smile and count out the change. "You're never going to have to find out," I'd say.

A few months later my grandmother refused to go to the grocery store with me anymore. She said she was sick of it all. Then she refused to give me a shopping list, and so I bought the foods I thought might interest her. Every day, Los Angeles was further away from me. I got a dog and a better apartment. It was becoming increasingly clear that I wasn't going anywhere.

This wasn't because of Karl; in fact, Karl and I had broken up. It was because I just couldn't imagine telling my grandmother that I wouldn't be coming over for lunch anymore. I couldn't imagine telling my mother, who did the lion's share of the caretaking—booking the doctors' appointments and filing insurance papers and fixing her dinner—that I was leaving. I couldn't tell my mother or my grandmother that they were on their own when in fact I was a novelist and that was something that can be done pretty much anywhere. So I stayed put. Karl and I started talking again, and after a while we got back together. I always told him he had my grandmother to thank for that. Without her I never would have stayed.

My grandmother lived in fear that I would marry Karl and have a baby. If I ever complained of a headache or an upset stomach after a dose of fried fish, she always leapt to conclusions.

"I'm not pregnant," I'd tell her. "Not now, not ever."

"Don't have a baby," she warned me. "You don't need one." What she meant was that she was my baby and I didn't need another one. My grandmother loved her own baby, my mother. She loved my sister and my sister's children, but that was enough. She needed my undivided attention. She could no longer see well enough to read or watch her television programs. Books on tape worked for a while. I went to the library every week and picked out anything I thought she'd like, but soon that slid away from us, too. She couldn't remember how to work the tape player. She refused to knit or crochet anymore, even when I bought her bulkier yarn and thicker needles. She would try to break the needles in fits of frustration and then bury the whole thing in the trash. I started reading books to her in the afternoons after

we'd eaten. I read her *That Quail, Robert*, which she had read to me as a child. In the end, when Robert died, we both cried until we felt ill and exhausted. My grandmother had spent her life taking care of other people, cooking their food, cleaning their houses. It was her proof that she was valuable in the world. Now I cleaned my grandmother's apartment, which hurt her every single time. My cleaning was an accusation, no matter how quietly I went about it.

My grandmother, who had always been easygoing, was becoming increasingly agitated. Bank statements and doctors' bills sent her into awful fits of panic. In the evening she would wait by the back door for my mother to come home and then wave the papers around tearfully, saying there was a terrible mistake and she didn't understand. Some nights it would take my mother hours to calm her. I started to edit the mail when we walked down to the box in the afternoons, pulling out offers for free credit cards, notices that she may already have won, bills that would be put aside for my mother to pay. Anything with numbers I stuffed into my pockets, because numbers seemed to drive her wild.

It was my mother who figured out that the difference between a good day and a bad was often decided by my grandmother's hair. In her states of complete despair, my grandmother's hair fell from its bobby pins and stood wildly out to the sides. My mother, who was now fixing her mother's dinner and bringing it down to her on a tray at night, also got up early in the morning to fix her mother's hair before going to work. When her white shoulder-length hair was in a neat French twist, my grandmother seemed to feel she had a grasp on things. Unkempt hair meant food on her clothes, a forgotten pan boiling down to smoke on the stove, nameless weeping panic.

In this arena I was no help at all. I did not want to touch her hair. I could cook and clean and shop. I could get her to doctors' appointments an hour early to soothe her. I could leave my work whenever

she called and said she needed me because she couldn't find her radio or she'd dropped a glass jar of molasses on the tiled kitchen floor. I could kiss her and hug her and get down on my knees every two weeks to soak her feet and clip her toenails. I could do anything, except her hair.

Those were the days, around the time her hair became more than she could manage, that my grandmother began to talk seriously about wanting to die. This got worse after her younger brother, Lou, the last of her siblings, died out of turn and left her the only one of the Nelson children. If a train was coming to take her away, I pictured her packed and waiting on the platform, every day waiting, sitting on her suitcase, past goodbyes. She ate less and less. She lay on the couch and cried. If she wanted to talk about death, then I would talk to her. I would tell her I was sorry and that I understood, even though I'm sure I didn't. It seemed to me, to my mother, and to my grandmother herself, that she was in fact dying, and soon she would go to sleep and slip off into her peace. Some nights I would sit over dinner with Karl and cry. Karl was a doctor. He didn't think she'd last much longer. Her heart had an arrhythmia. She took blood thinners to avoid a stroke. She seemed held to life by about three silk threads. But she didn't die. She simply got worse. When she was ninety-two years old and weighed 102 pounds, her doctor put her on antidepressants and we put her into a geriatric psychiatric unit.

My grandparents moved from California to Tennessee in 1975 so that my mother could help take care of her father. He had already lost a leg to poor circulation, and he had become too difficult for my grandmother to manage alone. I do not believe my grandmother loved my grandfather, a thought that didn't occur to me until I was in my thirties. Although she didn't complain about him after he died, none of the stories she told contained proof that he had ever shown her much kindness. She raised his children like her own, and

they had one child together, my mother. Her happy memories were about her friends, her children, her sisters, especially Helen and the nights they did each other's hair and worked on their dresses for the dance. When my grandmother thought of my grandfather at all it was how he had raised his voice to her in front of other people, how he had made her feel embarrassed and ashamed. When she began to forget the people she had known in her life, my grandfather was the first to go.

My mother had kept my grandmother at home for sixteen years. She had wanted to keep her at home until she died. But the thing about death is that you never have any idea when it's coming. I used to think all the time: If only I knew when she would die, I could pace myself. My grandmother was ninety-two. Could I do this every day for another five months? Absolutely. Another five years? I wasn't entirely sure. My mother and I went to the hospital twice a day. That was the point at which I learned how to fix my grandmother's hair.

When my grandmother was discharged from the hospital, we put her in assisted living. She was perfectly aware of what was happening to her, and I wish it had been otherwise. I cannot remember a worse time for any of us. We woke up in our separate beds, under our separate roofs, all of us in a state of despair. I went to New York to speak at a memorial service for a friend on September 10, 2001, and then was trapped in the city by the attacks on the World Trade Center. My grandmother could not raise any concern for what had happened to the country. She only wanted to know why I wasn't there. "Where is Ann?" she would cry.

My grandmother adjusted, after a fashion, but it never held. As soon as a new normalcy was established and each of us adapted to it, everything would change again. I changed along with it. Anything I thought I couldn't do turned out to be something I managed fine. I stayed in the room with her and held her hand when the dentist pulled

out her tooth. I turned back her eyelids to clean out a persistent infection. I swabbed out her ears. I learned how to remove impactions. I brought my grandmother over to my house in the afternoons and fixed her lunch. I'd put her in my bathtub and scrub her down, then I'd haul her out again and dry her and cover her in lotion and powder. Every Tuesday I washed her hair in my kitchen sink and pinned it up after it was dry. I did her nails and rubbed her neck and took her back to where she lived.

"Don't leave me off at the front door," she'd always say. "I won't be able to find my way back."

"Have I ever dropped you off at the front door?" But then I always wondered if that wasn't exactly what I was doing. What would have happened if my grandmother had stayed in Kansas and lived in an old hotel that was falling down around her but full of her sisters and nieces? What if I was there with her? Would she remember where the bathroom was? Would her teeth all be splitting in half? Would she open her eyes when she walked?

One day when I took her back after lunch she told me she had never been to this place before. "You've made a mistake," she said, holding my wrist with both hands. "We have to go back. This isn't the place where I live."

I brought in several of the women who worked there and we showed her the things in her room and talked to her gently, but nothing would calm her. After that I came and ate lunch in the dining room with her. A few months later, my mother took her home for the day and my sister drove in from South Carolina where she was living, and together with her son we moved the contents of my grandmother's apartment from the third floor to an identical apartment on the first floor in a locked dementia unit called "The Neighborhood." I had drawn a chart of all the pictures on her walls so that we could hang them up in exactly the same spots. Everything was in the same spot

except the room itself, and when we brought my grandmother back she never knew the difference.

My mother and I were nervous about The Neighborhood the way anyone is nervous about places that are locked. We had hoped to be spared that. At first it seemed like a madhouse, but in a few days we were all much more comfortable. It was so much smaller, and no one expected my grandmother to figure out how to go to lunch by herself. My mother and I read Laura Ingalls Wilder's *Little House* books out loud to her, turning the page down when we were finished so the other one could come along and read the next chapter the next day. The Ingalls family gave us a place to put our anxiety. Instead of worrying about my grandmother, I could worry about the blizzard that came up out of nowhere and buried Pa alive. I worried about the threat of Indians, and poor Jack the dog, who was later kept on a chain. It was a pleasure to encounter so much diverting hardship. Of all the books in that series, *The Long Hard Winter* is the most brutal. The Ingalls family was trapped in their cabin with less and less to eat while their supply of firewood dwindled down to twigs. Their suffering, even in the face of our own suffering, was overwhelming. Then one day I went to see my grandmother and found the book had been shredded. Somehow she had picked up this one volume instead of any of the others and ripped apart every single page, ripped them down to individual words, so that her entire room was covered in a drift of tiny letters. I had to admire that. I didn't want to hear any more about that winter either.

I never tried to associate my grandmother who lived in the dementia unit with the grandmother I had known years before. I resolved to love the woman I had. I put aside all memories of her feeding the quail in her backyard in Northern California. I made a point to forget about her cherry trees and the friends she had who came over to drink gin and tonics in the evenings. That person, the careful seamstress of dolls' clothes, the generous sharer of S&H

Green Stamps, the one who made stews and loved her dogs and washed my hair in her kitchen sink—she was gone. But this person I had in her place still loved bananas and was capable of very sweet moods. She slept most of her days away, and sometimes I would wake her up and feed her a piece of mango mousse cake that I told myself was her favorite. She would barely have the last bite swallowed before she was asleep again. When my grandmother fell out of bed in the middle of the night and broke her hip, I learned to call her Eva in the emergency room instead of Gram. For Eva, she would turn her eyes towards me and sometimes say yes. I hoped that she was Eva again, and that her dreams in those long days of sleep were full of dance halls and the blacksmith's shop and her mother's kitchen in the old hotel.

The hip replacement didn't kill my grandmother, who by then was ninety-five. Neither did the monthlong stay in the dreaded nursing home, where my mother and I took turns sitting with her in the afternoons after physical therapy, spooning bites of applesauce into her mouth. She went back to The Neighborhood in a wheelchair, and everyone kissed her and praised her for coming home. My grandmother had forgotten most of her words by then, but she always said thank you and please. She would tell anyone who showed her kindness that she loved them and for that she was greatly loved. The two subsequent falls that sent her back to the emergency room (where doctors would see me and say, "Ann, you're back!") only left her badly bruised. She could not remember that she didn't know how to walk anymore, and so she kept getting up.

What killed her, finally, was a fever caused by sepsis, which was caused by the bedsores that no amount of turning could prevent. For four days she sweated and shook and said nothing, giving my sister enough time to drive in from South Carolina. Heather and my mother and I stayed in her room together during the days, and at night we

went home and waited. The last morning I came in early and my grandmother and I were alone. There were things I had wanted to tell her that up until then had seemed too sentimental and foolish to say out loud, but there is a time for everything. I told her a story about Helen, how she and Helen were young again, how they were beautiful. "You and Helen are going to the dance together now. From here on out you'll always be together." Helen had been dead for fifty years. If it was possible that one soul could wait around for another, I felt certain that Helen would have waited for Eva. I felt certain about nothing. I felt certain that this had been one of the greatest loves of my life, and I climbed into the bed and held her in my arms and told her so. Her eyes were open, and she touched her finger to her lips. I was crying and then that was that. I got up to call my mother. The nurse came in.

I married Karl a few months before my grandmother died. It was a decision that had been nearly eleven years in the making. I never would have moved back to Tennessee without him, and I never would have stayed long enough to make up my mind without her, and so together they did me, and each other, a great service. By the time we finally married, love no longer seemed like such a romantic thing, though I understand that romance is part of it. Since my grandmother died, I have dreamed about her every night. I go back to The Neighborhood and I find her again. Her death was just a misunderstanding. She is better now, walking and laughing, telling me stories. She doesn't need me to take care of her anymore, and she has not come back to take care of me. We are simply together and glad for it. There are always those perfect times with the people we love, those moments of joy and equality that sustain us later on. I am living that time with my husband now. I try to study our happiness so that I will be able to remember it in the future, just in case something happens and we find ourselves in need. These moments are the foundation upon

which we build the house that will shelter us into our final years, so that when love calls out, "How far would you go for me?" you can look it in the eye and say truthfully, "Farther than you would ever have thought was possible."

(*Harper's Magazine*, November 2006)

The Bookstore Strikes Back

In late February of 2012 I am in my basement, which is really a very nice part of my house that is not done justice by the word *basement*. For the purposes of this story, let's call it the "Parnassus Fulfillment Center." I have hauled 533 boxed-up hardback copies of my latest novel, *State of Wonder*, from Parnassus, the bookstore I co-own in Nashville, into my car, driven them across town (three trips there, and three trips back), and then lugged them down here to the Parnassus Fulfillment Center. Along with the hardbacks, I have brought in countless paperback copies of my backlist books as well. I sign all these books, and stack them up on one enormous and extremely sturdy table. Then I call for backup: Patrik and Niki from the store, my friend Judy, my mother. Together we form an assembly line, taking the orders off the bookstore's website, addressing mailing labels, writing tiny thank-you notes to tuck inside the signed copies, then bubble-wrapping, taping, and packing them up to mail. We get a rhythm going, we have a system, and it's pretty smooth, except for removing the orders from the website. What I don't understand is that no matter how many orders I delete from the list, the list does not get smaller.

We are all work and no progress, and I'm sure something must be going seriously wrong. After all, we've had this website for only a week, and who's to say we know what we're doing? "We know what we're doing," Niki says, and Patrik, who set up the website in the first place, confirms this. They explain to me that the reason the list isn't getting any shorter is that the orders are still coming in.

You may have heard the news that the independent bookstore is dead, that books are dead, that maybe even reading is dead—to which I say, Pull up a chair, friend. I have a story to tell.

The reason I am signing and wrapping books in my basement is that more orders have come in than the store can handle, and the reason so many orders have come in is that, a few days before, I had been a guest on *The Colbert Report*. After a healthy round of jousting about bookstores versus Amazon, Mr. Colbert held a copy of my novel in front of the cameras and exhorted America to buy it from Amazon—to which I, without a moment's thought (because *without a moment's thought* is how I fly these days) shouted, "No! No! Not Amazon. Order it off Parnassus Books dot net and I'll *sign* it for you." And America took me up on my offer, confirming once and for all that the Colbert Bump is real. That explains how I got stuck in the basement, but fails to answer the larger question: What was a writer of literary fiction whose "new" book was already ten months old doing on *The Colbert Report* in the first place? Hang on, because this is where things start to get weird: I was on the show not because I am a writer, but because I am a famous independent bookseller.

Let's go back to the beginning of the story.

A year before, the city of Nashville had two bookstores. One was Davis-Kidd, which had been our much-beloved locally owned and operated independent before selling out to the Ohio-based Joseph-Beth Booksellers chain ten years ago. Joseph-Beth moved Davis-Kidd into a mall, provided it with thirty thousand square feet of retail space, and put wind chimes and coffee mugs and scented candles in front of

book displays. We continued to call it our "local independent," even though we knew it wasn't really true anymore. Nashville also had a Borders, which was about the same size as Davis-Kidd and sat on the edge of Vanderbilt's campus. (In candor, I should say that Nashville has some truly wonderful used-book stores that range from iconic to overwhelming. But while they play an important role in the cultural fabric of the city, it is a separate role—or maybe that's just the perspective of someone who writes books for a living. We have a Barnes & Noble that is a twenty-minute drive out of town if traffic is light, a Books-a-Million on the western edge of the city near a Costco, and a Target that also sell books. Do those count? Not to me, no, they don't, and they don't count to any other book-buying Nashvillians with whom I am acquainted.)

In December 2010, Davis-Kidd closed. It had been profitable, declared the owners from Ohio who were dismantling the chain, but not profitable enough. Then, in March 2011, our Borders store—also profitable—went the way of all Borders stores. We woke up one morning and found we no longer had a bookstore.

How had this happened? Had digital books led us astray? Had we been lured away by the siren song of Amazon's undercut pricing? Had we been careless, failed to support the very places that had hosted our children's story hours and brought in touring authors and set up summer-reading tables? Our city experienced a great collective gnashing of teeth and rending of garments, but to what extent was Nashville to blame? *Both of the closed stores had been profitable.* Despite the fact that our two bookstores were the size of small department stores and bore enormous rents, they had been making their numbers every month. Nashvillians, I'd like the record to show, had been buying books.

The Nashville Public Library organized community forums for concerned citizens to come together and discuss how we might get a bookstore again. Our library, and I will bless them forever, immedi-

ately jumped up to fill the void, hosting readings of orphaned authors whose tours had already been scheduled to include trips to Nashville (including mine), and in every way trying to responsibly tackle the problems we faced as a city in need of a bookstore. Someone went so far as to suggest putting a little bookstore in the library, though selling books in the same building where books were free struck me as a bad plan. Surely, I thought, *someone* would open a bookstore.

My secret was that I did not much miss those mall-sized Gargantuas. The store I really missed had been gone much longer than they had. Mills was the bookstore of my youth. My sister and I used to walk there every day after school, stopping first to check out the puppies in the pet shop across the street, and then going on to admire the glossy covers of the Kristin Lavransdatter series, which is what girls read after they had finished the *Little House* books, back before the *Twilight* books were written. Mills could not have been more than seven hundred square feet small, and the people who worked there remembered who you were and what you read, even if you were ten. If I could have that kind of bookstore, one that valued books and readers above muffins and adorable plastic watering cans, a store that recognized it could not possibly stock every single book that every single person might be looking for, and so stocked the books the staff had read and liked and could recommend, if I could re-create the bookish happiness of my childhood, then maybe *I* was the person for the job. Or maybe not. I wanted to go into retail about as much as I wanted to go into the army.

"You're like a really good cook who thinks she should open a restaurant," my friend Steve Turner told me over dinner. I had gone to Steve for advice, because he has a particular knack for starting businesses, which has led to his knack for making money. He was trying to talk me down from the ledge. "And anyway, you already have a job."

"I wasn't thinking of working in the bookstore," I said.

He shook his head. "Don't ever think you can start a business and just turn it over to someone else. It never works."

In truth, I left that dinner feeling relieved. I'd been to the oracle and the oracle had told me that mine was a bad idea, which must have been what I'd wanted to hear.

In fact, it was exactly Steve Turner's admonition I was thinking of when I met Karen Hayes the next week. We were introduced by our one friend in common, Mary Grey James. Karen was then a sales rep for Random House, and Mary Grey had been a rep for Harcourt. They had both worked at Ingram, a large book distributor outside of Nashville. Karen, who is tall and pale and very serious in a way that brings pilgrims or homesteaders or other indefatigably hardworking people to mind, meant to open a bookstore. Her plan was to quit her job and devote her life to the project. All she lacked was the money. I suggested, having never considering investing in the book business, and not having been asked to do so, that I could pay for the store and promote it. Karen and I would be co-owners, and Mary Grey would be the store's general manager, thus solving the problem of how I could *have* a bookstore without having to actually *work* in a bookstore. We hammered out a tentative plan in the time it took to eat our sandwiches. Then Karen pulled a prospectus out of her bag and handed it to me.

"It's called Parnassus Books," she said.

I looked at the word, which struck me as hard to spell and harder to remember. I shook my head. "I don't like it," I said. How many people would know what it meant? (In Greek mythology, Mount Parnassus is the home of literature, learning, and music, and, I think, a few other valuable things.) I had wanted a store called Independent People, after the great Halldór Laxness novel about Iceland and sheep, or perhaps Red Bird Books, as I believed that simple titles, especially those containing colors, were memorable.

"I've always wanted a bookstore called Parnassus," Karen said.

I looked at this woman I didn't know, my potential business partner. I wanted a bookstore in Nashville. Why should I get to name it? "You're the one who's going to work there," I told her.

That night, after talking it over with my husband and then secur-
ing a more detailed character reference from Mary Grey, I called
Karen. According to her numbers, three hundred thousand dollars
would be needed to open a twenty-five-hundred-square-foot book-
store. I told her I was in. This was on April 30th, 2011; in two weeks, I
was to leave for the U.K. leg of the *State of Wonder* book tour. The
U.S. leg of the tour started June 7th. Karen was working for Random
House until June 10th. "Should I announce this on book tour?" I asked
her. I knew I'd be giving interviews all day long during the entire
month of June. Should I tell people what we had planned over lunch?
That we had a name I didn't like but money in the bank, that we were
strangers?

"Sure," Karen said, after some real hesitation. "I guess."

When I look back on all this now I'm dizzied by the blitheness that
stood in place of any sort of business sense, the grand gesture of walk-
ing over to the roulette table and betting it all on a single number.
Anyone I mentioned this plan to was quick to remind me that books
were dead, that in two years—I have no idea where "two years" came
from, but that figure was consistently thrown at me—books would no
longer exist, much less bookstores, and that I might as well be selling
eight-track tapes and typewriters. But somehow all the naysaying
never lodged itself in my brain. I could see it working as clearly as I
could see me standing beside my sister in Mills. I was a writer, after
all, and my books sold pretty well. I spoke to crowds of enthusiastic
readers all over the country, and those readers were my proof. More
than that, I was partnered with Karen Hayes, who wore the steely
determination of a woman who could clear a field and plant it herself;
and with Mary Grey, my dear friend who had opened a bookstore
before. Moreover, our two giant, departed bookstores had been profit-
able every month; there was the roulette ball bouncing up again and
again until finally coming to rest on the number I had chosen.

I would leave soon on my U.S. tour, but Karen and I managed to

look at some possible spaces. We were like a couple of newlyweds in an arranged marriage looking for our first apartment. We didn't know what the other one would like, and our conversations were awkward exchanges followed by long periods of awkward silence. One place had only studded two-by-fours for walls, a forlorn toilet lying on its side in the center of the dark room. Karen could see the potential. (Karen, it quickly became clear, has a much greater capacity for seeing potential than I have.) She saw it again in a restaurant space that had been empty for four years. We picked our way carefully towards the kitchen, letting the beams from our flashlights slide over grease-covered refrigerators and stoves. I had eaten in this place as a child, and it was disgusting even then. It was also huge. "Maybe we could partner with someone who wanted to start a cooking school," Karen said, looking at the hulking appliances. We were open to all possibilities. I was certain that some of the men who showed us these spaces had failed to secure bit parts on *The Sopranos* or in *Glengarry Glen Ross* but were still practicing for the roles. Often I was grateful for the lack of electricity, certain I would see things in those rooms I didn't want to see. I wanted someplace whistle-clean and move-in ready, preferably with built-in cherry shelving. Karen, however, was in the market for cheap. The place we both favored had once been a sushi restaurant and now had a lien against it. When the manager finally got around to giving us an answer, it was a pronouncement that bookstores were dead and that he wouldn't rent to us at any price.

And so, without a location or anything like an opening date, I left for my book tour, and on the first day announced on *The Diane Rehm Show* that, along with my partner, Karen Hayes, I would be opening an independent bookstore in Nashville. I was vague on every detail, but when asked about the name, I managed to say "Parnassus."

Early in the tour I got a phone call from The Beveled Edge, the frame shop in Nashville where I had long done business. They asked if I wanted them to sell my new book. My alterations shop, Stitch-It, followed suit. I was extremely grateful to be able to tell people in my

hometown where they could go to find my novel, but the experience made me feel the loss of a real bookstore more acutely. Parnassus was a good idea for Nashville, yes, but selling books was also in my own best interest.

State of Wonder was my sixth novel and eighth book, and while I've been on many book tours, this one brought with it an entirely new sense of purpose. I was going out to bookstores to read and sign, sure, but I was also there to learn. I wanted to know how many square feet each store had, and how many part-time employees, and where they got those good-looking greeting cards. Booksellers do not guard their best secrets: they are a generous tribe and were quick to welcome me into their fold and to give me advice. I was told to hang merchandise from the ceiling whenever possible, because people long to buy whatever requires a ladder to cut it down. The children's section should always be in a back corner of the store, so that when parents inevitably wandered off and started reading, their offspring could be caught before they busted out of the store. I received advice about bookkeeping, bonuses, staff recommendations, and websites.

While I was flying from city to city, Karen was driving around the South in a U-haul, buying up shelving at rock-bottom prices from various Borders stores that were liquidating. I had written one check before I left, for a hundred and fifty thousand dollars, and I kept asking if she needed more money. No, she didn't need more money.

At the end of the summer, Karen and I finally settled on a former tanning salon a few doors down from a doughnut shop and a nail emporium. Unlike the property managers we had encountered earlier in our quest, the one responsible for this location was a business-savvy Buddhist who felt a bookstore would lend class to his L-shaped strip mall, and to this end was willing to foot the bill to have the tile floors chipped out. The space was long and deep, with ceilings that were too high for us to ever dream of hanging things from. The tanning beds were carted away, but the sign over the door stayed up for a ridicu-

lously long time: TAN 2000. I went to Australia on yet another leg of my book tour, leaving all the work on Karen's head.

The word had spread to the Southern Hemisphere. In Australia, all anyone wanted to talk about was the bookstore. Journalists were calling from Germany and India, wanting to talk about the bookstore. Every interview started off the same way: Hadn't I heard the news? Had no one thought to tell me? Bookstores were over. Then, one by one, the interviewers recounted the details of their own favorite stores, and I listened. They told me, confidentially and off the record, that they thought I just might succeed.

I was starting to understand the role the interviews would play in that success. In my thirties, I had paid my rent by writing for fashion magazines. I found *Elle* to be the most baffling because its editors insisted on identifying trends. Since most fashion magazines "closed" (industry jargon for the point at which the pages are shipped to the printing plant) three months before they hit the newsstands, the identification of trends, especially from Nashville, required an act of near clairvoyance. Eventually, I realized what everyone in fashion already knew: a trend is whatever you call a trend. *This spring in Paris, fashionistas will wear fishbowls on their heads.* In my hotel room in Australia, this insight came back to me more as a vision than as a memory. "The small independent bookstore is coming back," I told reporters in Berlin and Bangladesh. "It's part of a trend."

My act was on the road, and with every performance I tweaked the script, hammering out the details as I proclaimed them to strangers: all things happen in a cycle, I explained—the little bookstore had succeeded and grown into a bigger bookstore. Seeing the potential for profit, the superstore chains rose up and crushed the independents, then Amazon rose up and crushed the superstore chains. Now that we could order any book at any hour without having to leave the screen in front of us, we realized what we had lost: the community center, the human interaction, the recommendation of a smart reader

rather than a computer algorithm telling us what other shoppers had purchased. I promised whomever was listening that from those very ashes the small independent bookstore would rise again.

What about the e-books, the journalists wanted to know. How can you survive the e-books?

And so I told them—I care *that* you read, not *how* you read. Most independent bookstores, and certainly Barnes & Noble, are capable of selling e-books through their websites, and those e-books can be downloaded onto any e-reader except for Amazon's Kindle, which worked only for Amazon purchases. So you can support a bookstore in your community and still read a book on your iPad.

Say it enough times and it will be true.

Build it and they will come.

In Melbourne, I gave a reading with Jonathan Franzen. I asked him if he would come to the bookstore. Sure, he said, he'd like to do that. Down in the Antipodes, my mind began to flip through my Rolodex. I know a lot of writers.

Meanwhile, back in Nashville, Karen and Mary Grey had hired a staff, and together they washed the warehoused Borders bookshelves again and again while they waited for the paint to dry and the new flooring to arrive. In a burst of optimism, we had hoped to open October 1st. Lights were still missing when we finally did open on November 15th. We had forgotten to get cash for the cash register, and I ran to the bank with my checkbook. That morning, the *New York Times* ran a story about the opening of Parnassus, along with a photo of me, on page A1.

Imagine a group of highly paid consultants crowded into the offices of my publisher, HarperCollins. Their job is to try and figure out how to get a picture of a literary novelist (me, say) on the front page of the *Times*. "She could kill someone," one consultant suggests. The other consultants shake their heads. "It would have to be someone

very famous," another says. "Could she hijack a busload of school children, or maybe restructure the New York public school system?" They sigh. It would not be enough. They run down a list of crimes, stunts, and heroically good deeds, but none of them are Page One material. I can promise you this: kept in that room for all eternity, they would not have landed on the idea that opening a twenty-five-hundred-square-foot bookstore in Nashville would do the trick.

The bookstore that does in fact open in Nashville is so beautiful I can't even make sense of it. While I've spent the summer talking, Karen has taken her dreams out of the air. She has made the ideal bookstore of her own imagination into a place where you can actually come and buy books. I realize now my business partner is something of a novelist herself. She attended to the most tedious details, and then went on to make a work of art. Through every color choice, every cabinet, every twinkling hanging star, she had conjured a world that was worth inexpressibly more than the sum of its dazzling parts, the kind of bookstore children will remember when they are old themselves. Parnassus, I could finally see, was perfectly named, as she had known all along it would be. Every time I walk through the door I think, Karen was the one person I met who wanted to open a bookstore, and how did I have the sense upon meeting her to sign on for life?

On opening day, National Public Radio wanted an interview from the store. They wanted background noise, but too many people made too much background noise and we had to retreat to the back corner of the storage room. Then *CBS This Morning* called at four o'clock that afternoon. I would have to get on a plane in the next two hours to be on CBS in the morning. When we had our grand opening the following Saturday, an all-day extravaganza that stretched from early-morning puppet shows to late-night wine and cheese, an estimated three thousand Nashvillians came through the store, devouring books like locusts sweeping through a field of summer wheat. All of us who

worked there (not a number I normally include myself in, but in this case I was among them) had waited so long for customers that once they finally came we could not stop telling them what we wanted them to read. One more joy I had failed to consider: that I can talk strangers into reading books that I love. The shelves we had so recently washed and dried and loaded down were startlingly empty. Karen kept running back to the office to order yet more books, while I kept climbing onto a bench to make yet another speech. Every local television news program came, every local newspaper, along with *People* magazine. I was interviewed so many times a person walking past the window of our bookstore on his way to the Donut Den might think that we had won the Derby, or cured cancer, or found a portal to the South Pole.

"You know," I had told Karen early on, "you're going to wind up doing all the work and I'm going to get all the credit. That could get really annoying."

But she didn't seem annoyed, either by the abstract concept or, later, by the omnipresent and unavoidable reality. "You just do your job," she told me. "I'll do mine."

My job has become something I could never have imagined, and while it surely benefits Parnassus, Parnassus is not exactly the point. Without ever knowing that such a position existed, let alone that it might be available, I have inadvertently become the spokesperson for independent bookstores. People still want books; I've got the numbers to prove it. I imagine they remember the bookstores of their own youth with the same tenderness that I remember mine. They are lined up outside most mornings when we open our doors because, I think, they have learned through this journey we've all been on that the lowest price is not always the best value. Parnassus Books creates jobs in our community and contributes to the tax base. We've made a place to bring children to learn and to play, and to think those two things are one and the same. We have a piano. We have a dachshund. We

have authors who come and read, and you can ask them questions, and they will sign your book. The business model may be antiquated, but it's the one that I like, and so far it's the one that's working.

And maybe it's working because I'm an author, and maybe it's working because Karen works like life depends on this bookstore, or because we have a particularly brilliant staff, or because Nashville is a city that is particularly sympathetic to all things independent. Maybe we just got lucky. But my luck has made me believe that changing the course of the corporate world is possible. Amazon doesn't get to make all the decisions; the people can make them by how and where they spend their money. If what a bookstore offers matters to you, then shop at a bookstore. If you feel that the experience of reading a book is valuable, then read the book. This is how we change the world: we grab hold of it. We change ourselves.

(*Atlantic Monthly*, November 2012)

This Is the Story of a
Happy Marriage

My GRANDMOTHER WAS a good Scrabble player, and a patient one. She would play with me after school when I was ten and eleven and twelve. I was a bad speller and she was always working to improve my skills.

"DRAIN," I said, and put my tiles down.

She thought about it for a minute. "I don't like the word *drain*," she said. "How many points?" Scrabble was, after all, a lesson in simple arithmetic as well.

"Why don't you like drains?" I asked, though I was already picturing things clogged in the sink, toothpaste and hair.

"It used to be my name," she said. "When I was married before."

Children have a real failure of imagination when it comes to thinking of the adults in their lives as having done anything of interest, anything at all, in the time known as *before*. My grandmother told me the story, trimmed for an eleven-year-old sensibility: she and John Drain were married for ten months. They lived in Kansas. When she went home to Ogden to take care of her sick mother, John Drain did

not remain unoccupied for the two weeks of her absence. "You didn't love me enough to stay home with me," he said. Soon thereafter, a petition was filed for divorce.

"When I went into the lawyer's office, the lawyer shook my hand and said, 'Good afternoon, Mrs. Drain,'" my grandmother said. "And when I left his office, he shook my hand again and said, 'Goodbye, Miss Nelson.'"

I went home later that evening and broke the news to my mother: her mother had been married before. My mother said she already knew this.

While I hadn't known the story about my grandmother's first marriage, I knew the one about her father's first marriage by heart. My grandmother's father, Rasmus Nelson, had had a wife and two sons back in Denmark. He came to this country and settled in Kansas to work as a blacksmith. He worked and saved for years until he had enough to send for his family, and when he did, he wrote to his wife and told her to come. His wife wrote back to say she wanted to move to Kansas, very much, but first she had to tell him that she had three sons now.

The invitation was rescinded.

Sad as it was, that wasn't the part that kept me up at night. My grandmother remembered that once a young man with yellow hair and blue eyes came to Ogden, Kansas, looking for his father, and that his father—my great-grandfather—refused to see him. That pale young man who had done nothing wrong came all the way from Denmark to find his father and was, in Ogden, denied. "What was his name?" I asked (this was a story I insisted on hearing many times, as opposed to the one about John Drain, which I left alone). But my grandmother was just a little girl at the time and she hadn't thought to ask her brother's name.

This is just to say that without doing a moment's work in genealogy, I know that a minimum of four generations of my family have

failed at marriage. On my father's side, six out of the seven Patchett children, my aunts and uncles, married, and five of them divorced. My sister and I have both divorced. Our parents divorced when I was four. I have many memories from early childhood, and though there are plenty of scenes in which both of my parents are present, I was too young to understand that they were married. They simply existed in the same house to take care of us. The explanation of what marriage was, and that it was over, all came in a single afternoon.

"Tell the story of your marriage," my young friend Niki says to me. "Write down how it is you have a happy marriage." But the story of my marriage, which is the great joy and astonishment of my life, is too much like a fairy tale—the German kind, unsweetened by Disney. It is a story of children wandering alone through a dark forest, past shadowy animals with razor teeth and yellow eyes, towards an accident that is punishable by years and years of sleep. It is an unpleasant business, even if it ends in love. I am setting out to tell the story of a happy marriage, my marriage, which does not end in divorce, but every single thing about it starts there. Divorce is the history lesson, that thing that must be remembered in order not to be repeated. Divorce is the rock upon which this church is built.

After my parents divorced, my mother moved my sister and me from California to Tennessee. We were going to Tennessee because Mike had moved there and she was dating Mike, that much we knew, but once we arrived that relationship seemed difficult. We relocated several times before landing in a tiny tract house in the unfashionable town of Murfreesboro, outside of Nashville. One night my mother and Mike came home from dinner and announced that they were married, which, much to our horror, seemed to mean he wasn't going home. Several months later, I came in from playing to find a boy a few years older than I was in the kitchen. I told him to get out of my house and then he told me to get out of his house. That was how I discov-

ered I had four stepsiblings. That was how my stepbrother Mikey discovered his father had remarried. I can only assume those books about how to discuss divorce and remarriage with your children had not yet been written, or that no one in this time-strapped, cash-strapped family consisting now of six children had the resources to go to the bookstore.

My father and his second wife, Jerri, seemed to have a happy marriage out in California with no additional children, but we only saw them one week a year. My sister and I adored Jerri and her mother, Dorothy. The house they lived in together was the site of some of my happiest childhood memories. One day before Jerri and my father were married, during our annual visit, I found Jerri with her sewing machine set up in the living room, making a dress. By what I could tell from the picture on the front of the pattern, it was a wonderful dress. "What's it for?" I asked.

"The wedding," she said.

"Whose wedding?" Jerri wasn't looking at me, she was pushing the gossamer fabric through the machine.

"My wedding," she said.

At that point I burst into tears, begging her not to get married, to wait, please wait, because sooner or later my father was bound to marry her. Which he was. He had just neglected to tell us.

The marriage of my father and stepmother, however appealing, was beside the point. It was the marriage of my mother and stepfather that I grew up in. They were together in some fashion, though not always married, from the time I was five until I was twenty-five. Mike also had a first wife, JoAnn, whom he had left behind in Los Angeles along with four children, ages eight, six, four, and eighteen months (the aforementioned Mikey being the oldest). I once asked Mike why he had divorced JoAnn, and he told me that she was a terrible housekeeper. Maybe that's as good a story as any to tell a kid why you left your wife. The truth would have been inappropriate, and the excuse could also serve as a cautionary tale since I wasn't the neatest child in

the world. Still, I am ashamed to say it was many, many years before I woke up and thought, *Wait a minute! She had four children and she was messy?*

Back at our house, there was a constant complaint about the alimony and child-support checks that had to be written, and that dialogue kept this first family present in our daily lives. Mike's children, who came from the West Coast twice a year to spend summers and Christmases with us, went to public schools, lived in a small, battered house in the San Fernando Valley, and had very little in the way of niceties. My sister and I went to Catholic school, had better clothes, and were brought along on the occasional vacation. When we moved to the country, my sister had her own horse and I had my own pig. We also had to live full-time within the walls of the second marriage, so that I imagine if you sat the six of us down now, the four Glasscock children and the two Patchetts, none of us would be able to say for certain who had really gotten the short end of the stick.

I don't think that anyone, not even the two principal players, thought this second marriage was going to work. It had the sharp smell of insanity from the get-go. There were fights and splits, reconciliations, intractable depression, and a large stash of firearms. Fidelity was not the order of the day. My mother was willing to put up with a lot, but she was not willing to be twice-divorced. That, she told me later, was her own personal line in the sand. Even when she and Mike did finally manage to divorce, they began to date each other again and then became engaged, complete with diamond ring. In fact, they were engaged when I got engaged, and stood together at my wedding, even though a few months after that they were done with each other for good.

This story would be more neatly convincing if it were about my mother marrying a crazy man she should have divorced right away, but nothing is ever as simple as that. My stepfather was crazy in those days, he'd be the first person to tell you, but his craziness was closely linked to his appeal. He was also an extremely successful surgeon, and

despite the burden of six children and two wives he did not stay poor for long. He flew a helicopter that he landed at the hangar he'd built in the front yard. He bought racehorses and drilled for oil and lost piles of money on both endeavors. He tried his hand at novel writing, sculpture, ironworking, tennis, fencing. He built a houseboat. Of his many interests and many children, I was his favorite. He sent me to college. He was furious with me when I said I wanted to put myself through graduate school, because he didn't want me to have to worry about money. More than twenty years after he and my mother finally parted company, he and I are still very close. "Who is this wonderful man?" my stepsister, Tina, likes to say. "And what has he done with my father?"

My mother, for her part, was overly beautiful, and if you don't think excessive beauty is a problem you should try living with it for a while. The bag boys at the grocery store tried to kiss her at the car. She couldn't have her phone number printed on her checks. People came to our table in restaurants to comment on her beauty; people let her go to the front of the line at the bank. Along with her looks came an overly sensitive nature that made people want to both protect her and run away with her. She did very little to try to put out the many fires that were started in her wake. When I first read *The Iliad* in high school I had a better understanding of my life: my mother was Helen of Troy.

I don't blame my mother and father for getting divorced, nor do I blame my mother and stepfather. But I had about as much coaching on how to conduct a happy union as a rattlesnake. I had two best friends through junior high and high school; both had parents who divorced and both were in the custody of their fathers, which, given the fact that these two divorces took place in the 1970s, speaks volumes as to how bad things were at home. We weren't the products of our parents' happy marriages; we were the flotsam of their divorces. In the house of my mother and stepfather, my sister and I were the spoils of war. I was still in high school when I decided I didn't want children. My somewhat twisted rationale was that I would never inflict childhood on

anybody, especially not someone I loved. I never changed my mind.

This is not to say that people who have watched their parents perfect the craft of divorce will necessarily divorce themselves, any more than the offspring of happy marriages will necessarily wind up being happily married. As evidence, read the wonderful companion memoirs of Geoffrey Wolff (*The Duke of Deception*) and his younger brother Tobias Wolff (*This Boy's Life*). When their parents divorced, their father got Geoffrey and their mother got Toby. The boys were raised in their parents' very different and equally disastrous second marriages, yet both boys grew up and married well. The Wolff brothers, with no discernible examples to draw upon, proved themselves wonderful husbands and fathers. They figured out the skill set for decency and commitment on their own. Clearly, we are not all ruined, and if we are, at some point it becomes our own responsibility.

Which brings me to my first marriage: not the happy one we have come to discuss, but the other one. I would like to wrench it out of the narrative but it will not be budged. Even though it appears that this is a wedding feast and should therefore mark the end of the tale, we're only just getting started. We are, in fact, still alone in the forest of the blinking yellow eyes.

Dennis and I met at the beginning of graduate school. I had a crush on him and so I invited him to my house for brunch. Because I didn't want it to look like I was asking him on a date, I cleverly invited a smart, pretty girl named Julie whom I had also met on the first day of school. Dennis left the brunch with Julie, and for a time they were happy together. Many months later, when they ceased to be happy together, he started going out with me. I moved into his small garage apartment during our second year. Thanks to twelve years of Catholic girls' school and four more at a practically all-women's college, thanks to my own nervousness about matters regarding men and women, my experience going into the first serious romantic relationship of my life was close to nil. If this were a deposition, I would like the record to state that I didn't know any better, and the things I thought I knew

were just cataclysmically wrong. For example, I could see no end of good things in Dennis; he just couldn't see those things in himself. I knew that he was funny and smart and talented, even though he often came across as angry. If I could show him what a wonderful person he really was, I could introduce his fine qualities to the world. All he needed was a little fixing, and I was just the person for the job.

It was as if I had been born before Freud. I existed in a world without psychology, and by psychology I'm not talking about therapy or analysis (both of which were big elements in the marriage of my mother and stepfather but were not services extended to the children of the house); I'm talking about the very simplest levels of self-awareness that can be picked up from an hour of *Oprah* or a few articles in women's magazines. There are women who want to be saved (charming prince, big white horse), and women who want to do the saving (Beauty, Beast). If these archetypes go all the way back to fairy-tale land, then it's safe to say I wasn't breaking new ground. I thought that men were like houses, that you could buy one on the cheap that had potential and just fix it up, and that fixing it up was actually better than getting a house that was already good because then you could make it just the way you wanted it. In short, I was an idiot, but I was also twenty-two years old. I was pretty and good-natured. I worked hard at everything I did. I should have been treasured for those things alone, which was not the case. I was not treasured, not one bit.

It would not be revisionist to say I was miserable right from the start. But hanging on to miserable relationships was something I was born for. Had I known anything about the elegance of quitting at the right time, I would have made so many people, starting with myself and Dennis, so much happier. Every week, every day that I stayed with him, I compounded my mistake. As hard as I searched for possible exits, I found none. Again, had I had even a passing contact with, say, a back issue of *Cosmopolitan*, I would have been able to figure out that the world wouldn't end were I to pack up and leave. But

Dennis seemed so sad, and how could I leave someone who was sad, especially when it was my job to make him happy?

Then one summer night we were taking a walk by the Iowa River and Dennis dropped to one knee, pulled out a diamond ring, and asked me to marry him. He might as well have pulled a knife. The word no flew from my lips before he had articulated the entire question. I then dropped to my knees, horrified by every single aspect of what had just happened. I could have walked into the river and sunk. I said I was sorry, and I was sorry, but I had had the kind of overt visceral reaction that could not be undone. It was a true disaster for both of us, and for our different reasons we looked at the ground, trembling. I was twenty-three and he was thirty. We had never talked about marriage, and certainly there would be no talking about it now. I didn't even get a real look at the ring, which had appeared, a brief spark of light, and then was gone.

Many months went by and still we continued living together, considerably more miserable than we had been before. We moved to Nashville, thinking we might be in need of a geographic cure. Nothing improved. Dennis did not forgive me. And then one night, after an enormous amount of suffering, I finally figured out a way to make it better. "Okay," I said while we were sitting in the living room. "Okay, we'll do it." And he went and got the ring out of his dresser and gave it to me.

We were married in June 1988. My wedding shoes were lost the day of the ceremony and never found. We married outdoors and bees swarmed the flowers in my hair during the exchange of vows. The wedding cake melted in the heat, and because there wasn't time to make another cake, my sister frosted the empty pans so that we could take pictures in which we pretended to slice. The car threw a rod through the engine on our way out of town and we spent our honeymoon, and all our honeymoon savings, at a Gulf station in Pulaski, Tennessee, the birthplace of the Ku Klux Klan. The marriage, which lasted fourteen months, was an unmitigated disaster.

We moved to Meadville, Pennsylvania, where we split a teaching job at a small liberal arts college. Since we didn't know anyone there, we could do a pretty good public presentation of a happy couple. Oddly, what I fell back on during that time were the lessons of my high school home economics classes. I decided I would maintain stability through food preparation. I made chicken or fish with a vegetable and a starch (rice, potatoes, pasta) seven nights a week. I made dessert. We drank huge quantities of milk. I had no idea what it meant to be married, what it meant to be a wife, other than I was supposed to make dinner, do the laundry, clean and iron. I was playing house. In retrospect, Dennis, who raged and slammed and could go for days without speaking to me, literally days without a single word, was probably every bit as terrified as I was. We were both falling back on what we knew and were completely unable to help one another. The next summer, exhausted by our lack of success, we went off to separate writers' colonies—summer camps for adults—and there, after two months without him, I finally found a bright red exit sign glowing in the dark.

At the risk of raising any hopes prematurely, I should say that this was not the exit sign that led to happiness, but the door that took me to the darkest part of my unhappiness, after which there began to be less darkness.

"Write the story of your happy marriage," Niki says.

"I'm trying," I say.

It happened in early August, at the end of my first day at Yaddo, an artists' colony in Saratoga Springs, New York. I was walking through one of the common rooms late at night where a group of women were talking and a young man was sitting in a corner, writing in a notebook. Another woman then came through the door behind me and she was crying. She said she thought she was having a miscarriage and needed a ride to the hospital. Did anyone have a car? The man

with the notebook had a car. "Shouldn't a woman go, too?" I said, thinking that if it all turned out badly someone might need to go back and hold her hand. The other women in the room looked at me blankly, and so even though I knew none of them, I said I would go. The three of us got in the car and drove to the hospital. As the woman was rushed away, the man and I promised to wait. We sat in the waiting room, and later on a bench outside the hospital, talking and smoking, until the next morning.

David, the man with the car, had an excellent grasp of psychology. He was a year and a half older than I was and had already been in two psychiatric wards. He had put in long hours with a psychiatrist. He was also considerably smarter than anyone I had ever met in my life. I was not one to talk about my troubles, which was probably one of the reasons I had so many of them, but he knew the right questions and, after all, we had a lot of time to talk. By midnight, David had heard the story of my unhappy marriage, chapter and verse. By three in the morning he was delicately suggesting that the way I was living was no way to live. When the third member of our party reappeared around six, she was surprised and touched to find we had waited. She had not lost the baby, and on that happy news we drove her back to Yaddo to rest. David and I were hungry, so we headed out to a diner for breakfast and stayed well past lunch. There was still a lot to talk about, and so we went back to Yaddo and talked until late in the night and saw the break of the next morning, at which point he came back to my room and we stopped talking.

I do not believe that I am entitled to a free pass on this one because of my childhood or my unhappy marriage, and truly, what I regretted was not my infidelity but the fact that I was forfeiting my status as the injured party. You can't be downtrodden and oppressed *and* be the one having the affair, so I chose to keep the affair a secret. More than twenty years later I think: the house was on fire and I

jumped out a window instead of going through the front door. How I left is not important to me now. I got out.

For the next three weeks at Yaddo I wandered and wept. I smoked and drank and went to the track at Saratoga Springs to watch the horses run. I stayed close to David, whom I loved with all the bright and voracious energy a burning house has to offer. I called Dennis at the artists' colony he was staying at and told him I was done, I wasn't coming home, I wanted a divorce. He told me he didn't want to talk about it, to just make up my mind and not wreck his time. I went to the swimming pool often, as swimming pools solve a lot of problems if you never sob but just can't stop the constant leaking of tears. In that swimming pool I met a striking dark-haired woman named Edra. Edra knew what was going on with me; probably everyone did. She asked me if I was going to divorce my husband. She had divorced her husband. I told her I didn't know.

Standing waist deep in the swimming pool at Yaddo, I received a gift—it was the first decent piece of instruction about marriage I had ever been given in my twenty-five years of life. "Does your husband make you a better person?" Edra asked.

There I was in that sky-blue pool beneath a bright blue sky, my fingers breaking apart the light on the water, and I had no idea what she was talking about.

"Are you smarter, kinder, more generous, more compassionate, a better writer?" she said, running down her list. "Does he make you better?"

"That's not the question," I said. "It's so much more complicated than that."

"It's not more complicated than that," she said. "That's all there is: Does he make you better and do you make him better?"

Look at this moment closely, two young women in a swimming pool on a beautiful day in upstate New York, because this is where the story starts to turn. The shift is imperceptible for a very long time but

still, I can put my pin in history's map and say, *There*. This was a piece of absolute truth, and while I rejected it as inapplicable to my very complicated twenty-five-year-old circumstances, I did not forget it. It worked its way into my brain and then stuck its foot in the door so that other bits of wisdom might follow, while back in present time I slipped beneath the surface of the water and swam away.

David's residency at Yaddo ended three days before mine, and when he left there were solemn oaths exchanged. When Dennis arrived, I told him I wasn't going home with him, but then suddenly he was a wreck and so I relented. We drove back to Pennsylvania, back into the marriage. We had been gone for the entire summer. School was starting in less than a week; there was no food in the house. Dennis, who hadn't seemed to care whether I left or not, was now quite desperate for me to stay. He was ready to roll up his sleeves, he told me. He would do anything to make our marriage work. I knew our marriage wasn't going to work. I knew the difference between bent and broken, and this thing was broken. Still, it might not be the best time to go. I stayed awake all night, staring at the ceiling, staring at my husband sleeping beside me in the bed, and felt that I might shatter into a human-size pile of glass shards. The next morning I went to my office at school and called David. I was going to need a little more time, I said. I was exhausted. I couldn't think. I needed to go to the grocery store. Maybe I could leave tomorrow instead of today. Maybe I could leave next week.

That was when I got my second gift. He told me he understood it was hard, and that maybe I wouldn't leave, but he said it was important to be honest with myself. David had his share of problems with alcohol and drugs, so he knew all about putting off the hard thing that needed to be done until another day. "It's like the old Bugs Bunny cartoon," he said quietly, "when Bugs is hosting the show and Daffy comes on the stage and says that Bugs told him yesterday that he could host the show tomorrow. And Bugs says, 'You *can* host the show tomorrow, but this isn't tomorrow, it's today.' Do you understand what

I'm saying here, Ann? Daffy does a whole routine about how yesterday tomorrow was today but Bugs keeps picking apart his argument, and Bugs wins. Because tomorrow just keeps on being tomorrow. It's never today."

I hung up the phone and sat in my office. It was very early on the last day of August 1989. It was always going to be tomorrow unless it was today. I walked home and told Dennis I was leaving. It did not go well, but then there was no reason it should have. I took my purse and the suitcase I had not unpacked from the night before and I left. I ran. I found someone I knew from the English department to drive me to the airport in Pittsburgh and I bought a one-way ticket to Nashville with cash. When I arrived, I called my mother and told her I had left Dennis and that I wanted to move home.

"What took you so long?" she said.

A little more than a year before, when I had been shopping for wedding rings, I told my grandmother I wanted one like hers, a plain gold band the width of a wire. She took it off her finger. "Here," she said, and handed it to me. "Fifty years is long enough for me to wear it." When I came home she was standing in the kitchen of my mother's house. We all lived in my mother's house then. "I didn't do such a good job with the ring," I said.

She shook her head. "You have me beat," she said. "The first time I got married I only made it ten months." Then my grandmother told me that Dennis had reminded her of John Drain from the very first day she met him.

David and I stayed together through the next spring. I flew up to Cambridge, where he was in school, every time I had the money saved. We were talking about getting married, but first he had to stop drinking. He went into rehab and told me that my attending Al-Anon meetings was a condition of our relationship. Al-Anon! Free group therapy in a church basement for people who had no idea that they were just like everybody else! It was exactly the kind of useful, every-

day psychology I lacked, so rooted in common sense that they didn't even need a professional to run the meetings. I could see the grave errors of my ways. I could reform and everything would be better. David was going to make it and I was going to make it and we would be together. But the week before I got the final signed papers for my divorce, David fell in love with a woman in his halfway house, and that was that.

"Oh, no," a woman in my Al-Anon meeting said. "He's not supposed to do that."

No, I thought, probably not. But there he goes. And there he would have gone had we been married. I remembered one night in a snowstorm in Boston. We were coming home from dinner. David was driving and we hit a patch of ice at the same instant the car coming towards us hit the same patch of ice and we both spun violently around one another and then slid off in opposite directions, utterly unscathed. When the car finally stopped its skid we just stared at one another, too stunned to inhale. "We just missed being killed by the thickness of a coat of paint," he said.

"You have to stop thinking you're going to marry everyone you sleep with," my mother told me. My mother was sorry to see me knocked down again so soon, but she was not sorry that I had lost my crazy-genius, alcoholic lover. "Listen," she said, "everything ends. Every single relationship you will have in your lifetime is going to end."

"This isn't helpful."

My mother shrugged, so what. "I'll die, you'll die, he'll die, you'll get tired of each other. You don't always know how it's going to happen but it's always going to happen. So stop trying to make everything permanent. It doesn't work. I want you to go out there and find some nice man you have no intention of spending the rest of your life with. You can be very, very happy with people you aren't going to marry."

My beautiful mother had learned a great deal along the rocky run

of her own experience and now she was passing it on to me. Because I was at that moment in desperate need of guidance, I decided to take her advice to heart. I remember sitting on the top of the stairs in her house and thinking that I didn't have another breakup in me. I was already too thin and too sad. I couldn't call all my friends again and cry on the phone. I had used up all the sympathy I had coming for the next five years. I was just going to have to let this one go. As much as I loved David, and I loved him the way you love the person who saves your life, I understood that I had avoided catastrophe by the thickness of a coat of paint. He had done me the two greatest favors that anyone had ever done me in my life: he got me out, and then he let me go.

It was on that day, on those stairs, that I decided I would never divorce again. I was as grateful for divorce as I was for my own life, but it had done me in. I now fully understood the passion with which my mother had promised not to be twice-divorced, and how holding on to her second marriage was like holding on to a bucking bronco set aflame. She did not let go through all the hell of her marriage, simply because she'd sworn to herself she would not let go. But now, with David gone, I saw a much simpler path: if I never married again, I would never again be divorced. In short, I had found a way to beat the system. I was free.

Snow White finds happiness with seven dwarfs. She isn't settling. She is very, very happy.

Here's a fail-safe recipe for popularity: be twenty-six, cheerful, and completely over the idea of marriage. Not in a coy way, not in a way that says you secretly hope someone will talk you into it. Wash your hands of wedlock and watch the boys fly in. At the moment that other women my age were starting to ask their boyfriends if their intentions were serious, I was explaining to mine that life was short and this was fun and that was all. Well, that's not entirely true: I remained serious

about love; I just gave up the notion that marriage was the inevitable outcome of love. I took my mother at her word and had some wonderful, long relationships with people I deeply enjoyed but would not have wanted to marry for a minute. Once I decided I liked someone well enough to want to spend time with him, I set aside my judgment. Did he leave his clothes in twisted piles on the floor? Fine by me, I wasn't the one picking them up. Was he always late? For everything? That could wear over the course of a lifetime but for a year or two it wasn't really a problem. Did I find his father impossibly grating? Yes, but who cared? We would not be spending holidays together for the rest of our days on earth. Not only was I dating for the first time in my life, I could put aside the constant assessment of character that talk of forever inspired. I decided instead to fall in love with a good sense of humor, a compassionate understanding of Wallace Stevens, an ability to speak Italian or dance on a coffee table.

My mother was happy as well. She had married Darrell, who was easygoing, adored her completely, and made his own pasta, three qualities we had not previously seen in our family. Of course, Darrell had his own ex-wife and three grown children, but they were all intelligent, highly civilized people who were willing to attach the complicated web of their family to the complicated web of ours. My mother's third marriage bespoke a real learning curve.

Not only did she have a good husband, she had a good job. After her final split from Mike, she returned to work as a nurse in the office of an internist named Karl VanDevender. They got along well. It seemed that everyone got along with Karl. He was a genial person and a good doctor, the kind of man people speak of as being golden. But even the golden have their problems. One night my mother called to tell me that Karl's wife had left him.

Part of removing myself from the cycle of marriage and divorce involved limiting my interest in the marriages and divorces of other

people. The marriages and divorces of other people are deeply private things. Both the successes and the failures are based on an unfathomable chemistry and history that an outsider has no access to. I knew from experience that any story I heard on the subject was unlikely to be entirely true, and that the truth was none of my business anyway. I made it a point to wish every marriage well, and to feel a moment of sorrow for any divorce, and that was all. The report was that Karl's wife had left abruptly, there hadn't been any arguments, and that the whole thing, as he had told my mother, came as a complete surprise. I wondered if any divorce ever really came as a complete surprise, and if it did, well, that was probably your answer as to why someone was divorcing you.

I had met Karl a few times over the years when I had stopped by the office to bring something to my mother. If I saw him in the hall we would have a brief exchange of pleasantries (*hello how are you very well and yourself?*). After my first book was published, he took my mother and me out to lunch and told me endlessly how lucky I was to be a writer. He said it so many times I finally told him I thought it would be strange if I sat there and told him how lucky he was to be a doctor. That was all there was to it. He asked me to mail him a list of my favorite books. He had been an English major in college. He wanted to know what he should be reading.

At the time that Karl's marriage was breaking up I was thirty years old and living in Cambridge, where I had a fellowship at Radcliffe College. My mother continued to call with updates. Karl's situation had taken over her work life. Not only did he confide in her, it seemed that no one in the hospital talked about anything else. It's a wonder that patients didn't die while doctors and nurses discussed the fate of Dr. VanDevender. He didn't want a divorce, but if his wife refused to come back, he planned to remarry as soon as possible. Eager candidates were lining up around the hospital. My mother claimed the call volume into the office had increased tenfold: men and women called

wanting Karl to date their mothers, sisters, daughters, friends, tennis partners. Women called wanting to ask Karl out themselves. He was forty-six and handsome. He had a good income and even better manners. It was springtime, and depending on how long it took for the divorce to become final, it seemed very likely that Dr. VanDevender would find someone to marry by Christmas.

Up in Cambridge, I felt sad for Karl in the way you feel sad for someone who is about to embark on a long round of chemo and radiation. He was at the start of something I had completely finished and the notion of anyone having to face that, even someone I scarcely knew, made me feel sick.

"You'll never guess who Karl wants to date now," my mother said to me one night on the telephone. He had gone out with several women by that point. He had gone to Bali on a date.

It was supposed to be a guessing game but I told her just to tell me.

"You," she said.

He was sixteen years older than I was, lived a thousand miles away, and was my mother's boss. "That's not going to happen," I said.

Months later, when I was home visiting, Karl called and asked me out to dinner. Ever the fan of clarity, I explained my position on the matter. "I'm sorry for what you're going through," I said, "and I'm happy to talk to you, but I'm not going to date you. This isn't a date, okay?"

"Not a date," he said. "A meal."

The woman who owned the restaurant where we had dinner sent the waiter to our table three times before we had finished our entrées. "She needs to speak to you privately in the back," the waiter said. Three times Karl dutifully went to see what she wanted. She told him she was having heart palpitations; would he just listen to her heart?

"Wow," I said, when he came back to the table.

Finally, the owner gave up all pretense and brought her racing heart to our table, sitting in our booth very close to Karl. She was stunning, an ice-white blonde with blue eyes and cheekbones so

prominent they looked almost painful. She put her hand on his wrist and asked him when he planned to call.

"You're in serious trouble," I said when we got in the car. His manners were too good not to go when he was called away, and they were too good not to realize that lengthy, repeated absences constituted bad manners. He called me several times that week to talk. He said he just wanted to be married, to his wife, to someone, but he couldn't possibly exist in his present state.

When Gautama achieved enlightenment and became the Buddha, Lord Brahma was so moved that he came down to earth and knelt before him. Lord Brahma asked that the Buddha teach the dharma because there were so many people on earth who were living in a state of terrible suffering and this true path could ease the pain of many. The Buddha was reluctant at first because he didn't see his wisdom as being easily transferable. Everyone had to learn the dharma for themselves. But the Buddha practiced compassion, and so he was moved. He agreed to help all he could with the knowledge he had found.

I'm sorry—am I comparing myself to the Buddha? Yes, in this one small instance, I am. I had used my knowledge and my experience to save myself and now I had the chance to step beyond my life of happy self-preservation and save someone else. Like the Buddha, I was hesitant. I knew that I would be taking on something enormously complicated. Of course this was not exactly altruism on my part. Karl was so handsome and charming and lost, there was something irresistible about him. But he wasn't my type. I liked men who could be found on the couch reading Proust in the middle of the day, men who were boyish and broke, who hung on to outdated student IDs, who rode bicycles and smoked at the same time. Karl had no existential angst as to whether or not his life had meaning. He

put on a beautiful suit every morning and went out to do important work, not writing book reviews but saving human lives (and doing it with none of the fanfare I witnessed in those book reviewers). It seemed to me that dating outside one's natural inclinations fit perfectly within my mother's dictum. Here was a man I liked, a man who was tumbling so thoughtlessly towards a second marriage that a second divorce seemed the likely outcome. I could possibly talk him out of the mistake he was poised to make, or at the very least offer him a little safety until he pulled himself together. I could keep an eye on his two teenaged children, because, operating from a wealth of experience, it seemed to me they stood to lose the most in a reckless second marriage. The third time Karl and I went out I kissed him; I told him I would help him. He said that he needed some help. Then he asked me to marry him.

I shook my head. "That's the whole point," I said. "I'm the only person you're going to find who isn't going to marry you."

And I didn't. For eleven years.

I don't know how it happened. We weren't particularly happy early on in our relationship. Seeing someone through a divorce means not always seeing them at their best. We broke up a couple of times, but then circled back to one another, connected by some sort of invisible string. Every year in September, the month in which we had started to date, we would say to each other, Should we keep doing this for another year? For the first several years we were never very sure, and then we were. I didn't want to stay in Nashville, but somehow I never left. Then David called me out of the blue. I hadn't heard from him in years. "I hear you're marrying some doctor," he said. "I wanted to say congratulations."

"You need to get a better source," I said. He said that he missed me. "Are you missing me because you think I'm about to get married? Because I'm not. I'm really not."

I didn't hear from him again.

Time passed and I had a harder and harder time remembering why Karl wasn't my type, or remembering what my type had been. It was as if we were growing into one another. He was smart and kind. My family loved him, I loved him. He encouraged me in everything I did. His answer to every question was yes. He was proud of me, and he never found a way to undermine my success or spoil a happy moment (a quality, I will tell you, that is hard to come by). And all that time he never stopped wanting to get married.

"We're happier than the married people," I said. "Why do you want to be like them?"

Besides, not being married had saved us. Had I said yes to Karl's initial proposal, or really to any of the proposals that came in the years that followed, I don't think we would have made it. By not living together, we could fight and then step away to cool off. I would think, *At least we're not married*, which is so much better than thinking, *I can't stay married to you*. I also thought our status was good for his children, who at this point weren't really children anymore, but still, they'd had enough change to deal with. I bought a small house three blocks away, an easy walk, and Karl and I had dinner together every night. People bothered us endlessly about our arrangement, but as far as I was concerned, what we had wasn't broken and didn't warrant fixing.

Karl remained unconvinced, especially when we returned from vacations and he dropped me off at my house. Often he was angry at me at the end of vacations. "I don't want to live this way anymore," he would say.

But how could I, who carried divorce in my veins all the way back to Denmark, be absolutely positive that it wouldn't happen this time? It would take an impossible leap of willful naïveté on my part to change my story now, no matter how much I loved Karl, I wasn't naïve. And I wasn't getting married.

One year, just before Christmas, Karl brought home a basket of cookies that some of the nuns he took care of at a local convent had made for him. There were a dozen different kinds of sweets, each wrapped separately in its own perfect little package. Karl had me unwrap them all until I found the one with a diamond ring inside. "Don't worry," he said, seeing the worry on my face. "It isn't an engagement ring. This is a you've-been-here-a-really-long-time-and-you-deserve-a-nice-ring-without-getting-married ring."

Which made it the most beautiful thing I had ever seen.

Months later, I was having dinner with my friend Beverly in New York and she asked me about the ring. The two women at the next table, who were so close they might as well have been having dinner with us, asked if they could see the ring too, and I gave them my right hand. "When are you getting married?" one of them asked.

I explained that I wasn't getting married, that this was just a ring from the person I loved.

The other woman at the table took my hand. "Does he want to marry you?"

I told them that he did.

"Wait a minute, he's a good guy and he loves you and he gives you this ring and wants to marry you and you're not going to marry him?"

"And he's good-looking," Beverly said, egging them on. "And he's a doctor."

"I just don't want to get married," I said.

The women looked at me with crystalline loathing. "Then you should give him back," one of them said, and they both returned to their dinner.

Give him back to whom, I wondered. To them?

The years go by in a perfectly fine life until the day Snow White takes a bite of the apple and falls to the floor. The Buddha sits down beneath the lotus tree and vows not to move until he has achieved en-

lightenment. Everything stops, and that is the moment of change. This is the story of a happy marriage.

Karl decided to go to the Mayo Clinic to have a physical. He'd never done anything like that before. In fact, he never got physicals. If he made an appointment to see one of his partners, he'd wind up never going, and if he did go they would just sit around and talk. He'd only be gone one night, and no, he didn't want me to go with him.

"Is everything all right?" I asked. "Do you feel all right?"

He told me he was fine.

It was the beginning of March. I drove him to the airport early in the morning. He didn't call until that night.

"Well," he said. "I failed a test."

I was standing in front of my living room window, staring out at the pitch-black dark. "What test?"

There had been an abnormal treadmill test, and then an echocardiogram that showed his heart beating at half its normal function. The left ventricular ejection fraction was at twenty-five percent. Normal was fifty-five percent. They had scheduled an arteriogram for the morning.

"I'm coming up," I said.

"Don't come up," he said. "We'll know more after the test. It's probably all going to be fine. And anyway, there's supposed to be a blizzard."

I was pacing a circle through my house: living room, kitchen, dining room, living room, kitchen, dining room, again and again while my dog followed behind. I could not stop walking. Neither Karl nor I was alarmist by nature but I was feeling decidedly alarmed. I was at the airport first thing the next morning.

"The plane might get to Minneapolis," the ticket agent told me. "Might. Or they could close the airport and you'll wind up getting

rerouted. But even if you make it that far there's no way you'll get a flight to Rochester. It's a whiteout."

I said I'd give it a try.

All these years I had thought to be afraid of only one potential ending: by not marrying Karl, we could never get divorced. By not marrying him, he would never be lost to me. Now I could see the failure of my imagination. I had accounted only for the loss I knew enough to fear. I sat in the boarding area. The flight to Minneapolis was delayed indefinitely due to heavy weather. "The way things are looking up there, we don't know when we'll be able to go," the agent announced over the loudspeaker, but then two minutes later she came back on. "Let's go right now," she said.

Clearly, this was a plane full of Minnesotans going home, not Nashvillians heading north. Everyone trudged on board without blinking and we flew away. "Lotta snow up there," the pilot said.

In Minneapolis, the situation was considerably worse. There were maybe twenty of us waiting for a small commuter plane to Rochester while we watched the snow beat into the windows. Rochester was having its worst blizzard in ten years. I looked at my watch. Arteriogram time. I had figured out everything except what I was supposed to do without him.

The pilot came and stood behind the ticket counter. "It's bad up there," he told us. We stared back at him, buried in our coats and hats and scarves. "What do you say, give it a try?" We stood up together, all of us one unit. We wanted to try.

Of course you know the plane did not go down in the blizzard. This is a true story and I am here to tell it, but it occurred to me for the entire fifty minutes of the flight that my being killed while trying to get to Karl who was sick would place a burden of irony on the rest of his life. I was in a single seat, and in the single seat behind me was a father who was loudly and continually threatening his two sons across the aisle. The two sons, who were maybe ten and twelve, were beating

each other, smacking and pinching and screaming like a couple of wolverines strapped into adjacent seats. Between the father and the sons, it was the worst behavior I have ever seen on a plane. Then, suddenly, all three of them stopped. That's how bad the flight was. We were pitching sideways through the snow, plummeting, climbing, and in the same instant they each put their hands in their laps and did not make another sound.

How the pilot saw the runway, how he saw anything, I will never know. We were in the air and then we were skidding to a stop and the passengers clapped and cried. I couldn't see an airport, a tower, a plane. It was as if heavy sheets of white paper had been taped over all the windows. "We're here," the pilot said. "Last one in. The airport's closed." We had arrived in Rochester ahead of schedule.

I made it to Karl's hospital room about thirty seconds before they wheeled him in. "See?" he said to the nurse when he saw me there. His voice was bleary from anesthetic. "Didn't I tell you she'd be here?" He took my hand. "They said no, she can't make it. They said everything's closed. And I said you don't know Ann." And then he drifted off to sleep.

Explain doubt to me, because at that moment I ceased to understand it. In return I will tell you everything I know about love.

They found no blockage in the heart, no arteriosclerosis. It was a parvovirus. He had a cardiomyopathy. The cardiologist explained to me that nearly half of the muscle tissue in Karl's heart was dead. They would put him on a beta blocker called Coreg. He would stay on it for the rest of his life. If his ejection fraction, the volume of the blood the heart was able to pump, fell much lower—say, to twenty percent—he would then be eligible for a place on the heart-transplant list.

I asked the doctor if there was any chance that things could get better on their own, that the situation could improve with time.

"Heart muscle tissue doesn't regenerate," he said.

Two days and many tests later, we were in the airport in Rochester for a flight back to Nashville. The snow had stopped and was now

plowed into towering banks. Karl and I stood together at the window, his arm around my shoulder, looking out across the field of white. "I guess when we get home we should get married," I said.

Karl nodded. "I think so."

"I'll put my house on the market."

"Good," he said.

And that was it. After eleven years of discussion there was nothing more to say. "Every relationship you will ever have is going to end," my mother had told me. If Karl needed my help, if there were decisions to be made in a hospital, I could do nothing as his girlfriend. He needed a wife. Maybe he had always needed a wife.

Karl admitted to me later that he had gone to Mayo thinking that there might be a problem. He was too tired. He was getting old too fast. Whatever had been wrong with him before, whatever I had not previously noticed, the Coreg made worse. If it was keeping him alive it was doing so at the expense of his health. He had trouble catching his breath, he had a hard time going up the stairs, he wasn't to lift anything. Literally, he was gray. All I wanted to do was get married.

Karl's illness gave us an enormous get-out-of-jail-free card where a wedding was concerned. We told our families that we were going to get married but that there would be no wedding. I had to move and we had Karl's health to think about. A party would be a poor expenditure of our limited resources of energy. No invitations, no dress, no lists or rentals or presents, which, blessedly, meant no thank-you notes. This thing that would happen between us was a very private matter. My stepsister Marcie listed my house and four hours later it had sold. I moved what I owned using four boxes. I filled them up, drove to Karl's, unpacked them, drove home again, filled them up, drove back, unpacked them. I looked around Karl's house now as a resident instead of a regular weekend guest. For the first time I noticed how much empty space there was, empty closets,

entire empty rooms. Pictures were leaned against dressers or hung at the wrong heights on preexisting nails. "It's like you never actually moved in," I said, though he had been living in the house for nearly ten years.

"I didn't want to do too much before you got here," he said.

We asked a friend of ours, a Catholic priest who ran a homeless shelter, if he would marry us. He said he didn't marry people.

"Perfect," I said. "Just swing by the house and sign the papers, or I can bring them to you."

We got the marriage license, which in the state of Tennessee is good for a month, and then a week or so later our friend called and said he was going to a Kentucky Derby party in our neighborhood. He could come by. He sat in the living room with us for a few minutes and said some nice things about love, drank a glass of cranberry juice, signed his name, and went off to his party. Later I had my mother sign as a witness and I mailed the form in. We are as married as anyone.

We went out later that afternoon, bought a new lawnmower.

Is it possible that anxiety ends at the moment when we no longer have time for it? I had waited to marry Karl until I thought he was going to die. At night we'd lie in bed in the dark holding hands. "I'm such an idiot," I said. "We should have done this a long time ago."

"It's exactly the right time," Karl said.

There were two things about marriage that surprised me. The first was that I discovered Karl had been holding out on me. He actually loved me more than he had previously led me to believe. This is not to say he hadn't loved me for the past eleven years, he had, but there was a portion of himself he kept to himself, thinking that if I wouldn't marry him, then chances were at some point I would go. It was like finding another wing in a house you had happily lived in for years. It was simply a bigger love than I had imagined.

The second thing that marriage changed was that it opened up an enormous amount of free time in our days. We no longer had to have the conversation about why we weren't married, neither with one another nor with the world of people who constantly inquired as to the status of our relationship. I had no idea how much time we'd spent on this topic until it was abruptly removed from the lineup. With all the extra hours, we could talk about politics and books and what should be done with the garden in the backyard. We could take in long stretches of companionable silence. I can't imagine that anyone actually cared why we waited so long to get married; it was just a topic of idle conversation. But after eleven years it was a huge relief to have it stop.

Other than that? We were pretty much the same.

Coreg made Karl crave chocolate. He stacked up chocolate bars in the pantry, chocolate chips in the freezer. He carried half-eaten bags of M&M's in his pocket. He had never cared about chocolate one way or the other and now he could hardly think about anything else. He wanted it for breakfast in pancakes. And then, about four months after we had signed the papers for our marriage, I noticed that the chocolate I was buying wasn't going anywhere.

He had stopped taking the Coreg.

"You're supposed to take it for the rest of your life," I said, feeling a wave of panic building far, far from the shore, a wave that by the time it was fully realized would be big enough to crush the city we lived in.

Karl shrugged. "I really didn't like it."

"You probably wouldn't like dialysis either, but that doesn't mean you can stop."

"Well," he said, "I stopped the Coreg." He was completely untroubled by this. It was as if all he was telling me was that he had finally found a way to stop eating so much chocolate.

Frantic, I went to talk with one of the cardiologists in Karl's prac-

tice, who backed Karl up like a brother-in-arms. "I never thought Mayo was right," he said.

Mayo wasn't right? Was that even one of the options? Karl was supposed to go back to Rochester for a follow-up appointment, but he never seemed to get around to it. Finally, after a great deal of begging and foot-stamping and breath-holding on my part, he agreed to have another treadmill test and echocardiogram in Nashville. The results were normal. Ejection fraction normal. Heart normal. "Everything's fine," he told me. Dinner is on the table. The phone call is for you. Everything is normal.

I blinked. "We have three absolute truths," I said, holding up three fingers for visual reference. "Absolute truth number one: half of the muscle tissue in your heart is dead. Absolute truth number two: heart muscle tissue does not regenerate. Absolute truth number three: there is no dead muscle tissue in your heart."

"Correct," my husband said.

"But it can't be correct." I wasn't the doctor but this did not strike me as complicated. "One of those three things can't be true and I want to know which one it is because if it's the third one, and you really do have a problem with your heart that you're now just ignoring, that's a problem."

"It's not a problem," he said. "Everything's fine."

We continued to have some version of this conversation for a long time and it never came out differently. As far as Karl was concerned, the news was good and he didn't care why.

But I had sold my house. We were married. Karl's complexion pinked up. He had no problem going up and down the stairs. He started carrying his own luggage again. It was as if he didn't remember anything that had happened. "Why do you think you finally changed your mind and decided we should get married?" he asked me one day, months after the prescription bottles had gone in the trash.

I looked at him. "I thought you were going to die," I said.

"You married me because you thought I was going to die?"

"Remember? We were in the airport in Rochester? There was talk about a heart transplant?"

"It wasn't because you loved me?"

"Of *course* I loved you. I've always loved you. But you asked me why I married you."

In fact, even as Karl's health continued to mysteriously improve, I still found myself lying awake at night, worrying that he was going to die. He may have made me a better person, but he had not made me a better Buddhist. I wanted to grasp, to possess. "Stay like this," I would think to myself as I watched him sleep. "Stay here, in this exact moment." I tortured myself over what awful thing might happen in the future instead of being wholly present and thankful for this moment. I realized that by not marrying Karl, by never allowing myself to be in the position to divorce him or to be divorced by him, I thought I had tricked fate. But in the wake of this commitment I was flooded with thoughts of what I wouldn't be able to control. I could understand why Gautama had to leave his wife and child in order to find the path to nirvana. The love between humans is the thing that nails us to this earth.

I wish I could say that we came to a point where the matter of Karl's heart condition was properly resolved, but really, it never has been. I once told the story to a doctor who explained that if the parvovirus was still active when the tests had been done, the heart could have been stunned, rendering the muscle tissue temporarily paralyzed rather than dead. Another doctor, a cardiologist I sat next to at a post–bar mitzvah luncheon, told me that it sounded to him like Karl wanted to get married and had run out of ways to ask me.

"He didn't fake it," I said. "I went to Minnesota. I saw the films."

"I didn't say he faked it," the doctor told me. "But the heart wants what it wants."

———

If my marriage were a fairy tale, this would be the moment that I closed the castle door. Stories are based in conflict, and when the conflict is resolved the story ends. That's because for the most part happiness is amorphous, wordless, and largely uninteresting. Still, I promised Niki, and so I will try to press ahead for another minute.

My marriage, which was long in the making and built on the bones of divorce, is one for beginners. We are both, astonishingly, in good health. We both had money when we married and two years later we merged it, every last cent, into joint accounts. (Which, I must tell you, was a moment of trust and commitment the likes of which most wedding vows couldn't touch. Likewise, we had both rejected any talk of a prenuptial agreement because how can you say, after eleven years of thinking it through, We have fully committed to staying together until one of us is dead but I want to make arrangements for what might happen if it doesn't work? "If you ever decide to leave me, just look in your rearview mirror," I like to say to Karl. "Because I will be coming after you.") We both have work we find meaningful and for which we have received so much recognition and positive reinforcement that it borders on the comical. We have no small children. We have a large master bathroom with two sinks. We have loving, supportive families who think we each picked the best person possible to spend our lives with. And—no small point, this—Karl has the kindest and most highly evolved first wife in the history of first wives. I touch my forehead to the floor in gratitude for how easily we all sit down at a dinner table together with her second husband and the wonderful grown-up children she and Karl had together, and now their grandchildren. When someone comments on my happy marriage I want to say, My God, look at the circumstances. With a script like this you'd have to be a fool not to make it work.

And yet, we have a wealth of differences that come mostly from the fact that we didn't grow up together. Karl was born in Meridian,

Mississippi, in 1947. His parents stayed married, as did the parents of his friends. His mother still lives in the house they moved to the year Karl turned one. He walked down the street to school. I was born in Los Angeles in 1963. By the time I started college I had moved fifteen times. We saw different movies, read different books. I never had a single date in high school, but when I went with Karl to his high school reunion women lined up all night to tell me how they had been in love with my husband. All I felt was the wondrous luck that he had found me. "Just think," I say to Karl, "every night we come home to the same house and we sleep in the same bed with the same dog, and of all the houses and beds and dogs in the world we hit on this combination." The fact that we came so close to missing out, missing out because of my own fear of failing, makes me think I avoided a mortal accident by the thickness of a coat of paint. We are, on this earth, so incredibly small, in the history of time, in the crowd of the world, we are practically invisible, not even a dot, and yet we have each other to hold on to.

When we do things differently, and very often we do, I remind myself that it is rarely a matter of right and wrong. We are simply two adults who grew up in different houses far away from one another.

I can't imagine that there is a right way to be married. The most essential terms for happiness I can think of—commitment, acceptance, love—could be challenged by one successful marriage or another. Even the very worst ideas for marriage, my own personal worst ideas, would be tolerable circumstances for someone else. I can tell you how I came to have a happy marriage, but I'm not so sure my results can be reproduced: wait until everyone you know gets divorced, then get divorced yourself, find a divorced man, date him for eleven years, wait until you think his situation is terminal, and then marry him. It will not be terminal.

I continue to think back to Edra, standing in that swimming pool on a bright day in summer. "Does he make you a better person?" was

what she asked me, and I want to tell her, Yes, with the full force of his life, with the example of his kindness and vigilance, his good sense and equanimity, he makes me a better person. And that is what I aspire to be, better, and no, it really isn't any more complicated than that.

(Audible Originals, Winter 2011)

Our Deluge, Drop by Drop

THE FIRST BIG flood in my memory was in 1974, when my family was living in Ashland City, a half-hour down the Cumberland River from Nashville. My mother was stuck out at the farm by herself; my sister and I were in school, my stepfather was at work. We lived in a hollow down a very long road, and by the early afternoon it had begun to fill with water. By the time my mother, who doesn't know how to swim, realized how high the water was, it was much too high to make it out in her car—a 1971 Jaguar XK-E the color of a lima bean that sat about six inches from the ground. She loaded a plastic Sunfish sailboat up with luggage, dragged the boat down the road by a rope in the rain, and then walked into water up to her chest until she reached the considerably higher (and aptly named) River Road, where she and her bags were picked up by a man who worked for us.

When the rain that has caused Nashville's worst flooding in seventy-five years stopped last Sunday night, I got to wondering: Why do people wait and watch the water rise? Why do they keep their luggage in the boat and themselves in water the color of milky coffee that

is no doubt full of snakes? There are things about human nature we'll never understand, but part of it can be explained by the fact that a flood is, at least in the beginning, only rain, which is not as sudden as an earthquake or as imperative as fire. Rain happens all the time.

I live in Nashville now, I have for a long time. I started watching the rain on Saturday morning. It was coming down so hard it looked white. My husband and I stood at the front door with our very old dog and decided she'd have to wait until things eased up. But they didn't ease up. We canceled our plans for the day. Finally I put on my flip-flops, shorts, and a raincoat and took the dog out. I went down the street to walk my mother's dog, and then the dog of a friend who lives on a hill around the corner. The water was up to my ankles, but it was mesmerizing, as was all that thunder and lightning. I went to see how high the creek was a block away; it was raging like an angry little river.

All night long the tornado sirens wailed, which in the South is a sound you get used to, like cicadas. (If I went down to the basement every time the tornado siren went off, I would have spent a great deal of my life in the basement.) The next morning when I went to walk my mother's dog again, the water was up to my knees at points and I could barely see through the rain. My husband went off to walk our friend's dog, but he couldn't make it there on foot. He picked me up in the car and we drove for fifteen minutes, looping over higher streets to make it to her house, which was only a block away. There we saw that yesterday's creek was now a torrent, leaping over the road and through the houses beside it. It would take just the slightest error in judgment to be swept away in the suburbs—though maybe fording floodwaters in order to carry small dogs to higher ground for purposes of relieving themselves could be called an error in judgment.

Three years ago my husband and I bought a small piece of land on the Cumberland, just off River Road on the way to Ashland City, not far from where I had lived as a child. We keep meaning to build a little house there, a single room with a wide porch where we would

spend quiet weekends, but we haven't gotten around to it yet. We go out there some evenings to have a picnic or paddle around in a canoe. We like to visit with our neighbors.

On Monday morning my husband called Monty, who lives to the left of our lot. He was on the second floor of his house. He said everything was lost—his cars had washed away and all the houses on the road were ruined. Then the phone cut off. I called him back and told him to come and stay with us in town. "I'm going to my sister's," he said. Then he told me he had to go. "The helicopter's here."

That afternoon, on the street where I live, we stood in the sunshine and took stock of our damages. While sump pumps turned driveways into rivers, one woman told us the water in her basement was up to her hip. Another had water to her shoulder. I offered up the leak in my chimney, which will require ripping out the ceiling in my living room, but that's small potatoes; my basement was dry. A block away, a family's furniture was piled on the front lawn.

The rain is over; what we're left with is the life that follows weather. While my more intrepid friends head out to pull up the carpets of strangers and muck out their living rooms, I stay home and do the laundry they bring back to me. It is thick with mud and leaves and bits of sticks. Every night when I'm finished, I mop the hall to the laundry room and pull a dozen ticks off myself. I wash boxes of mud-caked dishes and dry them all and put them down in my clean basement in neat, labeled boxes until the people they belong to are settled enough to want them back again. We're waiting to hear if the water treatment plant is going to close.

But in my limited personal experience this is nothing compared to the aftermath of the flood of '74, when the corpses of drowned cows floated down the road from two farms away and sank in our front yard. We didn't know about this until days later, when the water finally receded and we were able to return home. It turns out that cow removal is not the responsibility of the people who own the cows, but

of the people who wind up with them in the end. The dead cows, like the ticks and the mud, like the rain itself, serve to remind us that life is a civilized business until it's not. And in those rare times when we manage to emerge triumphant from an encounter with weather, we realize we've been placated: if we're still standing, it's only because the weather didn't feel like taking us out on that particular day. Once again I'm counting myself as lucky.

(*New York Times*, May 5, 2010)

Dog without End

———————————— • ————————————

TWO DAYS BEFORE my dog Rose died, I put her in the stroller and pushed her down the sidewalk. It was late in November but the day was mild and bright. For a minute she sat up on the fake sheepskin pad and sniffed the air, but then she lay down again. When my friend Norma had bought Rose a dog stroller the summer before I hadn't wanted it, but feelings of idiocy were quick to give way to Rose's obvious pleasure. She liked the jostle of the uneven sidewalks, the chance to track a squirrel or bark at another dog. If the late afternoon came without a walk, she would begin to cry and complain beside me on the couch until I finally took her outdoors and rolled her around. If my neighbors found my behavior to be worthy of discussion, so be it. My dog was happy.

Rose hadn't walked for more than a year, and she had been deaf for longer than that, but in the last two weeks the stronger antibiotic she'd been taking for a persistent bladder infection had turned her eyes to milk. Blind, she would trace a figure eight in the air with her nose, barking piteously whenever I walked away from her. She lost her appetite. I held the smallest bites of meat loaf, always her favorite, to

her black lips and she turned her head away. I took her to the vet constantly in those days, trying to hold on to the empty little sack of a dog she had become. There were pills and drops and ointments, bags of fluids to be administered subcutaneously. On the visit to the vet this particular late-November morning, he had told me what I already knew: it was over. It was now just a matter of deciding on the day.

Rose and I took our normal route, three blocks towards West End before turning right on Craighead. We went up a long hill and down again to where the street gave way to an alley. It was the middle of the day and the neighborhood was quiet. There was a golf cart coming up behind us with an older man driving, two little boys in the back. The man stopped the cart a few feet past us when it registered that I didn't have a baby.

"Boys," he said, when they were looking straight at us, "look at that. That's a little dog in there."

I knew this man by sight though not by name, the way you know the man in your neighborhood who drives a golf cart, the way he knows the woman who pushes the dog stroller. "She doesn't walk," I said.

He was wearing a ball cap pulled down over his sunglasses. "Well, isn't that nice of you to take her out like that. Boys, isn't that nice?"

The boys, who were for at least a minute genuinely interested in the unexpected visual of a dog now sitting up in a place formerly occupied in their experience only by human infants, nodded in thoughtful agreement.

"She's old," the man said to me.

"Sixteen," I said, though Rose, up until these past few weeks of sharp decline, had never looked her age. Soft as any rabbit, she was all-over white with one ginger ear, a gingered spot between her shoulder blades. White dogs are slow to show their age.

"My dog was sixteen," the man said to me. "Well, it was my girls' dog, but they were both away in college when she got so bad."

I had spent the vast majority of the last sixteen years alone in a room with this dog. I wrote books while she chased a ball or chewed a bone or, later, mostly slept. I had spent more hours of my life in Rose's physical presence than I had in the presence of my mother or my husband, so when I held up my hand to the man in his golf cart, I meant it as an act of self-preservation. "Don't tell me."

The man nodded, understanding, but he had already started to remember his dog. He was unable to stop himself. "She lost her mind at the end," he told me. "She would walk into a corner behind the door and she couldn't figure out how to back herself up. She'd get stuck there, and she'd start barking."

"I'm serious," I said. "Don't tell me this." I pushed the stroller back and forth while we idled.

"The last day I was home by myself. I had to call my girls and tell them. They'd had her since they were little. They'd always had that dog."

The boys in the back of the cart were maybe six and eight. I don't know for sure. I've never been a good judge of boys. "I'm asking you to stop," I said.

"When I went and got her, when I took her into the vet and he put her down, I cried." He shook his head at the thought, at the sadness of it all. "I stayed with her all the way until the end. I'll tell you, I never cried like that over anything in my life."

"Please," I said, begging him, nearly laughing. I did not want to have to run away from him with my stroller but I was prepared to. "Stop."

And then, of course, he did. He snapped to his senses. He wished us a good walk, and set the electric motor in motion. The boys waved as they rode away, and I reached down to rub Rose's ears. I let her smell my wrist. When she was settled again, I pushed the stroller on, down the alley and back up the next block towards home. I was trying not to think about the man or his dog or how he had known when that

last day was upon them. I was trying just to think about Rose and how the sun sat on the top of her head and how the warmth would feel good to her. Halfway up the street, I saw the golf cart circling back. The man drove a few feet past me and then stopped, turning his wheels towards the curb. This time the two boys did not so much as glance in our direction.

"What I didn't tell you was that my dog was in terrible shape," the man said, as if there had been no lapse in our conversation. "She was nothing like your dog at all. Look at her," he said, nodding down to Rose. "Look at the way she's sniffing the air, sitting up. She looks five years younger than my dog. She's going to last you a long time."

"Thank you," I said.

"I mean it," he said. "They aren't the same." Then he tipped his cap and drove away.

The next day my friend Kevin Wilson came to visit. After Kevin was out of college he used to come to my house and stay with Rose when I traveled. Since that time Kevin had gone on to get married and have a son. He'd published books and had dogs of his own. Now he crouched down beside Rose and cupped her head in his hand. He stayed like that for a long time, thinking, I suppose, about the way things used to be. "I always thought you had the one immortal dog," he said to me.

And that was the problem, though I hadn't known to put it into words. I had thought the same thing.

Rose died the next day, in the vet's office, in my arms, and though she was no longer drinking water and had developed a sharp, acrid odor like a chemical burning, she still required a second injection to bump her out of life. In every sense I understood that this was her time, and that we had both been lucky these sixteen good years. I had friends who had endured their own impossible losses and they stood beside me in both the real and metaphorical sense to brace me for

what was ahead. And still, when the vet came to take her from me and rested her up against his shoulder, something in me cracked. I stepped into that same river that the man in the golf cart had been in for all these years past his dog's death, and I sank.

I want to tell you that Rose was an extraordinary dog, bossy and demanding of attention, comforting in her very presence. Famously, she first appeared in the pages of *Vogue* fifteen years ago. She sat on my shoulder in book jacket photographs. When she was very dirty after a run I would tell her to go get in the bathtub, and she would. She once scampered onto the headrest of Karl's parked car, made a vertical leap through the open sunroof, and ran across the parking lot, into the grocery store, and up and down every aisle until she found us. She was loyal and brave and as smart as a treeful of owls. By explaining her talents and legions of virtues, though, I would not be making my point, which is that the death of my dog hit me harder than the deaths of many people I have known, and this can't be explained away by saying how good she was. She was. But what I was feeling was something else entirely.

I came to realize in the months following Rose's death, months that I referred to myself as being in the ditch, that there was between me and every person I had ever loved some element of separation, and I had never seen it until now. There had been long periods spent apart from the different people I loved, due to nothing more than circumstances. There had been arguments and disappointments, for the most part small and easily reconciled, but over time people break apart, no matter how enormous the love they feel for one another is, and it is through the breaking and the reconciliation, the love and the doubting of love, the judgment and then the coming together again, that we find our own identity and define our relationships.

Except that I had never broken from Rose. I had never judged her or wanted her to be different, never wished myself free from her for a single day. When she ate my favorite pair of underwear, had an acci-

dent on the carpet, bit my niece (very lightly and without conse-
quence), I took her side. When we took our first vacation together to
Ocracoke Island in the Outer Banks of North Carolina, Karl and I
went into the ocean to swim, leaving Rose on the beach, which was
the moment that Rose decided that the only thing worse than swim-
ming was being alone. That vacation turned out to be one day long, as
the next morning we were evacuated from the path of an incoming
hurricane. The entire population of the eastern Carolinas loaded up
their cars and drove inland. When we finally reached the venerable
Carolina Inn in Chapel Hill, it was past midnight and the lines for
rooms were long. I held Rose in my arms and asked the man behind
the desk if we could check in with our dog. "The Carolina Inn does
not accept dogs," he said stiffly; then he added, "Fortunately, I do not
see a dog." And so Karl and Rose and I slept in a king-sized bed and
ate our dinner off room-service trays and waited for the storm to pass.
But had the hotel turned us away we would have slept together in the
car. When I'd seen Rose swimming out towards us the day before, her
little head held high against the waves, I realized there was no leaving
her behind. There was never any space between us as far as I was
concerned. As far as Rose was concerned, I can't say. Maybe I crowded
her, but if I did, she never let me know.

When I was in the ditch, my friend Susan told me to find old pic-
tures of Rose, pictures of when she was healthy and young. Susan said
they would make me feel worse for a while, and then they would
make me feel better. And she was right. I'm not much for taking
photos, but my friends are, and they sent me pictures of Rose that
spanned from the first day Karl and I found her, through the last day,
because my friend Debbie had come over and made a portrait of Rose
the hour before she died. I bought a photo album and I arranged the
story of her life. What I hadn't imagined was that it was the story of
my life as well. If you flip through the pages you see us age together,
always the two of us, Rose in my lap, Rose at my side, other people

moving in and out of the frame over time while my hand forever rests on Rose.

The fall of 2011 was a hard one in my neighborhood. Junior, the Cavalier King Charles spaniel across the street, died suddenly of congestive heart failure. Blue, the blind Persian cat, outlasted all expectations, and was terribly missed. When Tarheel, the black Lab three doors away, succumbed to old age, his owner came that afternoon and knocked on my door. "I need to see Rose," she said.

I brought Rose out, wrapped up in a towel, and Linda sat with her in the rocker on my porch and cried.

"Some little dog out there has won the lottery and she doesn't even know it yet," my sister said to me when I told her that I was thinking it might be time to find another dog. We had waited six months before we started looking, long enough, I hoped, that I wouldn't just be trying to find Rose again. Still, I can't shake off the hope that we'll find this new dog in a similar way. My husband and I go to the Internet to look at dogs late at night. We call it Internet dog-dating, but like any kind of Internet dating, we are reduced to making judgments based on physical appearances, and as anyone who's hoping for a lifetime of companionship knows, looks are the least of it.

The story of how Karl and I came by Rose is more complicated than the one we tell, and certainly more complicated than the glossed-over version I first published in *Vogue*. Boiled down over the years, it became, *We found her in the park*, which, in the broadest sense, was true. But weeks before that, another girl had found her, a puppy abandoned in a parking lot, in a snowstorm. The girl then gave the small white dog to her sister, who thought that she could give her away at an annual Terrier Days dog festival (the logic being that Rose looked as if there had been a Jack Russell and a Chihuahua in her family lineage). Karl and I were only passing through before the event began, return-

ing to the parking lot after a hike. We told the girl how much we liked her puppy, and that we would think about taking her, but first we had to quickly make a lunch date with some out-of-town friends. When we left the two of them in the park, I had the feeling we weren't doing the right thing, and that anxiety gnawed at me all through lunch. This was the dog that I wanted, this particular dog I did not know and was not looking for, and once our friends had ambled through their meal, we hurried back to the park to stake our claim.

But the park was now flooded with people and dogs, people lined up to watch Jack Russells jump fences and run between bales of hay. We couldn't find the girl, but after some time we found the puppy herself. She was locked in the arms of a blond child wearing a tutu. Beside the child was a black Labrador, also wearing a tutu. I asked the girl about the puppy she was holding but she didn't answer. I found the girl's mother and told her that her daughter had my dog.

"A girl gave her to us," the woman told me. "She said someone else was interested but they had to leave."

"Then it was a misunderstanding," I said. "Because I told her we were taking the dog."

The woman started to disagree with me but hesitated, looking over at her daughter. I could see the details of her decision playing out in her head: the stained carpet, the missing shoes. They had a perfectly good dog. "I didn't want a second dog," she said finally. "My daughter wanted her." If she knew I was lying she didn't care. "My daughter is deaf," she said.

"Let her keep the puppy," Karl said, but I shook my head. They didn't want a second dog. Karl looked at me despairingly, then said he would meet me back at the car.

The woman and I made our way into the crowd of children and dogs dressed to match—Superman T-shirts, Batman capes—until we reached the pair in tutus. The Labrador seemed like a very nice dog. The woman took the puppy from her daughter, and the girl started to

cry. I'm sure there was something I should have said or done to be of comfort, but I had no idea what that might have been. I was with Rose now, who was my dog of all the possible dogs in the world. I moved quickly through the crowd before anyone changed their mind. When I found Karl I got in the car and locked the door. I told him to drive.

Sometimes love does not have the most honorable beginnings, and the endings, the endings will break you in half. It's everything in between we live for.

(*Vogue*, September 2012)

The Mercies

———— • ————

Long before any decisions had been made about where or when she might be moving, Sister Nena starts combing the liquor stores early in the mornings, looking for boxes. She is breaking down the modest contents of her life into three categories: things to keep, things to throw away, things to donate to Catholic Charities. Sister Melanie is doing the same.

"What's the rush?" I ask, picking my way past the long line of boxes that is already filling up the front hall, everything labeled and sealed and neatly stacked. It is August, and the heat and humidity have turned the air into an unbearable soup. I think they're getting ahead of themselves and I tell them so. Sister Kathy, who is responsible for assessing their situation and deciding where and when they should move, won't be coming from the mother house in North Carolina for weeks.

"We've got to be ready," Sister Nena says. She does not stop working. Her state of being is one of constant action, perpetual motion. A small gold tennis racquet dangles from her neck where on another

nun one would expect to find a cross. "I won't pack the kitchen until the very end."

Not that the kitchen matters. I suspect that the nuns, who are small enough to emulate the very sparrows God has His eye on, should be eating more, which is why I've brought them dinner. Sister Melanie will be going to Mercy, the nuns' retirement home, but she doesn't know when. Some days she is looking forward to the move, other days she isn't so sure. She stops and looks in the bag at the dinner I've brought, giving me a hug before ambling off again.

Sister Nena is certain that she doesn't want to go to Mercy. She regards it as the end of the line. She's hoping to land in a smaller apartment by herself, or maybe with another sister, though finding a new roommate at the age of seventy-eight can be a challenge. "It's up to God," she says in a matter-of-fact tone, then goes back to her boxes.

To make a generalization, nuns don't have much experience with moving.

Sister Nena was born in Nashville, the city where we both live. She was eighteen when she entered the convent. Sixty years later the convent is gone and the few Sisters of Mercy who are left in this city are scattered. For almost twenty years, Sister Nena and Sister Melanie have lived in a condo they once shared with Sister Helen. The condo, which is walking distance from the mall, is in an upscale suburban neighborhood called Green Hills. It isn't exactly the place I would have pictured nuns living, but then everything about my friendship with Sister Nena has made me reevaluate how life is for nuns these days.

"It's like that book," she says, explaining it to me. "First I pray, then I eat."

"That leaves love," I say.

"That's it. I love a lot of people. Pray, eat, love, tennis. I'm in a rut. I need to find something else I can do for others."

I guess I always thought the rut was part of it. A religious life is not

one that I associate with great adventure. But now that change is barreling towards her, Sister Nena is restless for its arrival. Day after day she is standing up to meet it and I can see she's had a talent for adventure all along. It seems to me that entering the convent at the age of eighteen is in fact an act of great daring.

"I didn't always want to be a nun," Sister Nena says. "Not when I was younger. I wanted to be a tennis player. My brothers and I knew a man who let us play on his court in return for keeping it up. It was a dirt court and they would roll it out with the big roller and I would repaint the lines. We played tennis every day." Nena, the youngest of three. Nena, the only girl, following her brothers to the courts every morning of summer on her bicycle, racquet in hand.

When I ask her what her brothers thought of her entering the convent, she says they thought she was crazy, using the word *crazy* as if it were a medical diagnosis. "So did my father. He thought I was making a terrible mistake giving up getting married, having kids. I liked kids," she says. "I babysat a lot when I was young. I had a happy life back then. I had a boyfriend. His family was in the meat-packing business. My father called him Ham Boy. It was all good but still there was something that wasn't quite right. I didn't feel comfortable. I never felt like I was living the life I was supposed to."

What about her mother, is what I want to know. What did her mother say?

Sister Nena smiles the smile of a daughter who had pleased the mother she loved above all else. "She was proud of me."

There would never be enough days for me to ask Sister Nena all the things I want to know, and she is endlessly patient with me. She can see it plainly herself: it hasn't been an ordinary life. Some of my questions are surely a result of the leftover curiosity of childhood, the quiet suspicion that nuns were not like the rest of us. But there is another way in which the questions feel like an attempt to gather vital information for my own life. Forget about the yoga practice, the meditating, the vague dreams of going to an ashram in India: Sister Nena

has stayed in Tennessee and devoted her life to God. She has lived with her calling for so long that it seems less like a religious vocation and more like a marriage, a deeply worn path of mutual acceptance. Sister Nena and God understand one another. They are in it for life.

The order of the Sisters of Mercy was started by Catherine McAuley back in Dublin. She recognized the needs of poor women and girls and used her considerable inheritance to open a home for them called Mercy House, taking her vows in 1831. Committing your life to God was one thing, but I think that choosing an order would be akin to choosing which branch of the military to sign up for. Army? Navy? Dominicans? From a distance it all looks like service, but the daily life must play out in very different ways. "The Mercys taught me in school," Sister Nena says.

I nod my head. I was also taught by the Mercys in school. I was taught by Sister Nena.

"They never manipulated me," she says in their defense. "But I admired them, their goodness."

I spent twelve years with the Sisters of Mercy and I am certain in all that time no one ever suggested that I or any of my classmates should consider joining the order. Nuns have never been in the business of recruitment, which may in part account for their dwindling ranks. What we were told repeatedly was to *listen*: God had a vocation for all of us and if we paid close attention and were true to ourselves we would know His intention. Sometimes you might not like what you heard. You might think that what was being asked of you was too much, but at that point there really was no getting out of it. Once you knew what God wanted from your life you would have to be ten kinds of fool to look the other way. When I was a girl in Catholic school I was open to the idea of being a nun, a mother, a wife, but whenever I closed my eyes and listened (and there was plenty of time for listening—in chapel, in math class, in basketball games—we were

told the news could come at any time) the voice I heard was consistent: *Be a writer*. It didn't matter that "writer" had never been listed as one of our options. I knew that for me this was the truth, and to that end I found the nuns to be invaluable examples. I was, after all, educated by a group of women who had in essence jumped ship, ignored the strongest warnings of their fathers and brothers in order to follow their own clear direction. They were working women who had given every aspect of their lives over to their belief, as I intended to give my life over to my belief. The nuns' existence was not so far from the kind of singular life I imagined for myself, even if God wasn't the object of my devotion.

In her years as a postulant and then a novice, Sister Nena moved around: Memphis, Cincinnati, Knoxville, finishing her education and taking her orders. When I ask her when she stopped wearing a habit she has to think about it. "1970?" Her hair is now a thick, curling gray, cropped close. "I liked the habit. If they told us tomorrow we had to wear it again I'd be fine with that. Just not the thing that went around the face. There was so much starch in them that they hurt." She touches her cheek at the memory. "It got so hot in the summer with all that stuff on, you couldn't believe it. But if it got too hot I'd just pull my skirts up."

It was around 1969 that she came back to Nashville to teach at St. Bernard's Academy, about the time I arrived from California and enrolled in first grade late that November. This is the point at which our lives first intersect: Sister Nena, age thirty-five, and Ann, very nearly six.

The convent where we met was an imposing and unadorned building of the darkest red brick imaginable. It sat on the top of a hill and looked down over a long, rolling lawn dotted with statuary. It was there I learned to roller-skate, and ran the three-legged race with Trudy Corbin on Field Day. Once a year I was part of a procession of little

girls who settled garlands of roses on top of the statue of Mary while singing, "Oh Mary, we crown thee with blossoms today," after which we would file back inside and eat our lunches out of paper sacks. The cafeteria was in the basement of the convent; the classrooms were on the first floor. On the second floor there was a spectacular chapel painted in bright blue. It had an altar made from Italian marble and a marble kneeling rail and rows of polished pews where I would go in the morning to say part of the Rosary and then chat God up in that personal way that became popular after Vatican II. My mother worked long shifts as a nurse when I was young and she would take my sister and me to the convent early and pick us up late. The nuns would let us come into their kitchen and sort the silverware, which, in retrospect, I imagine they mixed together just to give us something to do. My sister and I were well aware of the privilege we were receiving, getting to go into their kitchen, their dining room, and, on very rare occasions, into their sitting room on the second floor where they had a television set and a fireplace whose mantelpiece was a madly grinning openmouthed devil whose head was topped with a crucifix. Still, in all those years, I never set foot on the third floor or the fourth floor of the building. That was where the nuns slept, where Sister Nena slept, and it was for all us girls as far away as the moon, even as it sat right on top of us.

"How did we find each other again?" Sister Nena asks me recently while we are in the grocery store.

"You called me," I say. "Years ago. You were looking for money."

She stops in the middle of the aisle. "I forgot. It was for St. Vincent's School. Oh, that's awful. It's awful that that's why I called you."

I put my arm over her shoulder while she steers the cart. Sister Nena likes to steer the cart. "At least you called."

Sister Nena lived in the convent at St. Bernard's until she was sixty years old. That was when the order sold the building. The large parcel

of land, which sat smack in the middle of a hip and crowded neighborhood called Hillsboro Village, was valuable. A large apartment complex was built in the front yard where we had played. They had to rip out the giant mock orange trees first. Picking up mock oranges, which were smelly and green and had deep turning folds that were distressingly reminiscent of human brains, was a punishment all the girls sought to avoid. It surprised me how sorry I was to see those trees go.

An interior window over the chapel's doorway could be opened onto the third floor so that the nuns who were too infirm to come downstairs could sit in their wheelchairs and listen to Mass. When I was a girl I would try to glance up at them without being noticed. From my vantage point down in the pews they were tiny in their long white dresses, which may have been the uniform of advanced age, or may have just been their nightgowns. After the sale of the convent, the sisters who were retired or needed care were sent out to Mercy, which was then a new facility twenty miles outside of town. The primary school students were moved next door into the building that had once been the secondary school (the high school, never as successful as the primary school, was now defunct) and the convent building itself was converted into office spaces. Every classroom and nun's bedroom found another use: a therapist's office, a legal practice, a Pilates studio. The altar was given to a parish in Stone Mountain, Georgia. It had to be taken out through the back wall with a crane. The pews were sold. The now-empty chapel became a rental party space.

"That was hard," Sister Nena says in a manner that takes hard things in stride. "We had a lot of fun there, especially in the summers when everyone would come home. The sisters who taught in other towns would all come back. We'd sit up and tell stories and laugh, have a glass of wine."

I went back to St. Bernard's once, years later, and climbed the

back stairs to the fourth floor and stood in an empty bedroom/office to look out the window. It was like looking down from the moon.

The vows for the Sisters of Mercy are poverty, celibacy, and obedience; and service to the poor, sick, and uneducated, with perseverance until death. Obedience is another way of saying that you don't complain when your order decides to sell the place you live. You don't get a vote in the matter. Sometimes this strikes me as grossly unfair. ("You should have told them no," I find myself wanting to say, even though I have no idea who "them" might have been.) Other times, when I can manage to see outside the limitations of my own life, I catch a glimpse of what the move must have been to Sister Nena: another act of faith, the belief that God has a plan and is looking after you. It must be the right thing, because you had turned your life over to God, and even if you didn't understand all the intricacies of the deal, He wasn't about to make a mistake.

After the sale, the younger sisters, the ones who were still teaching, were relocated to rented apartments around town so that they could have an easier commute into work. "It was all right," Sister Nena says. "We'd all still get together on the weekends and have dinner." Sister Nena, who taught reading in grades one through three, and Sister Helen, my math teacher for those same grades, and Sister Melanie, the lower school principal, moved together into a rented condo, its three bedrooms making a straight line off the upstairs hallway. They were happy there. They continued to work until the time came to work less. They semiretired, retired, tutored children who needed tutoring, volunteered at Catholic Charities. After she left St. Bernard's, Sister Nena volunteered at St. Vincent de Paul's, a school for underserved poor children in North Nashville that remained in a state of constant financial peril until it finally went under.

Then, in 2004, Sister Helen had a stroke. After she got out of the hospital she was sent to Mercy. For a long time Sister Melanie and

Sister Nena thought that she'd come back, take up her place again in the third bedroom, but Sister Helen only got worse. Day after day, Sister Nena would drive the twenty miles out to Mercy to visit her friend and try to get her to do the puzzles in the children's math workbooks that she had taught from for years, and sometimes Sister Helen would, but mostly she would sit and watch television. Over time she recognized Sister Nena less and less, and then finally not at all. It was because of Sister Helen's stroke that I started seeing more of Sister Nena. We would have lunch after she played tennis, or have coffee in the afternoons. She would talk about her friend and sometimes she would cry a little. They had, after all, been together for a very long time. It was during one of those conversations she mentioned that Sister Helen's last name was Kain, and I wondered how I could never have known that before.

Sister Nena and Sister Melanie stayed in Green Hills, but by 2010 Sister Melanie was growing increasingly fragile, forgetful. It was the consensus among the other nuns, and Sister Melanie agreed, that she was ready to go out to Mercy.

The question then became what should be done with Sister Nena? She was, after all, still playing tennis like one of the Williams sisters three times a week and didn't seem like much of a candidate for the retirement home. Still, while one spare bedroom could be overlooked, the condo's rent was $1,400 a month and there were no spare nuns to fill up what would now be two empty bedrooms. It was decided that Sister Nena could stay out of Mercy, but she needed to find an apartment that was significantly less expensive. For the first time in her life, she would be on her own.

I like to take Sister Nena to Whole Foods. It is a veritable amusement park of decadence and wonder to one who has taken a vow of poverty. Her ability to cook is rudimentary at best and she doesn't like to shop, so I advocate prepared foods from the deli. Sister Mel-

anie, who adored the grocery store, made her pilgrimage to Kroger
every Sunday. It is not a habit Sister Nena plans on picking up,
claiming her Italian heritage will save her: as long as she has a box
of pasta and a jar of sauce she will never starve. I can usually per-
suade her to let me get a few things now that I know what she likes.
She is greatly enamored of the olive bar. After Sister Kathy's visit,
when the decision about everyone's future was settled, I take Sister
Nena to the store and we get some coffee and sit at a small table by
the window to discuss the details. She tells me she's found a place
in a sprawling complex called Western Hills, on the other side of
town. I don't like the sound of it. I know the neighborhood, and the
busy street is crowded with fast-food places, check-cashing centers,
and advertisements for bail bondsmen. She is set on getting a two-
bedroom so that she can have a little office for her computer and the
chair where she says her prayers in the morning. I argue for a smaller
place in the neighborhood where she lives now, but for once in her
life the decision is Sister Nena's to make and she intends to get what
she wants. "It's all going to be fine," she says, trying to reassure me
or reassure herself. "Sister Jeannine lives out there. She likes the
place. I've got it all figured out. Sister Melanie's helping me work on
a budget. They gave me a checking account, a credit card, and a
debit card."

There in the café at Whole Foods, amid the swirl of mothers with
strollers and young men with backpacks, my friend, a slightly built
Italian woman in a tracksuit, is not out of place. I have no idea what
she is talking about.

"I got a checking account," she says again.

"You've never had a checking account?"

She shakes her head. "Melanie handled all the finances. She paid
the bills." Then Sister Nena leans in, moving her cup aside. "What
exactly is the difference between a credit card and a debit card?"

The idea of going at the age of eighteen from your parents' house

into a convent, and leaving that convent at the age of sixty to live with two friends in a condo, and leaving that condo at the age of seventy-eight to live alone for the first time in your life, is something I can barely comprehend. Not to have had a checking account or a credit card makes me feel like I am having coffee with someone who just arrived from a Henry James novel.

"I know," she says, understanding my point completely. "In some ways I have a regular life and in other ways I don't at all."

I try to outline the details of credit versus debit as clearly as possible, explaining the different ways either one of them can trip a person up. "When you use the debit card you have to write it down in the registry the same way you would a check. You need to write everything down and then subtract it from your balance each time so you'll know how much you have."

She takes a sip of her coffee. "I can do that. I'm smart enough."

"You're perfectly smart," I say. "But I don't know if you know all of this already. Once a month you get a statement from the bank. You have to balance your checkbook against the bank statement." I never thought much of the intellectual content of my secondary education, which was weighed down by a preponderance of religion classes and gym. But while the nuns may have been short on Shakespeare, they were long on practicality. By the time we were in high school we had learned how to make stews and sauces and cakes. We knew how to make crêpes. We could remove stains and operate a washing machine. We were taught not only the fundamentals of sewing, but how to make a budget and balance a checkbook, how to fill out a simple tax form. Down at the primary school, Sister Nena had not received the benefits of any of these lessons.

She puzzles over what I have been telling her about bank statements for a long time. When I get to the part about how she is supposed to put a tiny check mark in the tiny column once she'd received the canceled check, she suddenly perks up as if she has found the

answer to the problem. Then she starts laughing. "You shouldn't tease me like that," she says, putting her hand on her heart. "You scared me to death. You shouldn't tease a nun."

"I'm not teasing you," I say.

By the slight flash of panic that comes across her face I can tell that she believes me. Still, she holds her ground. "I don't have to do that. I never saw Sister Melanie do that."

All the Sisters of Mercy living in their separate apartments submit a budget to the mother house, estimating the cost of their electric bills and phone bills, food and rent. What they come up with for their monthly stipend is a modest number at best. The order picks that up, along with all medical expenses and insurance. Two years ago, when Sister Nena's car was totaled by a car that ran a red light, the order agreed that she could have a new car. I drove her to the Toyota dealership. All she had to do was sign a piece of paper and pick up the keys. "I hope it's not red," she said on the way there. "I don't like red cars."

The car, a Corolla, was new, and it was red. Sister Nena walked a slow circle around it, studying, while the salesman watched. It wasn't every day a car was purchased over the phone for someone who hadn't seen it. "I take it back," she said to me finally. "The red is nice."

When Sister Nena was a young nun teaching at St. Bernard's, around the time that I was her student, she received an allowance from the order of twenty dollars a month. All of her personal expenses were to be covered by that sum: shoes, clothing, Lifesavers. Any cash gifts from the parents of students that came inside Christmas cards were to be turned over, as was any money from her own parents folded into birthday cards. It wasn't a matter of the order leeching off the presents, it was the enactment of the vow. The sisters were still to be poor even when a little extra cash had presented

itself. I can't help but wonder if there was ever a small temptation to take a ten-dollar bill from one's own birthday card, but the question seems impolite. "What if your mother sent you a sweater?" I ask instead. I am not being willfully obtuse; I am trying to figure out the system.

"Oh, that wasn't a problem. You got to keep the sweater."

It is possible that the only reason any of this makes some limited sense to me is that these were the lessons I was taught as a child. The notion of a rich man's camel not being able to make its way through the eye of the needle was a thought so terrifying (my family was not without means) it would keep me up at night. I believed then that turning away from the material world was the essence of freedom, and someplace deep inside myself, someplace that very rarely sees the light of day, I still believe it now. I imagine that no one who has spent sixty years embracing the tenets of poverty thinks to herself, *I wish I'd had a two-hundred-dollar bottle of perfume.* That said, after our coffee and the perilous conversation about checking accounts, we go into Whole Foods to do some shopping. Sister Nena is adamant about wanting to go to Kroger, a less expensive grocery store a few blocks away, because the weekly nun dinner is going to be at her house that night and she'd promised to make pork chops. I tell her no, I am buying the pork chops where we are. I believe that pork chops are not an item that should be bargain-hunted.

"When did you get to be so bossy?" she asks me.

"I've been waiting my entire life to boss you around," I say. I fill up the cart with salads and bread and good German beer while Sister Nena despairs over how much money I spend.

In the checkout line I am still thinking about the twenty dollars a month, a figure she tells me was later raised to one hundred. "I worked almost fifty years and I never once saw a paycheck," she says, and then she shrugs as if to say she hadn't really missed it.

Whole Foods is designed to look like a loft in SoHo—high windows and exposed pipes run across the ceiling. I watch a sparrow fly towards the cereal aisle. "When I was a little girl," I say to Sister Nena, "and I would think about whether or not I was supposed to be a nun, I always thought I'd like to be in a cloistered order, a big wall, no visitors." From the vantage point of the future, of course I can see that I would have chosen the cloister because it would have been a wonderful place to write—no telephone, no house guests, none of life's thousand distractions, no place to go. I would have made a fine contemplative nun. I could easily excel at a vow of silence. I might even be good at poverty and chastity and obedience if, in return, I could have quiet days to work. Sister Nena and I continue to load the food onto the conveyer belt. For a moment I picture myself in white, in silence. "If I had been a nun I would have been a Poor Clare," I announce.

At this Sister Nena takes my arm she is laughing so hard. "You?" she says, gasping. "A Poor Clare?"

Sister Nena has lined up plenty of help for the move to her new apartment. Although Sister Melanie moved out to Mercy last week, she has come back to lend a hand. Sister Nena's eighty-year-old brother, Bud, is there, along with two of his children, Andy and Pam, and Sister Nena's friend Nora has come too, and together we load up our cars with everything Sister Nena didn't want to leave to the two movers. It is six-thirty in the morning and has just started to rain.

"We can probably take all the boxes in the cars," she says. "That way the movers wouldn't have to bother with them."

"They're movers," I say, trying to remember if I have helped a friend move since I was in graduate school. "That's what they do." I go to take apart Sister Nena's computer, which is a series of enormous black metal boxes with dozens of snaking cables coming out the back.

It looks like something that might have come out of NASA in the seventies. I am very careful putting it in my car.

The Western Hills complex is actually set farther back from the busy street than I had realized, and it is so big that it has the insulated feel of a small, walled city. Once our caravan arrives and the contents of our cars are transferred into the apartment's small living room, the rest of the group goes back to their lives and Sister Nena, Sister Melanie, Sister Jeannine, who lives in Western Hills, and I begin to put the food in the refrigerator and the clothes in closets while the movers bring in the furniture and the remaining boxes. The three nuns, all in their seventies, do hard work at a steady pace, and while I may be tempted to sit down for a moment on the recently positioned sofa, they do not, and so I do not. I tell the movers where to put the television.

"I'm sorry," the young man says to me. "I know you told me your name but I don't remember."

"Ann," I say.

"Sister Ann?" he asks.

It is true that in a room with three nuns I could easily pass for a fourth. We are all dressed in jeans and sweatshirts. We have all forgone mascara. "Just Ann," I say. I think about my mother, who, like the nuns, is in her seventies now. She was and is a woman of legendary beauty, a woman with a drawer full of silk camisoles and a closet full of high-heeled shoes who never left the house without makeup even if she was walking the dog. My sister and I have often wondered how her particular elegance and attention to detail passed over us, how we have inherited so little of her dexterity where beauty is concerned. But as I talk to the mover, a Catholic kid with a shamrock tattooed inside his wrist, I think of how we would arrive at the convent very early in the morning, and how we would stay sometimes until after dark. Maybe what rubbed off over the years was more than faith. Maybe the reason I'm so comfortable with Sister Nena and the

rest of the nuns is that I spent the majority of the waking hours of my childhood with them. Where influence is concerned, timing is everything.

That first time Sister Nena called me all those years ago, when she was looking for someone to help her buy school supplies for the children at the St. Vincent de Paul School, she told me she had prayed about it for a long time before picking up the phone. She wasn't happy about having to ask for money, but the children didn't have paper or crayons or glue sticks, and she knew I'd done well over the years. She'd read some of my books. "I taught you how to read and write," she said.

"You did," I said, and didn't mention that she had in fact done a great deal more for me than that. Sister Nena had been the focal point of all of my feelings of persecution, the repository for my childish anger. I knew that she had thought I was lazy and slow, dull as a butter knife. I watched the hands of other girls shoot up in class while I sat in the back, struggling to understand the question. Even though I had no evidence to the contrary at the time, I was certain that I was smarter than she gave me credit for being, and I would prove it. I grew up wanting to be a writer so that Sister Nena would realize she had underestimated me. I have always believed that the desire for revenge is one of life's great motivators, and my success would be my revenge against Sister Nena. When I was a child I dreamed that one day she would need something from me, and I would give it to her with full benevolence. It was true that she had taught me how to read and write, but what she didn't mention on the phone that day, and what she surely didn't remember after nearly fifty years of teaching children was what an excruciatingly long time it had taken me to learn.

I had started first grade at the Cathedral of the Incarnation in Los Angeles when my parents divorced. In late November of that

year, my mother took my sister and me to Tennessee for what was supposed to be a three-week vacation to see a man she knew there. We never went back. In California, I had not yet learned to read, and when I was eventually enrolled in St. Bernard's, I landed on Sister Nena's doorstep. I remember her well. She was child-sized herself, wearing a plain blue polyester dress that zipped up the back. She had short dark hair and the perpetual tan of a person who played tennis on any passable day. She moved through the class-room with enormous energy and purpose and I could all but see the nonsensical letters of the alphabet trailing behind her wherever she went. I was perilously lost for all the long hours of the school day, but I had yet to conclude that I was in any real trouble. It was still a time in my life when I believed we would go home again and I would catch up among the children and the nuns I knew in California. In Nashville, we stayed in the guest room of strangers, friends of the man my mother was seeing. These people, the Harrises, had daugh-ters of their own who went to St. Bernard's and the daughters were not greatly inclined to go to school, nor were the Harrises inclined to make them. Many days we all stayed home together. It was 1969, a fine year for truancy.

I started second grade at St. Bernard's as well, having learned very few of the lessons that had been laid out in my first year there. The enrollment at the school was small and we had the same teachers for grades one through three. Again, Sister Helen was there with the math I didn't understand. Again, Sister Nena rolled up her sleeves, but the making of letters eluded me. We left the Harrises' house and found our own apartment, and then moved again. After Christmas we moved to Murfreesboro, a less expensive town thirty minutes away where I was enrolled in public school, but we didn't stay there either. A few months into third grade we were back in Nashville and I was back with Sister Nena. I still couldn't read whole sentences or write the alphabet with all the letters facing in the right direction. I knew a

handful of words and I did my best to fake my way through. Sister Nena, seeing me turn up for a half year of school for the third year in a row, had had enough. She kept me in from recess and kept me after school, badgering me with flash cards and wide-ruled paper on which I was expected to write out letters neatly, over and over again. I had fallen through the cracks and she had plans to pull me up, by the hair if necessary. She would see to it that I wasn't going to spend the rest of my life not exactly knowing how to read or write. Cursive was waiting just ahead in fourth grade, she warned me. I had better get up to speed. In fourth grade there were great expectations and no one would be there to drag me along. (She might as well have said that in fourth grade classes would be conducted in French, a confusion that came from a Babar book my sister had. Because it was both in cursive and in French, I believed that cursive was French.) I was terrified of all there was to do, of how far behind I had fallen, and somehow I convinced myself that I was terrified of Sister Nena. I wouldn't be in trouble if it wasn't for her because no one else in my life had noticed I couldn't read.

The only thing interesting about my anger towards and blame of Sister Nena was my willingness to hold on to it, without any further reflection, until I was in my thirties. I had let my seven-year-old self, my eight-year-old self, make my case against her. How much happier I would have been never to learn anything at all! It wasn't until I sent her a check for school supplies that I found myself wondering how often I was in her classroom those first three years, and how much work she had in front of her every time I wandered in. It isn't often the past picks up the phone and calls, affording the opportunity to reconsider personal history in a way that could have saved countless thousands of dollars in therapy had I been inclined to go. I found myself thinking about my childhood, my education. It is a pastime I am particularly loath to engage in, but I was struck by the fact that all I had made a point of remembering was her exaspera-

tion with my epic slowness, and not her ultimate triumph over it. To overstate the case, it was a bit akin to Helen Keller holding a grudge against Annie Sullivan for yanking her around. When the children of St. Vincent de Paul ran out of glue sticks again and Sister Nena called me a second time, I suggested we go shopping together and buy some.

She was standing outside her condo in Green Hills when I arrived, waiting for me. Sister Melanie and Sister Helen, still in good health, were home as well. Tennis and prayer and a habit of eating very little must agree with the human body because Sister Nena seemed to have forgone the aging process completely. She was exactly the person I had known when I was a child, and she was nothing like that person at all. She opened up her arms and held me. I was one of her students, one of who knows how many children who had passed through her classroom. That was what she remembered about me: I was one of her own.

There have been very few things in my life that have made me as happy as taking Sister Nena shopping. In the beginning, it was all school supplies, though eventually she confessed her longing to buy small presents for the teachers at St. Vincent's who were every bit as poor as their students and were paid a sliver of the wages a public school teacher made. She picked out bottles of hand lotion and boxes of Kleenex, staplers and Lifesavers, gifts too modest to embarrass anyone, but her joy over having something to give them all but vibrated as we walked up and down the aisles of Target, piling things into our cart. It turned out the real heartbreak of the vow of poverty was never being able to buy presents for the people who were so clearly in need.

Despite my constant questions about what she might need for herself, it was years before Sister Nena let me buy anything for her. She wouldn't dream of letting me take her to the olive bar back then. That

came later in our friendship, after Sister Helen had her stroke, after her best friend Joanne died of cancer, an immeasurable loss. We inched towards each other slowly over many years. At some point I realized that the people she was closest to were dying off or being sent away. Over the course of the years there was a place for me.

"You're at the top of my prayer list," she tells me. "And not because you buy me things." She has come to understand that letting me buy her things makes me happy, and my happiness, instead of the things themselves, is the source of her joy.

"I know," I say.

"It's because I love you," she says.

So ferocious is my love for Sister Nena that I can scarcely understand it myself, but I try. Hers is the brand of Catholicism I remember from my childhood, a religion of good works and very little discussion.

"I like the Catholic Church," she says to me sometimes.

"Good thing," I say, which always makes her laugh. I think that she is everything I have ever loved about our religion distilled down to fit into one person, everything about the faith that is both selfless and responsible: bringing soup to the sick; visiting the widowed husbands of her friends who have died; sticking with the children who are slow to learn and teaching them how to read, because it wasn't just me—it turns out there are legions of us. She babysits two Haitian girls, Islande and Thania, and helps them with their reading and their math. They ask their mother to bring the phone to their beds before they go to sleep so they can call Sister Nena and say goodnight, tell her they have said their prayers. I think of how Sister Nena spoke of the Mercys who taught her in school and how she had admired their goodness. I think of how it took me half my life to fully comprehend the thing she had discovered as a child. (I have no doubt that she had been a better student than I was.)

She is happy in her new apartment, though she probably could

have set up camp in a closet somewhere and been fine. Happiness is her mind-set, her decision, and though she often reminds me that God will take care of things, she is also determined not to trouble Him if at all possible. It's a little bit like wanting to move all the boxes before the movers come. She will take on the work of her life quickly, do it all herself when no one is watching so that she can show God how little help she needs.

Any worries she has these days are focused on Sister Melanie, who is adjusting slowly to her new life at Mercy. Sister Melanie is shy and had long relied on Sister Nena for her social skills. "She stays in her room all the time," Sister Nena says. "Whenever I go out to see her, there she is. I tell her, no one's going to find you in here. You have to get out." She is reaching down into that place where Sister Melanie has wedged herself. She is trying to pull her up.

We get together the day after the funeral of her friend Mary Ann. Mary Ann was the other Catholic in her tennis group. "I'm fine. I'm not sad," Sister Nena tells me when I call. I know better than to believe her. "You don't have to take me out."

"What if I just want to see you?" I say.

Over lunch she tells me that the last time she saw her, Mary Ann was very peaceful. "She looked at me and said, 'Nena, I'm ready. I want to see God.'" Then Sister Nena corrects herself. "I'm wrong. That was the time before last. The last time I saw her she couldn't say anything. When I went to her funeral and I saw the urn there I thought, 'Where is her soul?'" Sister Nena looks at me then, hoping that I might know. "Is it with God? I want to believe her soul is with God. She was so certain. I'm just not sure. I shouldn't say that." She puts her hand flat out on the table. "I am sure."

"Nobody's sure," I say.

"Sister Jeannine is sure." She shakes her head. "I don't know. I'm

contradicting myself. I know God made us but I'm not so sure about what happens afterwards."

"What do you want to happen?" I ask her.

This she knows the answer to immediately. It is as if she has been waiting her entire lifetime for someone to ask her. "I want God to hold me," she says.

You above all others, I tell her. You first.

(*Granta*, Spring 2011)

BLOOMSBURY

RUN

Tip and Teddy are becoming men under the very eyes of their adoptive father, Bernard Doyle. A student at Harvard, serious Tip is happiest in a lab, whilst Teddy, a gentle dreamer, thinks he has found his calling in the Church, and both are increasingly strained by their father's protective plans for them. But when they are involved in an accident on an icy road, the Doyles are forced to confront certain truths about their lives and the identity of an anonymous figure who is always watching.

'A spectacular read ... Full of suspense, exciting and unpredictable, this is a novel that keeps you guessing until the end'
SUNDAY EXPRESS

'Her books are so warm, so overflowing with love and affection, that when you've finished reading one your first inclination is to embrace it'
GUARDIAN

ORDER BY PHONE: +44 (0)1256 302 699; BY EMAIL: DIRECT@MACMILLAN.CO.UK

DELIVERY IS USUALLY 3–5 WORKING DAYS. FREE POSTAGE AND PACKAGING FOR ORDERS OVER £20.

ONLINE: WWW.BLOOMSBURY.COM/BOOKSHOP

PRICES AND AVAILABILITY SUBJECT TO CHANGE WITHOUT NOTICE.

WWW.BLOOMSBURY.COM/ANNPATCHETT

BLOOMSBURY